Scoring Transcendence

SCORING TRANSCENDENCE

CONTEMPORARY FILM MUSIC
AS RELIGIOUS EXPERIENCE

Kutter Callaway

BAYLOR UNIVERSITY PRESS

Cover Design by *the*BookDesigners

Library of Congress Cataloging-in-Publication Data

Callaway, Kutter, 1979–
 Scoring transcendence : film music as contemporary religious
experience / Kutter Callaway.
 263 p. cm.
 Includes bibliographical references and index.
 ISBN 978-1-60258-535-5 (pbk. : alk. paper)
1. Motion picture music—History and criticism. 2. Motion
picture music—Religious aspects. 3. Children's films—United
States—History and criticism. 4. Animated films—United
States—History and criticism. 5. Pixar (Firm) I. Title.
 ML2075.C354 2013
 261.5'78—dc23
 2012028958

To Jessica Kay and Callie Kay.

Music is always something more than music
when I hear it in your presence.

CONTENTS

ACKNOWLEDGMENTS

It almost goes without saying that books are never written in isolation. This particular book is no different. It simply would not exist without the insights and contributions of numerous individuals, some of whom I would like to thank here. While many have contributed something significant to this project, any and all of its faults are wholly of my own making.

I would first like to thank Robert Johnston. His constant support for both this project in particular and my work in general has allowed me the freedom to engage in a manner of theological reflection that is both timely and firmly rooted in the rich history of the Christian tradition. It would be difficult to overstate his contributions to either this book or my burgeoning understanding of what it means to do theology in the contemporary world and, perhaps more importantly, what it means to be a theologian.

I also owe a debt of gratitude to Jim Buhler from the University of Texas for introducing me to an entire world of film music scholarship of which I had previously been unaware. Dr. Buhler's insights and guidance undoubtedly strengthened the many film music analyses that are contained in the following pages. His constant willingness to partake in a thoroughly interdisciplinary endeavor not only provided me with a model for how to engage in a fruitful dialogue across disciplines, but it also afforded me the means for producing a much stronger work of theology.

With a great deal of patience, my editor, Carey Newman, helped not only to shape this into a much more readable book but also to shape me into a much better writer. I greatly appreciate the time he invested and the passion he demonstrated for my original idea.

Finally, I will be forever indebted to the love of my life, Jessica Callaway—a woman who routinely sets aside her own dreams and aspirations in order that mine might be realized. In a very real sense, this book is the fruit of her unwavering support and devotion. What is more, the inspiration for this work is rooted in our shared experiences of God's presence in and through the music of film. I am therefore dedicating this book to both her and the daughter who has captured our hearts. I love you both.

INTRODUCTION

On the opening weekend for one of Disney/Pixar's more recent animated films, *Up* (2009), my wife and I settled into two theater seats located in the midst of a frenetically undulating sea of parents and young children. Although this was certainly not strange for a Saturday matinee screening of what is ostensibly a children's film, we became increasingly aware of the fact that we were not only surrounded by an overwhelming number of individuals whose raw energy belied their diminutive stature, but that we were apparently the only two filmgoers who had failed to arrive at the film that day with a ready-made nuclear family of our own. As we observed numerous parents attempting to corral their children in preparation for the beginning of the movie, we were unexpectedly confronted with the sobering reality that life is so often marked by the palpable presence of an absence—a discernible lack that indelibly shapes who we are and how we see the world. More specifically, our lives were distinguished by the absence of children. After trying unsuccessfully for an extended period of time to bear children, my wife and I reveled in the joy of discovering that we had finally conceived. Yet, as the apparent randomness and absurdity of life would have it, we subsequently lost two pregnancies to miscarriage, each one further reinforcing a certain degree of helplessness and a commensurate loss of identity both as individuals and as a family.

1

It was this very juxtaposition—our personal experience of loss along with the presence of what seemed to be a surfeit of children—that formed the immediate context for our viewing of *Up*. In the tradition of many films produced by Pixar Studios, *Up* is not only whimsical and heartwarming but also poignant and emotionally rich. The movie tells the story of Carl Fredricksen, a curmudgeonly old man, and Russell, a precocious Boy Scout and stowaway, as they attempt to navigate Carl's balloon-suspended house to Paradise Falls, the very destination for the adventure that Carl and his late wife, Ellie, had once dreamed of embarking upon together. Yet, through a particularly touching opening montage that traces Carl and Ellie's life from the early stages of their nascent relationship to Ellie's eventual death, we quickly discover that the impetus for this somewhat fantastical journey is Carl's own sense of loss and regret for allowing Ellie's life to come to an end while their collective dream remained unrealized. We are thus introduced to a man whose fundamental awareness of the world is marked by the presence of that which is absent—his wife, his love, his life. Consequently, it is this "married life" montage in particular that not only provides the primary impulse for the rest of the film's narrative but, according to an overwhelming number of viewers and critics, invests the film as a whole with a "beauty," a "human subtlely," and an "emotional depth" that move beyond what we typically expect from an animated children's film.[1] Indeed, for my wife and me, the images of Carl and Ellie wrestling with the unique but often unspoken pain of their own miscarriage shifted our experience of the film from mere escapist entertainment into something far more significant.

Yet what is most compelling about *Up*'s married life montage is not simply the subject matter or the particular manner in which the sequence is structured, but the very means through which the film makes its appeal to the audience. Interestingly, in the words of one critic, the film is "filled with long stretches of silence, where the story is told visually and

beautifully without the need for words."[2] In fact, though, neither the montage nor the film itself is actually silent. Rather, much like many films from the so-called "silent" era, *Up* is teeming with sound, and the married life montage is no exception. During every moment in which we see the discrete images that together form a narrative of Carl and Ellie's life, we also hear the distinct sound of music—music that is at once uplifting and heartbreaking, winsome and profound. To be sure, the music that is foregrounded in the married life montage is a simple, eight-bar phrase that merely repeats a singular melodic line through the use of differing tempos, textures, and orchestration. Nevertheless, it lends to the film's already vibrant animation a certain *je ne sais quoi*—a power and depth of meaning that is irreducible to one particular filmic element. In other words, it "works." Moreover, as the public discourse surrounding the film suggests, the music works on a level that is related in significant ways to something fundamentally human and, thus, something essentially "spiritual."

Given our personal experience and the context in which we viewed the film, the music in *Up* was nothing less than transformative for both my wife and me. The images of Carl and Ellie's miscarriage offered us an invitation to remember our loss and, in an important sense, functioned as an embodiment of our pain. But it was the music that expressed something that even the most explicit visual or narrative reference to our pain-filled story could not contain: the redemptive power of a hard-won hope.

Needless to say, I was unable to stop the film after the married life montage in order to request that each member of the audience complete a questionnaire concerning the effects of the film's music. However, it was clear from the muffled sobs and tear-stained faces of nearly every adult in the theater that our experience was certainly not unique. In a way that almost defies description, the music's ineffable presence seemed to fill the theater, uniting the individual members of the audience

with both the narrative and one another. It suggested the presence of an otherwise hidden meaning in the events it accompanied—a deeper coherence that helped to shape these events into a meaningful narrative. Thus, the music in this film did not only afford a series of discrete images a sense of narrative and temporal unity, but, for the briefest of moments, it also offered us a glimpse of meaning and purpose in the face of life's apparent meaninglessness. It was a powerful, spiritual, and perhaps even revelatory experience. And it all occurred in less than four minutes.

A THEOLOGY OF FILM MUSIC

In the pages that follow, we will be exploring this film musical phenomenon from an expressly theological perspective. In doing so, the basic assertion I want to put forward is that a musically aware engagement with film opens up new possibilities for theological dialogue and reflection that would otherwise remain inaccessible. By "theological," I simply mean that we will be attempting to articulate something of the presence and activity of God in the contemporary cultural situation—an articulation that not only begins in conversation with a particular cultural product (i.e., film) and the aesthetic experience it engenders, but one that is also faithful to the biblical witness and the Christian tradition.[3] In due course, I will spell out the various implications of my argument. However, I have chosen to begin with an autobiographical account, and have done so for a specific reason. Namely, it is much more difficult to communicate abstractions drawn from one's biography than it is to convey the raw, subjective truth of one's concrete experience. What is more, for the great majority of readers, *how* I have arrived at my observations is just as important as *what* I have to say regarding film, music, and theology.[4]

In an important sense, my interests in the theological significance of film music are directly related to (and inspired by) a number of musical-aesthetic experiences like the one I have

outlined above—experiences that have both shaped and given expression to my understanding of life and the world. The concrete truth of the matter is that I am not a wholly detached and uninterested observer; I am fundamentally interested and, to a certain degree, implicated in the object of our inquiry. By turning toward these experiences as an entry point for theological reflection, I am simply acknowledging that we always come to the theological task with questions, concerns, and conceptions that are indelibly shaped by our particular situatedness. However subjectively I might formulate these personal anecdotes, they reflect an experiential veracity that is essential for any theological reflection. For, in the final analysis, it is only in and through our concrete experiences that we are able to discover that God is indeed present, not only in our own lives, but also in the lives of others.

Yet, as the ensuing discussion will make clear, this exploration is not an entirely subjective undertaking, for my individual experiences with film music necessarily take place within and in relation to a larger community of both film-goers and theologians. In particular, this examination of film music's theological significance is located within the ever-expanding scholarship on theology/religion and film. In recent years, a number of theologians and religious studies scholars have turned toward film not only as a source for theological reflection but also as a contemporary form of life that is functioning in a discernibly "religious-like" capacity in the broader culture. Interestingly, though, within the ongoing theology/religion and film dialogue, almost no attention has been paid to the various ways in which music makes an integral contribution to a film's theological or religious import. Most often, scholars either wholly disregard music or simply mention it in passing, employing ad hoc methods that fail to capture music's unique contribution to film. However, even in those singular instances when an individual scholar might intuit the importance of a film's music, his or her understanding of that music

remains limited, due to the absence of a basic vocabulary or a larger interpretive framework for articulating the significance of music's position and function in film. This general lack of concern regarding film music is particularly surprising, not only because music is capable of expressing theologically informed understandings of life and the world, but also because of the ways in which filmgoers typically accept and understand their cinematic experience. That is, on a concrete level, audiences routinely identify music as one of the key elements that allows a film to function in "powerful," "spiritual," and even "revelatory" manners.

There may be a number of explanations for why those contributing to the theology/religion and film discourse have largely overlooked and even disregarded music. Here, though, I will briefly suggest two possibilities that directly impinge upon our discussion. First, modern theology in the Western world has generally elevated second-order thought and reflection over and against first-order religious experience, favoring the "tidiness" of abstract theological conceptualizations over the inherent "subjectivity" of our most elemental human experiences. Yet, in the current cultural climate—a context that is often identified by numerous "posts" (e.g., "postsecular," "postromantic," "postpostmodern")—there is an increasing recognition that intuition, imagination, and emotion are important if not fundamental dimensions of the human enterprise, which is to say nothing of the artistic enterprise. Thus, theological scholarship simply lags. Even though theologians are able to acknowledge that films are comprised of the dynamic interplay between words, images, and sounds, they limit themselves to those filmic elements that are more easily verified through a process of observation, analysis, and repetition. When it comes to the inherent affectivity of music or the meaning making it engenders, contemporary theology has very little to say.

Second, it seems that, in many ways, those who are contributing to the theology/religion and film dialogue have inherited

the "siloization" that characterizes contemporary film studies. Although musicologists are increasingly engaging in the study of film, many in the field of traditional film studies are either suspicious of or uninterested in musically oriented analyses. In part, this suspicion is related to the fact that the highly specialized vocabulary and interpretive frameworks of music theory often preclude film scholars from understanding what musicologists are saying. However, even in those cases in which a modicum of understanding is achieved, film theorists are inclined to believe that musicologists are simply making too much of a film's music, for, rather than an integral element of film, they often conceive of music as a superfluous addition to an otherwise autonomous form. Likewise, theologians, who have been historically concerned with understanding "texts" and thus employ methodologies that often have a literary or textual orientation, likely find the interpretive approaches of traditional film studies more amenable than the seemingly esoteric methodologies of musicology—methodologies that center on the technical specificity of music and musical idioms. In many cases, this decidedly technical vocabulary not only precludes theologians from taking full advantage of the scholarship on film music, but also makes it difficult to speak about music in a language that other nonmusicians can understand. Consequently, as theology/religion and film scholars have primarily drawn from the insights of traditional film studies, they have (perhaps unknowingly) isolated themselves from the contributions of film music scholars and, in doing so, have overlooked the possibilities for theological dialogue that are presented by a musically aware approach to film.

Recently, though, a small number of scholars working in the field of theology and film have highlighted the need to correct this oversight.[5] Yet, outside of these isolated instances, almost no thought has been given to the ways in which music contributes something essential to film, or to the ways in which this contribution is theologically significant. In an

important sense, then, this book represents an attempt to address and correct this lacuna.

HEARING IMAGES, SEEING SOUNDS

It might go without saying, but in addition to the difficulties I have outlined above, an inquiry of this nature could also descend into a series of theological or musicological abstractions. In fact, it is this impulse toward abstraction that both theology and musicology seem to hold in common. Thus, to concretize our theological reflection, I am intentionally focusing on the music in a particular set of films. I have chosen these specific films for a few key reasons. First we are focusing upon films that debuted between 1999 and 2009.[6] This time period not only serves as a helpful controlling mechanism for our movie selection, but it also represents a theologically significant period in contemporary cinema—a decade in which movies have increasingly reflected a broader cultural concern with ultimate questions, spirituality, and even the "transcendent."[7] While disappointments still abound, the movies that have been produced in the first decade of the twenty-first century have proven to be artistically, spiritually, and thus theologically rich.

Second, each of the movies that we analyze offers a helpful illustration of how music "works" in both the form and experience of film. Therefore, by engaging in conversation with these films and filmmakers, we are able to demonstrate the various ways in which a musically aware approach to film offers something substantive to contemporary theological reflection.

Third and finally, the films we analyze are readily available on DVD, thus allowing the reader to access both the film itself and the music therein at one and the same time. Because our chief concern is not the composition of a particular score (or even the composer per se) but the music that audiences hear within their concrete experience of filmgoing, our musical analyses remain intentionally and explicitly tethered to the

music that is always heard in relation to a host of other filmic elements. For, as I hope to make clear, within the cinematic experience, what we hear is never quite the same in light of what we see, and likewise, what we see is never quite the same in light of what we hear. In other words, we do not simply hear a film's music or see its images; we quite literally hear images.

It is for this very reason that I have also chosen not to include musical notation in our discussion. Generally speaking, the inclusion of this highly representational system serves as an abstraction from the ways in which audiences actually experience film. Indeed, many, if not most, of the large-scale tonal structures or motivic relationships that might be discerned through an analysis of the written score are, in practice, inaudible to most audience members.[8] What is more, musical notation often works exclusively.[9] Many filmgoers (and theologians) who do not have musical training simply assume that they would be unable to follow an argument that requires an understanding of notated music. And while we cannot altogether escape a consideration of certain technical aspects of music and music theory, by noting the time that a piece of music occurs on a DVD rather than analyzing the sheet music for a score, we are able to identify and speak of particular musical examples without excluding those who may not understand musical notation but still certainly derive meaning from the music they hear in film.

One of our principal goals, then, is to develop a mode of film music analysis that will remain accessible to nonmusicians who are interested in theological dialogue—an interpretive framework that will allow us to offer an explicitly theological construal of film music's power and meaning. Yet, before we dive headlong into this endeavor, a final caveat is in order regarding a few operative assumptions that we will not be able to explore fully here. For example, I am working with the assumption that film functions as a prime location for meaning making and identity formation in contemporary

culture. In many respects, movies serve as the lingua franca of (post)modern society, providing a common vocabulary for the construction of meaning and the communication of contemporary mores and values. In other words, individuals often "make sense" of their life and the world through their experiences with contemporary cinema.

Additionally, I am assuming that, even when our analysis focuses upon a film's formal structures, its "meaning" is always already related to the film's reception. That is, meaning making occurs in the contemporary space where a film's form meets an active audience.[10] Thus, I will be integrating questions of reception at every level of discourse.

I will also be operating with the assumption that film is an inherently commercial medium. The whole of a film's "life"— from its production to its distribution and reception—is located within and determined by a series of economic structures.[11] Some might, and indeed do, decry this aspect of movie making and consumption, suggesting that filmmakers should aim to free their work from the strictures of Hollywood's commercializing machinery.[12] However, my concern here is not with the somewhat misguided notion that film either could or should speak from a location unfettered from economic influences, but with the question of what processes are in play when individuals work in, with, and through these structures to find meaning in a decidedly commercial art form.

Finally, I am assuming that contemporary films are primarily concerned with the construction of a narrative. That is, they tell stories. While exceptions certainly exist, on the whole, the telling of a story has always "reigned supreme" in the filmic medium.[13] Although the very first films were primarily actualities or documentaries, the story film has completely dominated the market since the first few years of the twentieth century. Additionally, though, what is unique to the art of (sound) film is the means by which it conveys its story. That is, a film's narrative is constructed upon the mutually

interdependent interaction between both sounds and images. Films tell their stories through the dialectic tension that arises between an "imagetrack" and a parallel but equally integral "sound track."[14] While each of these tracks is structured by its own internal dialectic, the soundtrack is specifically organized around the dynamic interplay between music, dialogue, and sound effects. Therefore, music is best understood as an essential yet subsidiary element in the film's overall "soundscape" that, along with sound effects and dialogue, functions to establish the film's narrative context. It is this "narrative context, the interrelations between music and the rest of the film's system, that determines the effectiveness of film music."[15] Thus, I will be working with the assumption that our musical analyses must be located within a broader understanding of a film's overall soundtrack, which, in conjunction with a film's imagetrack, forms the core of a film's narrative context.

At the risk of overstatement, I am suggesting that the music we hear in film does not simply invite a theological response; it demands one. And throughout our discussion, I will continue to make the case that a more robust awareness of film music opens up avenues for theological dialogue that would otherwise remain inaccessible. On the one hand, this dialogue most certainly concerns the fruitful, two-way conversation that occurs between a film and a filmgoer. As this mutually enriching conversation progresses, we are able to enhance our shared understanding of a film's power and meaning. What is more, we come away with an enlarged understanding of each other and, at times, the "other." On a deeper level, though, this dialogue reveals something larger, for it has to do with humanity's fundamental relationship with the divine. And so the theological question I want to explore in the pages that follow is not simply how and why individuals derive meaning from their experience of the music they hear in a film, but what it means for God to converse with human beings in and through the images we hear.

1

MUSIC IN THE FILMS OF PIXAR ANIMATION STUDIOS

In order to demonstrate the rich interpretive potential of film music analyses and to identify the principal concerns that will drive the remainder of our discussion, we begin with an extended illustration. While subsequent chapters will attend more fully to those lingering methodological and interpretive questions that this initial examination raises, here we are opting for the kind of heuristic insight that can only ever emerge when we allow ourselves simply to listen and receive, dancing in step with the music that we hear in the midst of our filmgoing.

In particular, we take up in the first two chapters an analysis of the music in the films produced by Pixar Animation Studios. Our interaction with these films and their music necessarily involves both celebration and critique, for our goal is to engage in a kind of dialogue that is both mutually enriching and mutually critical—one that offers a more robust understanding, not only of film music's power and meaning, but of theology as well. That is, while we are concerned with the ways in which theology might inform and, in some cases, expand our understanding of these films, we are equally concerned with the ways in which these films grant us new insight into our basic humanity, the world in which we live, and the presence of the Creator in the cultural forms we humans create.

PIXAR
A "Common Narrative" from a "Collective Auteur"

Given the broader focus of the book and the selection of films that we will consider in the chapters that follow, it may be necessary to offer a rationale for why I have allowed the films of Pixar Animation Studios to have the opening word in our discussion. Indeed, the larger argument I am making is not first and foremost about Pixar films or even animated film, and as our discussion progresses, we will increasingly attend to the music in "live-action" films. Yet, as the studio name suggests, each of Pixar's feature-length films is in fact animated. As such, these movies not only trade upon the expectations and conventions of the genre of animated film, but they also exemplify a particular form of filmmaking—one in which there are no "givens" whatsoever. That is, no "natural" filming environment exists that might serve as a starting point for the creation of the film's narrative world. In contradistinction to live-action films, the world that exists within an animated film is wholly constructed; every sound, every shadow, and every movement is the direct product of the filmmakers' intentional, shaping influence. Consequently, music is frequently called upon to invest this wholly constructed world with a modicum of "life." Music functions in these films to "animate" the animation; it inspirits and breathes life (or *anima*) into images that are patently artificial and entirely virtual. For this reason, Andrew Stanton—a writer, director, and executive producer for the great majority of Pixar's films—suggests that, within the context of an animated film, "the music has to raise its game. If you turn the sound off, you will see us struggling to convey the story with the visuals, the actions, and the posing."[1] Thus, Pixar's films provide a particularly salient example of the irreducible contribution that music makes to film, for, in relation to live-action films, animated movies are far more dependent upon music's

signifying capacities (and sound more generally) to tell their story convincingly.

Second, due to the narrative burden that it shoulders in the context of an animated film, music works to shape both the form and the style of these movies (i.e., both the structural components of the film and how the film is delivered to an audience) far more explicitly than it does in live-action films.[2] Although many filmmakers begin with a general "sound-scape" in mind, the dynamics of the music/image relationship play an even greater role in the original conception and development of animated films. For example, one of the original creative "visions" for *WALL-E* centered upon the unique interplay between music and image. Stanton, the film's writer and director, states, "I always loved the idea of putting an old-fashioned song against space. I always loved the idea of the future against the past juxtaposed, and I just thought that was a great intro to the movie."[3] Indeed, in both the opening credits sequence and the film's climax, songs from the musical *Hello Dolly* ring out over images of empty space, a desolate Earth, and a lonely, forgotten robot who longs for the intimacy of a loving relationship. This seemingly odd combination of music and image clearly illustrates the inherently audiovisual nature both of the structure and style of Pixar's films and of film in general. Consequently, their movies serve as prime examples of how music actively shapes not only a film's formal structures, but also the ways in which film music addresses audiences within the cinematic event.

Third and finally, an examination of the music in Pixar's films serves as a fitting starting point for our discussion because each of their movies is readily accepted and understood as a type of contemporary, intergenerational "shared narrative."[4] Regardless of which mode of critical analysis we employ, we are repeatedly confronted with this conception of Pixar's films, for these are the interpretive parameters that the films themselves have established. For instance, from the perspective of

auteur criticism, Pixar operates as a kind of "collective auteur." That is, it is a relatively small studio that has consisted of essentially the same group of collaborators from its inception.[5] We are therefore able to discern a distinctive vision that has remained consistent throughout each of Pixar's films, namely, a desire not only to develop common narratives that are rooted in a "shared experience" of our life and the world, but also to convey those stories in a way that excludes no one.[6]

Similarly, this same theme emerges when we approach Pixar's films in terms of genre criticism—a form of analysis and interpretation that concerns the intersection between studio intentions and audience expectations. While the filmmakers at Pixar certainly "prime" generic expectations regarding the ability of animated films to serve as intergenerational stories that are held in common, audiences internalize these expectations and then demand that the studio produce films that meet them. A close friend of mine, who is the father of both a two-year-old and a four-year-old, offered a helpful distillation of these generic expectations when he commented on the criteria by which he evaluates animated films. A "good" animated movie must not only appeal to his children, but it must also speak to his own sensibilities as an adult, for, in his words, "[an adult] still has to be able to enjoy the film even after they watch it over and over with their children. . . . That is why I have been able to watch *Cars* with my kids over sixty times, and I still love it." Thus, while Pixar's intention may be to produce films that function as shared narratives, what is perhaps more interesting is the fact that audiences (and especially parents) approach these films with the expectation and understanding that they will appeal to both children and adults and, consequently, will be worthy of repeat viewings.

It thus comes as no surprise that, if we shift our focus toward thematic criticism, each of Pixar's films addresses not only the wonder and terror of our common childhood experiences but also the deeply rooted fears and insecurities of

adulthood. However, what is most remarkable about Pixar is that it has consistently succeeded where other animated production companies have not. That is, children are not the only ones who love these films. Rather, Pixar's exploration of those themes that resonate with our common human experience has captured the imagination of filmgoers both young and old. Not only did 57 percent of American adults see *Finding Nemo*, but according to those who contribute to the Internet Movie Database (IMDb), eight of Pixar's ten feature-length films are firmly ensconced in the top 250 movies of all-time.[7] In a similar vein, a recent MSN article suggested that *WALL-E* was the eleventh best film of the twenty-first century.[8] At the risk of understatement, Pixar's films are not only critically acclaimed, but they are overwhelmingly popular among adult audiences.

The filmmakers at Pixar are doing something more than simply telling well-crafted children's stories with computer-generated images; they are constructing the very narratives that numerous contemporary individuals hold in common, those shared stories that are capable of functioning on multiple levels and are accessible across ages. In doing so, these films certainly merit some manner of theological dialogue. Yet, the larger theological point I want to make is directly related to the *music* in Pixar's films. That is, I want to suggest that, as we turn toward an expressly musical analysis of these films, we are able to identify a progression and a development in Pixar's "creative vision" that would otherwise remain inaccessible—a marked shift in the studio's filmmaking that is actually signaled by the music we hear. In some cases, this music precludes their movies from serving as stories that are genuinely held in common; in others, it provides the very means by which these films are able to function in the contemporary world as shared, intergenerational narratives. Here then is our starting point for theological dialogue—one that is made available through a more robust awareness of how music functions in film. Let us turn, then, to an expressly musical analysis of

Pixar's films and consider the ways we might develop a fuller understanding of their power and meaning.

FROM *TOY STORY* TO *UP*
A Musical Trajectory

As we are chiefly concerned with Pixar's entire body of work, our musical analysis has two related focal points. On the one hand, we are interested in identifying the various manners in which the filmmakers at Pixar employ music in each of their films and, thus, how music aids in expressing the creative "vision" that unites their work as a whole. On the other hand, we are concerned with the ways in which their use of music has developed over time and how these musical changes have affected the ability of Pixar's films to function as intergenerational, shared narratives. Therefore, I want to highlight three specific shifts that have occurred in Pixar's filmmaking that are directly related to the position and function of music in their films. Although space precludes a detailed examination of all the music in any single film, we will analyze a number of embedded examples that will serve as representative types for conceptualizing the various ways in which Pixar uses music in their films.[9] In doing so, we will discover that, without an awareness of how music is working on both formal and phenomenological levels, it becomes increasingly difficult to understand not only how and why these films have so successfully captivated the contemporary imagination, but also how they might serve as a source for theological reflection and dialogue.[10]

Shift 1
From a Predetermined Emotionality
to an Invitation to Feel

It only took a moment to be loved a whole life long.

—WALL-E

As both the first feature-length film in cinematic history to be made entirely with computer-generated imagery (CGI) and Pixar's first film, *Toy Story* (1995) was a groundbreaking movie. However, while the film was well received by critics for its technological innovation and its compelling cast of characters, the film's music actually follows a rather conventional path—one rooted in the longstanding tradition of animated film. That is, much like numerous animated movies that have preceded it, the nondiegetic music in *Toy Story* is so closely synchronized with the image track that it blurs the distinction between the diegetic and nondiegetic realms.[11] Due to its frequent use in animated film in general and Disney films in particular, the practice of allowing music to mimic screen action closely is often referred to as "mickey-mousing." Although a number of film music theorists have denigrated this conventional use of music, it is a particularly effective means not only for underscoring dramatic moments in a film but also fleshing out the film's three-dimensional space.[12] In this way, mickey-mousing certainly highlights the ambiguity of the diegetic boundary, but it also blurs the distinction between music and sound. It works to "sweeten" the film's soundscape, either embellishing the sound effects or replacing them entirely.[13]

For example, in *Toy Story*'s opening segment, music works as both a dramatic embellishment and an effects sweetener. Although incredibly brief, this sequence not only introduces Andy, the young boy and owner of the toys who populate his room, but it also anticipates the emotional tenor of the whole film. Starring in a dramaturgy that Andy has scripted, Sheriff Woody defeats the villainous "One-Eyed Bart" (Mr. Potato Head) and casts him into "jail" (the crib where Andy's younger sister sleeps). As the sequence comes to an end and the opening credits roll, Andy's sister slobbers onto the nose of Mr. Potato Head and repeatedly pummels his body into the edge of her crib. With each subsequent strike, a complementary bar of music accompanies the visual activity, in this case

the descending notes of a tuba.[14] Here the music functions to enhance the sound effect, which, if rendered according to the conditions of verisimilitude, would lack any sort of dramatic or affective punctuation, for the "real" sound of a small plastic toy hitting the edge of a crib would be texturally and dynamically thin in comparison. However, by embellishing the sound effect and, in an important sense, making the diegetic world "other" or different from our own, this musical synchronization highlights a "particular action or thing, especially one that is fraught with significance but might otherwise go unmarked and so unnoticed."[15]

Thus, as the various limbs of Mr. Potato Head fall helplessly to the ground and surround the heroic cowboy who rests safely out of harm's way, the music emphasizes the narrative significance of the contrast between the protagonist and his discarded counterpart. In other words, through the music's closely paralleled relationship to the film's images, we sense that Woody and Andy are involved in a secure and endearing friendship, whereas Mr. Potato Head is nothing more than a "child's plaything." For his part, though, Woody is wholly unaware of either the fate that awaits him or the events that will eventually lead him to reevaluate his status as a favored toy and thus recognize the deeper significance of his existence. Yet, as the nondiegetic music heightens the very unreality of the diegetic sound effects, we recognize that it is only we, the audience, who are privy to the emotional significance of this scene—an affective meaning that is largely determined by the close synchronization between the music we hear and the images we see.[16]

Although *Toy Story* features the most pervasive and persistent use of mickey-mousing, the majority of the music in Pixar's early films functions in a strikingly similar fashion. *A Bug's Life* (1998), *Toy Story 2* (1999), and *Monsters, Inc.* (2001) all feature music that works in close synchronization with the images in each film. However, rather than simply mimicking

a corresponding visual activity, the music in these films often mirrors the flow of important narrative events or announces the arrival of significant (and sometimes not-so-significant) characters.[17] We might refer to this use of music as "motivic mickey-mousing."[18] While the frequent jump from one musical motif to another lends a sense of movement and pacing to the images, given the amount of characters in these films and the rate at which narrative events typically unfold, it results in a nearly continuous (though highly sectionalized) mode of underscoring. At one point in *Toy Story 2*, for instance, as Buzz Lightyear and the other toys search throughout Al's Toy Barn for their lost friend Woody, we hear no fewer than ten different musical figures in the span of four-and-a-half minutes, each of which signals the appearance of a different character or narrative situation.[19] Similarly, in *A Bug's Life*, as the dreaded Hopper first arrives to collect the ant colony's food offering, the music we hear is working on the level of both classical and motivic mickey-mousing. While the piercing sound of horns enhances the effect of the colony's "grasshopper alarms," and the descending notes played by strings and wind instruments mimic the collapse of their food altar, a quick-tempoed figure with a busy texture mirrors both the haste with which the ants make their final preparations and the tragedy that befalls the colony due to Flik's misguided actions.[20] In these scenes, the highly synchronized and nearly "wall-to-wall" music works to telegraph the emotions that the audience is clearly meant to associate with each character and every event. Thus, we feel hurried as the ants work feverishly to fill their quota; we feel anxious as we watch Flik's ingenuity, although well-meaning, bring about more harm than good; and we feel our hearts sink as the colony's food sinks beneath the surface of the water.

It is important to note that, especially in the context of an animated film, this hyperexplicit, illustrative music is extremely effective in communicating the emotional import

of a scene or a character. In most cases, as it offers clearly defined interpretive parameters, there is little doubt as to how the filmmakers want the audience to feel. Thus, the music that underscores a toddler's relentless beating of Mr. Potato Head signifies both the humor and trauma of life as an undervalued toy. Likewise, the bright horns and upward movement of the music that accompanies almost every appearance of Buzz Lightyear express the naive and semidelusional optimism of a toy who earnestly believes that he is a space ranger. In an important sense, this music does not simply run parallel to the imagetrack; rather, it intentionally overdetermines the affective meaning of the film's images. Put differently, the music in these films essentially fills the affective space that is opened up by the cinematic event with a predetermined meaning. Very clearly, and sometimes very loudly and incessantly, we are told exactly how we are to feel about the images we see.

To be sure, as we will consider in more detail in later chapters, the very presence of music in film signifies emotions. In a certain respect, any and every piece of music that we hear in a film carries some kind of emotional freight. Thus, one might conclude that the affective space opened up by the cinematic experience always comes to us predetermined or "prefilled" when music is involved. However, there is a subtle yet significant difference between music that routinely "insists" on a particular meaning and music that "invites" or "encourages" an audience to feel. In other words, while film music frequently works in terms of emotional suggestion, filmmakers can and do employ music in such a way that, rather than circumscribing the audience's interpretive options in order to induce a specific emotional response, it opens up an affective space that allows filmgoers to draw from a wider range of emotional associations.

Given the predominance of highly synchronous, continuous, and illustrative music in their earlier movies, it would

seem that the filmmakers at Pixar were originally committed to employing music that functioned in terms of the former categorization. Beginning with *Finding Nemo* (2003), however, we are able to identify a transition in Pixar's filmmaking—one that finds its fullest expression in the way that music is called upon to create an affective space within the cinematic experience.[21] Part of the reason for this shift is likely due to the unique contributions of different composers; whereas Randy Newman scored the first four Pixar films, Thomas Newman and Michael Giacchino have composed the music for five of the last six films.[22] Yet, the musical predilections of different composers do not tell the whole story, for the "invitation to feel" that the music in these later films offers is indicative of a basic progression in Pixar's overarching, creative vision. Commenting on the song that served as the inspiration for *Ratatouille* (2007), Brad Bird suggests that filmmakers "are constantly trying to get the audience into a state of feeling and how things feel rather than how things are. [They] are trying to get to a very primal, very simple—I think nourishing—thing, which is indulging in the human aspect of being alive."[23]

We are able to see, hear, and feel Bird's notion of affectivity writ large when Remy the rat describes his love of food and the aesthetic experience it occasions.[24] Here, the relationship between music and image is once again synchronous. However, rather than music "sweetening" the visual action, the converse is true; abstract colors explode and swirl about, mirroring the music's unique ability to express that which must go without representation, namely the profound, sensual pleasure of the culinary experience itself. As Remy first tastes a piece of cheese, then a strawberry, then the two "in concert," the musical interplay between a jazz fusion number and a lyrical French waltz does not so much tell us how to feel, but rather invites us into a "state of feeling"—one that allows the audience to indulge for a moment in "the human aspect of being alive."[25]

Much like *Ratatouille*, *WALL-E* (2008) offers another salient example of the shift in Pixar's filmmaking and clearly demonstrates the way in which the music in their later films offers the audience an invitation to feel. Significantly, the film's principal characters—WALL-E (i.e., Waste Allocation Load Lifter Earth-Class) and EVE (i.e., Extraterrestrial Vegetation Evaluator)—are robots who have no traditional dialogue. In fact, the first real dialogue we hear occurs nearly forty minutes into the film. Yet, both WALL-E and EVE most certainly "speak," and it is almost entirely through music and sound effects that their voices are heard. Whereas the sound effects that Pixar engineered are unparalleled in their ability to confirm the substantiality of *WALL-E*'s diegetic world, the music provides a "foundation in affect" by brightening or darkening the mood of the film through changes in timbre.[26] Yet, together, effects and music not only serve in their conventional roles, but they also carry a narrative burden that is typically reserved for more traditional modes of linguistic representation. In other words, in the absence of either human language or human characters, music and effects imbue the film (and its robotic protagonist) with a sense of "life," thus making WALL-E's movements, interactions, and, indeed, expressions of love at once believable and affecting.

What is more, though, the largely amelodic texture of Thomas Newman's score, which emphasizes unique orchestration and color over melody and the development of leitmotivs, "asks us to pay attention exclusively to the details of the setting, that is, it directs attention to the background but without fully transforming that background into a foreground: *it leaves an unfilled space*."[27] Many filmgoers are likely familiar with Newman's use of amelodic textures from his work on *American Beauty* (1999), in which a marimba figure underscores the voiceover narration in the film's opening sequence. However, the music in *WALL-E* functions in a markedly different capacity. Whereas dialogue fills the space left by the marimba

in *American Beauty*, there is no dialogue in *WALL-E*. Consequently, rather than serving as an accompaniment for the film's narration, the amelodic texture of the music in *WALL-E* invites the audience to either inhabit or simply disregard the unfilled affective space that it opens up.

As *WALL-E*'s opening sequence moves from images of space to the desolate Earth below, where a lone robot is hard at work, we hear the initial bars of "2815 A.D.,"—a repetitive musical figure featuring descending, chromatic notes plucked on a harp, and long washes of strings. Through this combination of music and image, we gain a sense of WALL-E's isolation and the perfunctory nature of his life's work. However, as the music draws our attention to this secluded and fragmented setting without bringing the background environment into the film's foreground in any heavy-handed way, its amelodic texture both opens up and refuses to fill the affective space. Consequently, the music does not insist on a particular meaning but invites the audience to feel WALL-E's loneliness, to empathize with his sense of duty, and to long with him for the day when he too will experience the transforming effects of love.

As "2815 A.D." is quite brief and we hear it in only one other location in the film, this piece of music is not functioning as an easily identifiable leitmotiv, nor does Newman develop it as such. Consequently, the music in *WALL-E* is best understood not thematically but in terms of its orchestration and texture. If approached in these terms, we are able to identify how the music not only functions as WALL-E's "voice" but how it effectively offers the audience an invitation to feel. In the film's ultimate scene, for example, WALL-E suffers irreparable damage while sacrificing his own metallic "body" for the sake of the human community's return to Earth, leaving his circuit board destroyed and his memory erased. EVE rushes to repair the robot she has come to love and waits in desperation to see if her work has "salvaged" WALL-E. In this moment, the film reveals the full weight of the narrative burden that film

music carries when located within an animated movie, especially one featuring mechanical protagonists. For it is nearly impossible to communicate the expressly human capacities of "amnesia," "recognition," or "love" with a character whose only physical capabilities are the upward or downward turning of his telescopic "eyes." Yet, as WALL-E "reboots," we recognize his amnesia, not because of a recurrence of "2815 A.D." or a thematic development of this music, but because the music we do hear reflects both the texture and orchestration of that forlorn figure that recalls WALL-E's life before EVE.[28] Rather than a discernable melody, we once again hear a surging undulation of strings and the staccato plucking of a harp. As EVE pleads with WALL-E to "remember" her, just as she literally "re-membered" him, the music withdraws and we are left with a significant period of musical silence in which EVE physically touches WALL-E's hand and begins to "sing" to him. Here, rather than telling the audience how to feel, the music simply creates an affective space—one that we can choose to inhabit or reject. In doing so, the music not only provides us the means by which we might empathize with EVE's loss and WALL-E's sacrifice, but it serves as a potential location for experiencing the full breadth of emotions that relate to our own deep-lived experiences of life, love, and loss.

Again, the music in this scene is certainly suggestive on an emotional level; it induces and, in a certain sense, influences our emotional response. But given its amelodic texture, its jaunty rhythms, and its eclectic orchestration, and given the lack of traditional dialogue filling the space that it carves out, it is more appropriate to speak of this music as encouraging rather than dictating the audience's affectivity. In other words, the music in *WALL-E* exemplifies a major shift in Pixar's filmmaking—from predetermining a film's affective meaning to offering audiences an invitation to feel.

Shift 2
From Straightforward "Commentary"
to Hard-Won Clarity

MARLIN: *I promised him I'd never let anything happen to him.*

DORY: *That's a funny thing to promise. . . . [Y]ou can't never let anything happen to him—then nothing would ever happen to him.*

—*Finding Nemo*

The second shift I want to highlight emerges directly from the first, and is therefore intimately bound up with the way in which music can either overdetermine a film's meaning or leave an unfilled space within the cinematic event. More specifically, Pixar's filmmaking has developed in relation to the "interpretive clarity" that nondiegetic music provides. A number of film music scholars have helpfully pointed out the ways in which film music (especially nondiegetic music) not only "illuminates" what we see but actually structures and, in some cases, reconstitutes the image, which "would not be what it is without the music."[29] Music offers an interpretive clarity unobtainable in the real world, for it reveals a "surplus" in the image that is in need of interpretation. In other words, music suggests that there is more to the image than meets the eye.[30]

The filmmakers at Pixar have effectively appropriated film music's capacity to affect and inform that which we see. However, as we examine each of their movies in succession, we are able to discern a noticeable change in the way they have called upon music to structure the images in these films and to offer insight into the otherwise hidden, inner dynamics of the films' characters and narrative worlds. And while this shift in their filmmaking is entirely musical, it serves as one of the primary means through which Pixar has enlarged its artistic

vision concerning what exactly constitutes a shared narrative in the contemporary culture.

In Pixar's earlier films, music is most often employed as a means for providing the audience with straightforward commentary. That is, while the music certainly grants us insight into the images we see, the interpretive clarity it offers is often ready-made, issuing from the music's direct and relatively undemanding explanation of narrative events. This commentative function is most noticeable when we consider the ways in which popular and lyrical songs are positioned in Pixar's first few films. For example, Randy Newman's song-based score in *Toy Story* set the tone for how Pixar would position music in subsequent films, turning to lyrical music as one of the primary means for conveying narrative information. In particular, the song "You've Got a Friend in Me" serves not only as direct commentary on the screen action, explicitly (and redundantly) recalling the film's primary theme, but it also works to structure the film's formal frame and serves as its dominant leitmotiv. This song, in both its lyrical and instrumental forms, predominates the film to such a degree that, regardless of those narrative situations that might suggest otherwise, we remain confident in the bond of friendship that exists between Woody and Andy.

In addition to underscoring both the opening title and end credits sequences, which, together, establish the overall mood of the film and serve as a buffer between the "outside" world and the world of the diegesis, we hear an instrumental version of "You've Got a Friend in Me" as Andy willingly plays with Woody prior to the arrival of Buzz Lightyear.[31] Yet, the same music plays at a later point in the film as Andy reluctantly takes Woody to Pizza Planet even though his first choice was actually Buzz. Thus, in a relatively straightforward manner, the music explains to the audience that, come what may, Woody will be Andy's friend, even to the bitter end.

However, the widespread use of lyrical music is not restricted to this principal leitmotiv. Indeed, in addition to structuring the small-scale units of the film (e.g., the opening title and end credits sequences), lyrical songs highlight major transitions in *Toy Story*'s overarching narrative. During the montage in which Buzz Lightyear supplants Woody as the most beloved toy in Andy's room, the musical underscoring tells the audience that "strange things are happening" to Woody; whereas he was once "on top of the world . . . living the life, things were just the way they should be," a "punk in a rocket" came along and challenged the "power and respect" that Woody once garnered among the toys. Similarly, as Buzz finally accepts that he is a toy and not, in fact, a space ranger, the foregrounded, nondiegetic music spells out his self-realization, suggesting that he could not "fly if [he] wanted to." As these lyrics assume the role of an inner monologue, Buzz proclaims, "Now I know exactly who I am and what I'm here for," and thus, "I will go sailing no more." In the end, though, as both Buzz and Woody reconcile with one another and come to accept their lot as the objects of a young boy's affection, the film concludes by returning to the music that renders the primary theme transparent: you've (still) got a friend in me.

As one might expect, the sequel to *Toy Story* follows the same musical trajectory set forth by the original. *Toy Story 2* not only directly recalls "You've Got a Friend in Me" in numerous places—both diegetically and nondiegetically—but it also imitates the way that music is positioned in the original film, for it too uses lyrical songs as a type of straightforward commentary. As Jessie the cowgirl remembers her former owner and expresses her despair regarding her eventual abandonment, the music tells us exactly what she feels: "So the years went by; I stayed the same. But she began to drift away. I was left alone. Still I waited for the day when she'd say 'I will always love you.' "[32] In spite of her desolation, though, the film ends with Jessie finding a renewed sense of joy and belonging

as the toy of a new owner and the member of a new family of toys. Much like its predecessor, the final sequence in *Toy Story 2* depicts all of Andy's toys singing a rendition of "You've Got a Friend in Me," thus clearly encapsulating Jessie's transition from a collector's item to a being-in-relation.

In much the same way, the end credits music in both *A Bug's Life* and *Monsters, Inc.* offers straightforward summaries of the themes in each of these films, and it does so through lyrical content. Commenting on Flik's journey from overlooked minion to resourceful hero, the end credits music in *A Bug's Life* states, "Was a bug, little bug, hardly there. How he felt, what he dreamed, who could care? Without any evidence, he was full of confidence. Didn't have much common sense. He just knew that he'd come through. It's the time of your life so live it well." Similarly, the music that underscores the closing credits in *Monsters, Inc.* highlights Sulley's newfound love for a human child whom he once believed to be toxic: "If I were a rich man, with a million or two, I'd live in a penthouse in a room with a view. And if I were handsome, it could happen. Those dreams do come true. I wouldn't have nothing if I didn't have you." In each case, lyrical music not only helps to establish the film's formal frame but also functions as a type of commentary. That is, in simple and noncontradictory ways, it explains to the audience how we are to interpret the images we see and the narrative that unfolds before us.

I suggested above that, from a musical perspective, *Finding Nemo* marks a shift in Pixar's filmmaking. However, as it concerns music's commentative function, *Cars* (2006), which debuted after *Nemo*, represents a kind of regression in Pixar's development. Interestingly, it is also the lone Pixar film to feature a large number of popular, lyrical songs that were not originally written for the movie.[33] Consequently, the music in *Cars* is meaningful not only in terms of the lyrical content of the music, but also in relation to the wider cultural sphere in which the film is located. To be sure, this cultural locatedness

invests the music with a signifying efficiency that it would otherwise lack. For example, although the popular songs in the film "preexist" as a part of the broader cultural lexicon, they have each been rerecorded and performed by well-known country artists. Thus, as Lightning McQueen travels via highway to compete in the final race of the Piston Cup, we hear a Rascal Flatts rendition of "Life is a Highway." This song not only unifies the images of the highway montage and directly expresses the adventure that awaits the film's main character, but it also draws upon the various meanings associated with an established country group. Through music, the audience is told that the story of Lightning McQueen will certainly involve a journey, but that this journey is primarily meaningful in relation to the conceptual worldview that is embodied by country music and country musicians.

At the same time, though, the film seems to flounder in both its (over)use of explicit musical signification and the way it employs music primarily as narrative commentary. On the one hand, the film seems to be about the trappings of celebrity, a theme epitomized by Sheryl Crow's "Real Gone": "There's a new cat in town, he's got high-paid friends. Thinks he's gonna change history. . . . But he's just perpetuatin' prophecy." On the other hand, as indicated by Brad Paisley's song in the closing credits, *Cars* points toward the importance of relying on others, regardless of one's talents: "When you make new friends in a brand new town . . . the things that would have been lost on you are now clear as a bell. That's when you find yourself." However, at moments, it also seems that the film is lamenting the apparent loss of traditional, small-town America, for, as James Taylor sings, "Main Street ain't Main Street anymore."

Consequently, the film is thematically confused and confusing, and this ambiguity stems primarily from the use of nondiegetic music as straightforward commentary. The interpretive clarity that the music offers is so categorical that it leaves the audience with few possibilities for moving beyond

a surface reading of the film's images or actively contributing to the meaning-making process. The music suggests that there is more to the image than meets the eye, but not much more; the "surplus" in the image is essentially explained away. Thus, while the music in *Cars* is reflective of an earlier paradigm in Pixar's filmmaking, it fails to capitalize fully on Pixar's original creative vision.

Cars, however, represents only a brief digression, for beginning with *Nemo*, Pixar's films generally exhibit a movement away from the model of music as commentary. Instead, the filmmakers at Pixar have increasingly called upon music to invest their films with a "hard-won" clarity. That is, their music offers insight into that which remains hidden within the image, but it does so in a way that allows for a greater degree of interpretive freedom.[34] Rather than simply telling the audience what the images mean, the music urges audience members to discern and discover that meaning for themselves.

For instance, Andrew Stanton, who wrote *Finding Nemo*'s screenplay while listening to Thomas Newman's past works, has suggested that the film's score is one in which "beauty and sadness are never too far from each other."[35] Given its paradoxical nature, it would be difficult to express this notion in a simple or straightforward manner without reducing it along the way. Yet, the idea that beauty and sadness exist side by side reflects something profoundly true about the human condition, especially for those who are parents. Fittingly, then, rather than offering direct commentary, the music in *Nemo*'s opening sequence allows the audience to experience the full weight of this seeming contradiction. In this particular scene, Marlin awakes from a barracuda attack to find that his wife and nearly all of his four hundred children have been consumed. He then spots a lone, disfigured egg resting on the ocean floor. As he cups his preborn child in his fins and professes his commitment to "never let anything happen" to Nemo, a haunting musical figure emerges from

the background. While a single piano plucks out a slow and bittersweet melody, we hear in the accompanying orchestration a rainmaker, a triangle, and a marimba—an eclectic collection of percussion instruments that have come to serve as identifying marks of a Thomas Newman score and, thus, the "beautiful sadness" his music expresses. In conjunction with the undying words of a father who had nearly lost everything he held dear and the images of his diminutive and fragile son, this music does not offer any trouble-free insights. Rather, as the supporting strings swell to full volume and the opening credits roll, the music ushers us into a world that is at once beautiful and heartrending, a world where our greatest joys collide with our greatest fears. In other words, the music creates a space in which the audience must wrestle with a complex world filled with ambiguity—a world where understanding never comes easy.

In an important sense, this use of music actually echoes one of *Finding Nemo*'s core themes, which Crush the sea turtle helpfully encapsulates. Responding to Marlin's almost paralyzing concerns regarding how a parent knows when a child is "ready" to experience the whole of life—both its wonders and its hardships—Crush replies, "You never really know, but when they know, you'll know. You know?" In other words, both children and adults come by wisdom not when they are restricted by the fear of the horrors that might befall them, but when they are given the freedom to engage life—when they are offered a space in which they might discover life's meaning amidst its seeming contradictions.

Finding Nemo is certainly not the only film in Pixar's oeuvre that reflects this shift away from straightforward commentary and toward a hard-won clarity. In their own right, *The Incredibles*, *Ratatouille*, *WALL-E*, and *Up* all feature music that functions in this manner. However, *Nemo* is unique in that it set the course for the films that would follow. By doing so, it established a new direction for the ways

in which the filmmakers at Pixar would call upon music to offer interpretive clarity.

Shift 3
From Undercutting Life's Harsh Realities to Dealing Honestly with Its Fragile Beauty

Remember the bad guys on those shows you used to watch on Saturday mornings? Well, these guys are not like those guys. They won't exercise restraint because you are children. They will kill you if they get the chance.

—*The Incredibles*

The final shift in Pixar's filmmaking has to do with the ways in which music either undercuts the harsh realities of life or allows a film to deal honestly with them. Interestingly, each of Pixar's films in some way addresses the bleak or more menacing side of our lived experience. Communities are fractured, children are separated from their parents, mothers and fathers are driven (sometimes irrationally) by fear, and evil lurks in the darkness of shadows. Yet, especially in the studio's earlier films, music often works to undermine or mitigate these stark (and perhaps all-too-real) narratives. Indeed, the music often anesthetizes the brutality of the images and narrative events we witness. An early example of this anesthetization occurs in *Toy Story* during the scene in which Woody reveals himself to Sid, the malicious next-door neighbor who has a penchant for torturing toys. While commanding Sid to "play nice" with his toys, Woody spins his head a full 360 degrees—a direct gloss on *The Exorcist*, arguably one of the most terrifying films of all time. As Sid flees the scene, we first hear a stinger chord of horns that registers his shock, followed by the screeching of violins (à la *Psycho*) as he runs in terror from his sister's doll.[36] However, these musical figures are not only incredibly brief, but they are immediately overwhelmed by cheerful and whimsical music in a major mode. Thus, the music quickly and effectively diminishes the

gravity of both the situation itself and the methods by which the toys achieved their aims. That is, it transforms a possibly frightening scenario into an otherwise innocuous moment in the narrative.

Monsters, Inc., however, presents the most apparent example of music's ability to undercut the harsh realities of a film's narrative world. The opening scene of the film takes place in the darkness of a young child's room. While the child is sleeping, the door to his closet slowly creaks open, causing the young boy to cower beneath his blankets. Two iridescent eyes appear beneath his bed and then rise above the fear-stricken innocent. As the child turns and sees the nightmarish figure emerging from the shadows, the underscored brass instrumentation comes to a crescendo and the child emits a bloodcurdling scream. Certainly, the monster's response to his now-shrieking victim is unexpected and even humorous; he too cries out in terror and subsequently falls upon a pile of jacks resting on the floor. Yet, as the segment explicitly trades upon the seemingly universal and primal fear of capricious beings lying in wait behind closed doors, it addresses an uncomfortable reality that stands at the heart of our collective experience: some unnamed and unseen force, it would seem, is pursuing us.

Consequently, if it were only these images and sounds that served as our introduction to the film, they would likely have imbued the narrative with a rather ominous mood. However, the film actually begins with an opening title sequence featuring lively, traditional animation. Commenting on the opening credits, Pete Docter, the film's director, states, "The purpose of the title sequence here is basically to set the tone of the film. Without it, we actually had an earlier version where we start right in on the kid asleep in bed. And it becomes a much more spooky, dark, kind of scary tone that we're laying down. With the title sequence, we are hoping to tell people [that] this is going to be fun, it's going to be colorful and upbeat."[37]

Significantly, though, it is not the animation alone that invests the film with a sense of "fun." Rather, this particular tone is the result of the combination and close synchronization of bright images and a light, airy jazz number. Being swing music, the underscoring has an upbeat tempo driven by a strong rhythm section that anchors the various saxophone, clarinet, and trombone runs. This music mimics and, in turn, is mimicked by the movement of the colorful animation that quite literally dances in step with the jazz ensemble. In doing so, the opening segment frames the film as a whole, and, just as Docter had hoped, supplies the movie with an upbeat and joyful quality.

But the music in this scene does something more than simply lend the film a sense of fun and color; it also minimizes the weightiness of the subsequent sequence. Rather than allowing the audience to experience and indeed feel the full import of our basic childhood (and adulthood) fears, the overall tone and feel of the film, which the opening credits have already firmly established as "fun" and "carefree," undercut any true fear or dread that this scene might otherwise evoke. Thus, *Monsters, Inc.* offers a helpful illustration concerning the ways in which the filmmakers at Pixar have positioned music in their earlier films. That is, by actively and intentionally undermining the full reality of those fears and anxieties that shape how we engage the world around us, music provides Pixar the ability to tell stories about monsters that are fun rather than frightening. And just like James P. Sullivan and Mike Wazowski at the end of the film, this creative vision banks on the power of laughter over screams.

Following *Monsters, Inc.*, though, the music in Pixar's films undergoes a considerable change. In each successive film, the music increasingly demonstrates its ability to break away from its narrative constraints, and as it does, it allows Pixar's later films to deal more honestly, or at least more directly, with a life that is at once cruelly indifferent and

heartachingly beautiful. The score for *The Incredibles* (2004), for instance, is structured on a large-scale level around a particular Michael Giacchino leitmotiv. Traditionally, the leitmotiv has functioned as a highly representational and even language-based mode of musical signification in which "a musical theme . . . acquires some of the properties of a word or symbol, with independent meaning or associations that can be called up when the theme is repeated."[38] Consequently, in many cases, when we hear a leitmotiv in a film, it carries a meaning that is often redundant or overdetermined. The first few occurrences of the primary leitmotiv in *The Incredibles* seem to point toward this type of redundant signification; the musical figure is linked directly to Mr. Incredible's strength and virility during flashbacks of the "golden age" of superheroes and reappears as he furtively returns to his heroic activity after a forced sabbatical.[39] What is more, during the early stages of the film, those narrative situations that feature this leitmotiv stand in sharp contrast to Mr. Incredible's everyday life. In fact, we hear no music at all as Mr. Incredible works begrudgingly at his office desk, as he argues with his wife about child-rearing, and as he unknowingly disregards his preadolescent children during a family dinner. This interplay between the leitmotiv and musical silence not only sets "the incredible" and "the banal" in firm opposition, but it also suggests that the only thing still truly incredible about Mr. Incredible is the severity of his midlife crisis. Thus, the recurring musical theme in *The Incredibles* initially anticipates and therefore primes the audience for a nostalgic return to a bygone past.

Yet, as we will discuss further in chapter 3, a leitmotiv can also break free of its close ties to a person or place and indicate something that is not already present in the image. For example, as the film progresses, *The Incredibles'* theme eventually detaches from its close association to Mr. Incredible. Rather than directly signifying his former glory or his extraordinary abilities, this musical theme increasingly

expresses the intrusion of the apparently mundane into the exotic, or rather, the subsumption of the extraordinary into the ordinary. Specifically, after Syndrome imprisons Mr. Incredible, we repeatedly hear the primary leitmotiv as the entire Incredible family—the very people Mr. Incredible believed to be the source of his disaffection—embarks on a mission to rescue their husband and father. As this musical theme disconnects from Mr. Incredible and becomes more closely associated with his family, it indicates something that was absent from his repository of powers, namely, the ability to recognize that the ostensibly ordinary aspects of his existence are actually what make his life "incredible."

To be sure, his marriage was on the verge of a breakdown, his nemesis had overpowered him, and his midlife crises had placed his children in harm's way. Yet, rather than allowing Mr. Incredible (and the audience) to brush these harsh realities aside through a return to a former glory, the music addresses these realities directly and honestly, for it underscores the emptiness of his nostalgia. Marriage is certainly wrought with difficulties, the loss of one's physical capabilities is always disheartening, and raising children is never devoid of stress and feelings of failure. However, to avoid or escape from these realities (nostalgically, musically, or otherwise) would be to deny the very things that invest life with meaning. Thus, instead of overlooking and diminishing the significance of these hardships and seeming banalities, the music in *The Incredibles* calls attention to them; it indicates the latent beauty of our mundane lives—an extraordinary beauty that resides and emerges from out of the ordinary.

However, it is one of Pixar's most recent films that provides what is perhaps the most demonstrative and affecting example of the leitmotiv's ability to break away from its narrative constraints and indicate something not present in the image. Much like *The Incredibles*, therefore, *Up* is also indicative of the third and final shift that we are highlighting in Pixar's filmmaking. Yet, the film addresses the fragile

nature of life's beauty in a slightly different manner than *The Incredibles*. That is, the music in *Up* works to represent that which lies beyond representation—the structuring presence of an absence. It indicates something or someone who exists in a realm beyond or outside the image, yet nevertheless impinges upon the immanent frame of the diegetic world.

Similarly to the music he composed for both *Ratatouille* and *The Incredibles*, Giacchino developed the score for *Up* around a central leitmotiv. We first hear this musical figure when the young Carl Fredricksen meets the equally young Ellie and she welcomes him into her "adventurer's club." However, the first full articulation of the film's dominant leitmotiv appears shortly thereafter, underscoring the married life montage—the brilliantly economical segment of the film that depicts the many joys and hardships of their adult life in four wordless minutes.[40] As it does, the music shares an empathetic relationship with the film's images. That is, the orchestration, tempo, and texture of the leitmotiv move in concert with both the elating highs and the crushing lows of their shared experiences. Given the explicitly "adult" subject matter of the montage—from financial woes, to an inability to bear children, to the despair over losing one's beloved—this segment directly addresses the heartrending realities of life. Yet, rather than undercutting this reality, the music, which moves to the foreground in the absence of dialogue, makes a substantial contribution to the pathos of both the scene and the film as a whole. Moreover, given its location in the film's formal structure, the married life montage establishes the overall mood of the film, imbuing it with a pronounced sense of human vulnerability in the face of life's fragility.

As the film proceeds, the leitmotiv that underscores the married life montage reappears constantly. It most often accompanies those moments in which Carl makes a concerted effort to realize the promise he made to his late wife regarding their great adventure to Paradise Falls. Thus, it initially

seems that the leitmotiv indicates the presence of a particular absence that continues to influence and affect Carl's life, namely, the "spirit" of Ellie. Indeed, Carl often speaks to Ellie as if his late wife is embodied in the house they once shared—as if her absence is the most palpable and formative presence in his existence. Interestingly, though, when Carl finally plants their house on the edge of Paradise Falls, the leitmotiv is nowhere to be found. As Carl sits in his recliner in the midst of a house that is now perched atop a breathtaking waterfall, he is, for the first and only time, completely alone. Here, the soundtrack functions to express Carl's newfound isolation, for rather than the leitmotiv, we hear musical silence.[41] Even Ellie, whose presence has heretofore been a tangible reality, is now absent—truly absent.

As Carl picks up Ellie's "adventure book," he initially stops short of the section titled "Stuff I'm Going to Do," believing it to be empty. The basic assumption with which Carl had been operating was that his life was a failure because he and Ellie had never embarked upon their great adventure. Yet, just prior to closing the book, he realizes that, in fact, it is filled with pictures of Carl and Ellie's life together. Significantly, as he thumbs through the remainder of the photo album and discovers Ellie's handwritten message to "go out and have a new one [i.e., an adventure]," the leitmotiv gently returns.

It is in this moment that the leitmotiv breaks away from the narrative. We realize that, rather than being closely tied to either Carl's memory of Ellie or the structuring presence of her absence, this musical figure actually indicates what we might call the "livingness of life"—the animating presence of something or someone who urges us toward wholeness and integration. For it is not only present as we watch Carl and Ellie share in the joys and sorrows of their life, but it also underscores Carl's quest to realize their collective dream. What is more, though, the leitmotiv appears in various forms throughout Carl and Russell's shared adventure—as Carl's house lifts off

with an unwitting stowaway, as he abandons all of his posses-sions and relaunches his house in order to rescue Russell from Charles Muntz, and as he stands in lieu of Russell's absentee father, awarding Russell his final Wilderness Explorer badge.[42] Thus, the leitmotiv expresses not simply the animating force that is at work in Carl and Ellie's relationship but the pervasive presence of the "spirit of adventure"—the energizing spirit of life that compels Carl not only to tether his house to innumer-able balloons but also to serve as a guide for a young boy who is desperately seeking wisdom regarding how one might navigate the complexities of the world.

Interestingly, some have suggested that the married life montage marks the aesthetic apex of the movie and that the "lighthearted" nature of Carl and Russell's subsequent adven-ture remains bound by the conventions of animated Disney films.[43] But this critique is problematic for two reasons. First, it disregards the fact that the film not only begins with Carl mourning the loss of his spouse but that it also ends with him assuming a role vacated by Russell's father. In other words, Carl is not the only character who experiences a profound lack in his life. Indeed, the film simply assumes the pain-filled absence of Russell's father and thus refuses to acquiesce to convention.[44] Second, it fails to account for the way in which music functions in this film, for the leitmotiv does not simply announce a character or recall the mood it established during the opening montage. Rather, it works to indicate some other force at work in the world—a presence that pervades the life of both the young and the old, both the widower and the father-less. This presence points to something that lies beneath or beyond the narrative. It opens both the characters and the audi-ence out into something deeper, something larger. And as it does, it avoids undercutting the harsh realities of life. Rather, it deals honestly with the paradoxical reality of life's concomi-tant loveliness and ugliness—a fragile life made beautiful in and through the animating presence of something Other.

2

A THEOLOGICAL EXPLANATION
OF PIXAR'S FILM MUSIC

Given the possibility that Pixar's films may be functioning in the contemporary world as the kinds of stories that individuals of all ages hold in common, these films and the music therein surely invite a theological response. Indeed, the sheer popularity of Pixar's films "raises important questions about primary narratives within a culture with which children and adults can both engage. As recently as fifty years ago (and before that for most of the previous two millennia) it could probably be argued that biblical texts supplied the basic narrative currency which people could use to speak of beliefs and ideals in the west. With the passing of Christendom, the Christian currency has gone. But the need for some common texts remains."[1] Thus, if we are not only to celebrate Pixar's contributions to our life and the world but also to engage in a mutually critical, life-giving dialogue regarding the ways in which music allows each of Pixar's films to function as a "shared narrative," it will be beneficial to outline briefly what we mean when we use this term.

First, a "shared narrative" must be accessible across ages and thus capable of serving as a location for meaning making and identity formation for both adults and children.[2] Second, a common narrative must not only be meaningful in different though related ways among myriad age groups, but must also function on multiple levels; it engenders "thick" interpretations that are deserving

of repeat readings, viewings, and hearings.[3] Finally, these narratives must address the human experience honestly; rather than circumventing the "messiness" and the dangers of life, or avoiding the darker realities of the world altogether, they must provoke the discovery and pursuit of meaning in the midst of life's ambiguity and mystery.[4] It is with these basic criteria in mind that we now offer an explicitly theological reflection concerning the ways in which these movies may very well be functioning as common narratives in our contemporary culture and, even more importantly, how music plays a key role in allowing them to do so.

A SHARED AFFECTIVE SPACE

The God who made the world and everything in it, . . . made all nations to inhabit the whole earth, and he allotted the times of their existence and the boundaries of the places where they would live, so that they would search for God and perhaps grope for him and find him—though indeed he is not far from each one of us. For "In him we live and move and have our being"; as even some of your own poets have said, "For we too are his offspring."

—Acts 17:24-28 (NRSV)

From a reception-oriented perspective, it is interesting to note that, generally speaking, Pixar's more recent films have garnered the most enthusiastic acclaim. In fact, according to the democratic mass of filmgoers contributing to IMDb, each successive Pixar film offers a slight but demonstrable advancement over its predecessor in terms of creativity and aesthetic appeal.[5] We could offer a number of speculations regarding exactly why this is the case. However, given the dearth of young children who participate in the IMDb community, it certainly stands to reason that, at least in part, these particular filmgoers more readily laud Pixar's later films because they are evaluating them according to adult-oriented criteria. Thus, as Pixar's filmmaking has developed over time, the animated

"children's" films they have produced have increasingly reso-
nated with adults and, in significant ways, managed to capture
the imagination of both young and old audiences alike.

As our prior analysis would suggest, music in particular
plays a key role in the way that audiences respond to these
films. Consequently, the reception of Pixar's films runs paral-
lel to the first shift we identified in their filmmaking—a shift
that is rooted in the way the filmmakers call upon music's
signifying capacities. In keeping with the traditional use
of music in the animated genre, Pixar's earlier films featured
music that primarily signified according to an explicit and
predetermined emotionality. The prevalence of closely syn-
chronized music in these films highlights the fact that music
frequently functions to overdetermine the affective meaning
of the film's images. The music unambiguously tells filmgoers
what and how to feel about the images they see and, in doing
so, primarily and most effectively relates to children. Indeed,
it is almost a given in the industry that younger audiences
require this type of clearly articulated affectivity. However,
when a film's affective space comes prefilled, it has a tendency
to preclude adults from accessing the film's power and mean-
ing, for it demands far less in terms of an individual filmgoer's
emotional investment. While *Toy Story*, *A Bug's Life*, and *Toy
Story 2* all feature numerous adult-oriented references and
innuendoes throughout their narratives, the music works to
prevent these films from appealing to a broader, intergenera-
tional audience on a deeper or more significant level.[6] Thus,
without a basic awareness regarding how music is functioning
in these movies, it becomes difficult to understand why some
of Pixar's films appeal primarily to children and why others
appeal to adults as well.

As we noted, the music in Pixar's later films moves in a
different direction, offering audiences an "invitation" to feel,
rather than inducing a predetermined emotional response.
On the surface, it would seem that *WALL-E* is simply another

well-crafted animated film much like the many Pixar films that preceded it. But as we pay closer attention to the ways in which the eclectic orchestration and amelodic texture of the music open up an affective space that the audience might inhabit, we realize that *WALL-E* is more than a "children's" film. By inviting audiences of various ages to commit themselves emotionally to the plight of WALL-E and his beloved EVE, it assumes the role of a shared narrative—a common story that is accessible across ages. On a concrete level, then, Pixar's films—especially their more recent films—are often meaningful in terms of the shared affective space they open up.

For example, reflecting on her experience of *UP*, one filmgoer stated, "I had no idea that slick animation could be so raw. . . . I can't remember the last time a movie touched my heart enough that I could use the phrase 'touched my heart' without irony. The wordless segment that tells the story of the protagonist's life with his wife might be the most powerful four minutes of film I have ever seen. I sobbed. And while the emotional purity of the subsequent 80 minutes may suffer from comparison, I have to say that I am grateful for the movie's second half, which brought me back up again, to where there is life even after the death of a loved one. Bravo."[7]

Another reviewer—a mother of a young son—makes a similar claim: "They [i.e., Pixar] created something that will touch everyone no matter what age. . . . [M]y almost 5 year old, cried when Ellie passed. . . . Pixar has managed to make all of their movies resonate with an audience from 3 to 100. Quite an amazing feat, but if you look at the big kids behind the scenes making these movies you will know why their recipe works and why Bugs Bunny and the Road Runner hour is no longer on TV."[8]

In the midst of a fragmented and fragmenting culture, there is a great need for a basic narrative currency that will allow modern individuals to frame their beliefs and ideals in a meaningful way. For this reason, we can certainly celebrate Pixar's

creativity and its aim of developing stories that are rooted in a common human experience. More specifically, though, we can affirm those Pixar films that provide contemporary persons with a shared affective space—a common location in which both children and adults are afforded the opportunity to experience and express an intense depth of emotionality. For it is this very depth of feeling that stands at the core of any authentically human and thus genuinely religious experience. Indeed, we only ever truly understand others through a kind of "empathic fusion."[9] That is, more than a simple form of cognition, humanity's basic awareness of the world involves an intersubjective immersion in both aesthetic and human subjects. In the same way that we are caught up in and even become "one" with a beautiful piece of music, we relate to others affectively, through empathy: "We can know objects through observation and analysis, but we can only know human persons through empathetic love."[10] The best musical-aesthetic experiences, then, provide an occasion in which myriad individuals are able to commune affectively with one another.

Consequently, by opening up a shared affective space in the contemporary world, we might say that Pixar's music creates a "communal womb" in which both adults and children are able to express collectively the emotionality that constitutes their basic awareness of the world and imbues their lives with meaning. What is more, though, it offers an occasion in which individuals affectively encounter the "other"—the musical other, the personal other, and something higher or deeper still. It is therefore in their willingness to offer audiences an invitation to feel that the filmmakers at Pixar succeed not only in providing contemporary individuals with shared narratives that are accessible across ages, but also in constructing a space that has the potential for serving as a truly religious experience—a location in the modern world where we might find the divine lying in wait, or, as the Apostle Paul suggests, a place where we might proactively "feel our way toward God."

However, it is here that we can engage in a mutually enriching critique of both Pixar's films and our theology. In light of the favorable reception and the attendant box office success of their more recent films, the filmmakers at Pixar would do well to position music in their films in such a way that it continues to offer audiences an invitation to feel, thus allowing their films to function as a type of contemporary shared narrative. Indeed, it is the crossgenerational appeal of these musical emotions that makes Pixar's movies at once critically acclaimed and profitable—an uncommon occurrence in modern cinema. Yet it is when they turn away from this creative vision and too readily call upon music to fill the affective space with a predetermined meaning that their films fail to serve as narratives that are truly held "in common." They are certainly entertaining, but less than meaningful, for they are naturally exclusive. To be clear, this critique is not a blanket criticism of all highly synchronized music or an argument for the inherent superiority of musical "counterpoint," for if a score was entirely unrelated to a film's images, it would be strangely indifferent.[11] Rather, it is simply to point out that when Pixar relies almost entirely on this manner of musical signification, their films are primarily addressing younger audiences and thus do not succeed in creating the kind of shared narratives that are needed in the contemporary world—narratives that integrate individuals of all ages into a larger community of meaning.

Thus, Pixar's success in creating shared affective spaces offers a helpful corrective for a theological tradition that has not only approached human affectivity with a certain degree of suspicion, but has also routinely undervalued the broader cultural forms of life through which both children and adults are able to commune affectively with one another and, ultimately, with God. In the first place, Pixar's ability to make films that are emotionally accessible for children and adults challenges theologians to reevaluate the ways in which our

feelings necessarily relate to our immediate awareness of one another. Might the depth of feeling that audiences encounter in these shared spaces point to a more robust, relational notion of our basic humanness—one that finds expression in the affective communion between the young and the old? And might this contemporary impulse toward a shared affectivity reflect the presence and activity of the divine in our lives?

Secondly, Pixar's films urge theologians to reconsider the theological significance of those ostensibly "secular" forms of life that might already be functioning in a religious manner—those affective practices around which contemporary persons orient their lives and to which they are ultimately committed. In the absence of any other religious or theological framework, might these films and the intersubjective emotions they engender be functioning in a way that opens contemporary individuals out onto something larger and more meaningful—something deeply human and therefore innately spiritual? Theology certainly has a number of hurdles to overcome in regards to the role of emotions in our lived experiences of life and the world. Yet, as our experience of the music in these films suggests, it is only as whole human beings—as irreducibly emotive/intuitive/cognitive/reflective creatures—that we are able to find fulfillment, and ultimately so. For it is only as whole human beings that God encounters us and, in turn, that we are able to feel our way toward God.

CULTIVATING WISDOM

Even in laughter the heart is sad, and the end of joy is grief.

—Proverbs 14:13 (NRSV)

Recently, while enjoying a holiday with a number of friends and their families, I was able to observe what is undoubtedly an increasingly common phenomenon. That is, at almost every moment during our time together, the children among us were participating in some form of filmgoing by means

of numerous digital media. At the restaurant where we ate lunch, one child watched *Up* on his father's iPhone; during our dinner, another was enraptured by *WALL-E* on his portable DVD player; and while the adults gathered around the television, the children gathered around a laptop computer to watch *Cars.* Although admittedly isolated, this anecdote helpfully illustrates not only the pervasiveness of Pixar's films but also the ease and frequency with which children and adults engage in repeat viewings of those films they genuinely cherish. Yet, as suggested above, these particular Pixar films are quite different, especially from a musical perspective. Given my interests in the topic, I asked one of our friends—a mother of two young children who is also a licensed therapist—if she noticed any differences between her son's experiences of the various Pixar films that formed the ever-present backdrop for our gathering that day. Her reply was telling and, as such, worth quoting at length:

> Some of the Pixar films depict some darker circumstances and some deeper emotions. As a parent, I see a much different viewing experience in my preschool children between, say, the light-hearted story portrayed in *Cars* and the loneliness and loss of *WALL-E.* Instead of keeping our kids from the darker and deeper stories, we have decided to embrace them as a family for a very specific reason. My three-year-old son Jack asked me why WALL-E was so sad as he pursued EVE after she shut down. He wanted to know why EVE wouldn't talk back to WALL-E and why WALL-E didn't know anybody who could help her. Why didn't WALL-E have any other friends, he asked? . . . Instead of turning off the movie and putting on *Toy Story,* stat, I saw that moment as an opportunity to communicate with my son about some emotions he hasn't experienced yet. He was displaying compassion toward a pretend robot; why not encourage that and use it as a teachable moment? I believe that exposing my kids to some of the darker realities of our human experience within the safe haven of our home has value for one simple reason: we intentionally cultivate a relationship with our kids that

can support that exposure. We use those moments to teach them about healing, compassion, redemption, truth, love, consequences, choice, free will—big concepts for such little people! But Pixar gives us an opportunity to enter into those big realities in a safe context. In my opinion, those darker and deeper stories will have a much more enduring impact on the developing minds and hearts of my little ones than the more prosaic and scripted fluff that makes up the majority of children's television and films. Don't get me wrong— we like fluff in our home because it's harmless, entertaining and gives me time to get some chores done! But it doesn't build relationship and initiate conversation the same way that films like *Up* or *WALL-E* do. Do I believe that those stories might be too dark for children who do not have safe relationships in which to explore them? Yes. The complex emotions and relationships presented in films such as *Up* or *WALL-E* may be confusing and triggering for children who do experience trauma, loneliness, abandonment, grief, denial and rage. If children do not have safe relationships and wise navigation through the troubled waters of their darker experiences, it's harder for me to see the value in re-presenting those experiences in the stories that fill their minds.[12]

These thoughts from the mother of a young son and daughter are clearly reflective of our basic claim concerning the second shift in Pixar's filmmaking. That is, whereas the music in Pixar's earlier films is often explanatory and functions essentially as straightforward commentary, the music in their later films (with the notable exception of *Cars*) urges the audience to discover the deeper meaning that is hidden in the film's images or resides just beneath their surface. In this way, the music offers what I have been calling a "hard-won" interpretive clarity; it engenders "thick" interpretations that necessarily call for repeat viewings, deeper reflection, and the active pursuit of meaning. In short, rather than telling the audience how to interpret the film, the music urges us to contribute something of our own to the interpretive process. In doing so, it creates a space in which both children and adults

are able to experience and reflect upon, in one mother's words, the "deeper emotions" and "darker realities" of our lives—the seemingly ambiguous complexities that comprise much of our lived experience of the world.

In *Finding Nemo*, for example, Thomas Newman's score refuses to clarify in any simple manner what the death of Marlin's wife and children means to him. Nor does it directly comment on how the loss of his only remaining son has forever altered his fundamental awareness of the world. In an important sense, the music actually adds to the narrative ambiguity. Just like the sea in which Marlin lives and swims, the music signifies the "beautiful sadness" that suffuses our world. Its presence does not sanitize these realities or treat them flippantly. Instead, the music prods us to locate these difficult circumstances in a larger framework of meaning—a larger narrative that the film itself does not supply. It invites the audience to observe the raw "stuff" of life and to seek out the inherent connections therein that may not be immediately apparent. In other words, it provides a space for the cultivation of wisdom.

According to Israel's wisdom tradition, the practice of cultivating wisdom is intrinsically dialogical. That is, rather than static, it is a dynamic and heuristic process of discovery.[13] By observing and reflecting upon the created order, one is able to discover "a new life orienting reality, a reality that emerges from the unexpected realm of ordinary experience."[14] Yet, in order to discover the life-orienting reality that resides in our ordinary experiences and thus to become truly wise, it is imperative that we address not only the mystery and beauty of life but also the uncertainties and the sorrows that so often seem to permeate the human condition. Indeed, as Proverbs suggests, wisdom begins with the recognition that "even in laughter the heart may ache, and the end of joy may be grief." That is, we do not come by wisdom in a simple or straightforward manner. Rather, wisdom emerges as we grapple with the complexities of life that constantly belie our formulaic reductions.

Thus, in those instances where music offers filmgoers a "hard-won" interpretive clarity, Pixar's films have the potential for serving as shared narratives in the contemporary world, for they engender thick interpretations and are deserving of repeat viewings. We might speak of and even celebrate this capacity theologically in terms of the wisdom that is inherent in the created order—a wisdom that not only speaks to human beings from out of creation but actually makes them wise. The best of Pixar's films are capable of provoking filmgoers to reflect upon the structuring power immanent in the world. Rather than simply offering the audience a straightforward, ready-made meaning, the music encourages individuals to discover for themselves a source of significance that, at first glance, appears to be absent. That is, as these films allow children (and adults) to consider the complexities of life and urge them to discover deeper meanings that emerge from out of their ordinary experiences of loneliness, loss, abandonment, and grief, the films create spaces for the cultivation of wisdom in the midst of a culture that, at present, is largely devoid of a basic narrative currency. And in the words of a parent who has willingly and intentionally entered these spaces with her children, it is for this very reason that Pixar's movies are both powerful and enduring.

Significantly, though, not all of Pixar's films succeed in this regard. Thus, as we offer a theological critique of Pixar's films, we are primarily concerned with those moments when music works to curtail the cultivation of wisdom. Rather than revealing a surplus in the image that filmgoers might interpret, the music in *Cars*, for instance, precludes individuals from actively pursuing and discovering the multifaceted meanings residing within the cinematic experience. By assuming a straightforward, illustrative function, it effectively reduces the audience's interpretive options. As noted above, *Cars* has one of the lowest ratings among all of Pixar's films on IMDb, second only to *A Bug's Life*. I have suggested that part of the

reason for its poor reception among adult audiences has to do with the way in which music functions in the film. As with Pixar's earlier movies, the music in *Cars* works exclusively, separating audiences rather than uniting individuals across age groups. However, *Cars* is also one of the studio's most profitable productions and is now only the second of Pixar's films to be made into a sequel. To be sure, it is unclear whether the fiscal success of *Cars* is related more to the film itself or to Disney's marketing strategies, such as the ever-expanding line of toys and paraphernalia that are "branded" as genuine *Cars* products. In either case, though, children (and their parents) apparently enjoy watching this film time and again, happily consuming both the film and its promotional tie-ins.

Yet the question remains: What exactly does this film cultivate? We might ask the same question of any of Pixar's films that, like *Cars*, fail to offer a hard-won interpretive clarity. They may be eminently engaging, but are they truly salutary and life giving? Do they prod children and adults to reflect upon and derive meaning from those life-orienting realities that are deeply embedded within our ordinary experiences? Moreover, do these films actually provide a much-needed "communal womb" in which both children and adults are able to cultivate wisdom? Do they allow filmgoers of all ages to examine the created order, to come into harmony with that order, and, thus, to become wise? Or do they simply manufacture meaning for the audience? From within a culture that suffers under the weight of a surfeit of information and a distinct lack of deep and thoughtful reflection, do films like *Cars* promote the cultivation of wisdom, or do they simply present us with something more easily digested but far from enduring?

These questions both challenge and helpfully inform our understanding of the relationship between theological reflection and contemporary forms of meaning making. Because Pixar films effectively function as shared narratives within the broader culture and thus offer locations in which individuals

are able to cultivate wisdom, we might ask why theologians and religious communities are not more intentional about creating spaces in which this wisdom might flourish and through which individuals might discover the deeper structures of their lives. In light of the Bible's increasing absence from modern life, film may in fact offer the primary narrative currency that allows modern persons to initiate and engage in meaningful conversations about their lives in the world. However, without a larger orienting framework, these conversations alone prove inert, for wisdom involves more than observational skills; it also requires a guide—a mentor whose very being has been shaped by the ordering power of ordinary experience. That is, to become truly wise, one must root oneself in a tradition of wisdom.

Ironically, though, along with their (largely understandable) rejection of those institutions that have seemingly collapsed upon them, (post)modern persons have concomitantly discarded the very traditions that have most fully developed this ancient art of wisdom. It would seem that in this regard theology is in a position to make a significant and somewhat obvious contribution to contemporary life. However, especially in the midst of a culture that is suspicious of religious claims in general and Christian truth claims in particular, it would be unproductive (and perhaps even unwise) to disregard or discount the wisdom that individuals have already discovered in modern forms of life, a wisdom that necessarily emerges from out of God's creative work in the world (Prov 8). Thus, by attempting to create spaces in which individuals and communities might reflect further upon their lived experiences, the theological task becomes one in which theologians "articulate the wisdom of God in ways that address the absurdities and uncertainties of life."[15]

In other words, rather than simply "interpreting" or offering a critique of a given movie from a theological perspective, theologians enter into a public sphere in which film serves as our shared cultural narrative, elucidating the insights of the

theological tradition as a possible guide for navigating the complexities of life. In doing so, Christian theology might not only assume a role in the contemporary world that it has long since abdicated, but it might also discover something new about God's wisdom along the way. That is, just as Nemo's father discovered, there is something at once beautiful and terrifying about swimming out into the uncharted waters of life and encountering therein a divine, structuring presence that not only saturates the very fabric of the created order but also works to make us wise. Wisdom is certainly calling out to modern persons in and through these films. Do we have the ears to hear her voice?

AN IMMANENT MYSTERY, A TRANSCENDENT SPIRIT

What do mortals get from all the toil and strain with which they toil under the sun? For all their days are full of pain, and their work is a vexation; even at night their minds do not rest. This also is vanity. There is nothing better for mortals than to eat and drink, and find enjoyment in their toil. This also, I saw, is from the hand of God; for apart from him who can eat or who can have enjoyment?

—*Ecclesiastes 2:22-25 (NRSV)*

As the author of Ecclesiastes reminds us, life is filled to the brim with pain, frustration, and anxiety. In spite of our repeated attempts to construct a meaningful reality, we are constantly confronted with the futility of our labors. And yet, rather than descending into a kind of existential nihilism, Ecclesiastes points us toward a profound and somewhat mysterious wisdom: we are meant to enjoy life. For it is in our ability to find enjoyment amid the unmistakable senselessness of our existence that we are most fully and directly related to the source of all our joys. That is, through our discovery of wisdom, we actually enter into the presence of the transcendent Spirit of God who is immanent in the world.[16] However, our encounter

with the Spirit in the form of wisdom does not negate the apparent randomness of our lived experience. In fact, it is only when we embrace and surrender ourselves to this seeming ambiguity that we are able to discover the deeper significance of our lives.

In an important sense, then, the final shift we have identified in Pixar's filmmaking is rooted in this wisdom. Rather than undercutting the harsh realities of our existence, Pixar's later films deal honestly with the fragile beauty of life, and music plays a key role in their ability to do so. For instance, in contradistinction to the music in *Monsters, Inc.*, which routinely works to assuage the fear or dread potentially induced by the film's images, the music in *WALL-E* and *Up* invites the audience to explore the full weight of life's uncertainties. Rather than glossing over these difficult realities, we are allowed to reflect deeply on the hardships and losses that have come to mark our lives, the formative presence of a profound absence.

It is perhaps here that we are able to most enthusiastically affirm the capacity of Pixar's films to serve as shared narratives in the contemporary world. Just as the third of our criteria would suggest, these films address the human condition honestly rather than avoiding its inherent "messiness." Of course, in its own right, the very subject matter of films like *WALL-E* and *Up* is affecting and powerful. Loneliness, isolation, and the loss of loved ones are near-universal categories that are deeply embedded in the human experience. Yet, in conjunction with the other elements of Pixar's films, the music is uniquely able to address these realities by opening the audience out into something larger than themselves, something that lies beyond the representational capacities of moving images. It signifies an ineffable presence that pervades the immanent frame of the cinematic world—a delicate yet distinctive beauty that somehow exists in the midst of the pain and the chaos. Rather than brushing aside or diverting our attention from the heartrending nature of a life lived fully and authentically, the music presses us into the one reality of

which we can be certain. That is, all of our joys in life may very well be "in spite of" something.[17]

Although it certainly expresses a mysterious and even paradoxical understanding of the world, the music also refuses to give way to a reductive nihilism; we are not left simply to revel in despair. Rather, the music indicates that which must necessarily go without representation—the joy that appears in the midst of tragedy, the poignancy of loving and dying, the transcendent in the immanent. We might even say that in addressing the ineffable in this way, music points toward those "limit situations" that stretch the limits of analytical language and thereby stretch our very selves. In other words, the music in Pixar's films is not merely formative; it is, on a very basic level, (trans)formative. For by positioning music in such a way that it addresses the inexplicable presence that suffuses our experiences of life, Pixar's films have the potential for mediating the immediate presence of God's re-creative Spirit. Through the music we hear in these films, we are able to encounter the animating Spirit of God that breathes life and beauty into the ashes of our existence.

Without an awareness of how music is functioning in Pixar's films, though, it becomes increasingly difficult to identify those moments when they are dealing honestly with life's harsh realities and when they are effectively subverting this reality. For example, commenting on *Monsters, Inc.*, Craig Detweiler suggests,

> [Pixar's] animated adventures work on multiple levels, appealing to viewers of all ages. The best Pixar films begin with genuine childhood (or parental) phobias, gradually turning those fears into laughter. . . . Ultimately, it humanizes the monsters, finding fears lurking in their (adult) closets as well.[18]

Yet, as our examination of the music in this film revealed, rather than gradually turning fears into laughter, the music in *Monsters, Inc.* actually undermines the genuine fears that

constitute our awareness of the world, and thus intentionally strips these fears of their potential import. To be sure, as Detweiler rightly concludes, in order to appeal to filmgoers of all ages, the filmmakers at Pixar must take great care to address both adult and childhood anxieties in a manner that will neither overwhelm nor do harm to younger audiences. However, it is equally unhelpful simply to avoid or dismiss these complexities altogether. A wholly sanitized rendering of our life in the world is no more constructive than one that is recklessly disconcerting. Thus, these animated films are at their best when they carefully navigate rather than circumvent the ambiguities and mysteries of life. And when they fail to do so, we might offer a critique of the vision they present, for this understanding of life fails to account for the ways in which the Spirit is present and active in both our fears and our laughter.

However, if our theological reflection is to take seriously the idea that our concrete experience of Pixar's films might serve as an encounter with God's presence in the world, then it must also develop the means by which we can determine whether the spirit we encounter in the cinematic experience is indeed the transcendent Spirit of God. Is the "spirit of adventure" that underscores Carl and Russell's collective journey actually the Shekinah, the indwelling presence of God who walked alongside the Israelites in their exile? Moreover, is the elevation of our own spirit in and through our affective response to the film's music an elemental resonance with the transcendent Spirit who is immanent in creation, our conscience, and our creativity? In his seminal work, *The Go-Between God*, John Taylor identifies three questions that aid in our ability to discern where and how God's Spirit is present and active:

> [1] Which factors in this situation are giving people the more intense awareness of some "other" who claims their attention or of some greater "whole"? [2] Which factors are compelling people to make personal and responsible choices? [3] Which factors are calling out from people self-oblation and sacrifice?"[19]

An awareness of both an "o/Other" and a larger "whole," social and personal responsibility, and giving of oneself sacrificially—these are, for Taylor, the marks of the Spirit's movement in the world. And while Taylor's criteria offer a helpful starting point for reflecting theologically on the presence of the Spirit in our filmgoing experiences, I would like to suggest one additional criterion—one that, in an important sense, will serve as the impetus for the remainder of the book. That is, we know we are in the presence of the transcendent Spirit of God when we encounter a beauty that issues from out of ugliness, or perhaps even more disturbingly for modern persons, from out of ordinariness. For, just as the story of Job intimates, in addition to making us aware of the other and drawing us into a self-giving relationality, the Spirit works to *embellish* both our life and the world in which we live. Like our own, Job's life was defined by unimaginable suffering. Yet, in the aftermath of his profound despair and his subsequent encounter with God's overwhelming presence, Job chooses to name his daughters "dove" (Hebrew *Yĕmimah*), "cinnamon" (*Qĕtsi'ah*), and "horn of eye shadow" (*Qeren Hap-pûk*) (Job 42:14). Why these names? Why, after experiencing irreparable loss, would Job choose names for his daughters that allude to women's cosmetic embellishments? Perhaps it has something to do with the aesthetic quality of an encounter with God's pervasive presence. Perhaps there is something intrinsically valuable about a life lived in relation to the heart-breaking beauty of God's Spirit. And perhaps this beautiful presence makes life somehow worth living, somehow worth the risk of losing everything we hold dear all over again.[20]

It is with the story of Job in mind that we return to the place where we began our exploration: the Spirit-filled experience of *Up* that I shared with my wife. In the short time since I penned the introductory words to this book, we discovered that my wife was pregnant once again. For the third time we are now expecting the arrival of our first child. And

while our hearts and minds are filled with equal amounts of elation and uncertainty, of one thing we are sure: this particular joy is most certainly in spite of something. For, like Job, we are confronted daily with the harsh reality that, while life is indeed beautiful, it is also fragile. The various kicks, hiccups, and seemingly random movements of the daughter that we can feel growing beneath my wife's skin are, for us, simply the embodiment of all that is lovely and good with this world. She has broken into our lives like a joyful melody in the midst of a mournful dirge. Yet, given the certainty of suffering and death that we know all too well, we can do nothing more than receive these moments as a gift. In a way, this makes both her life and the profound love I already feel for her all the more mysterious. Just as the author of Ecclesiastes says, "As you do not know the way the spirit comes to the bones in the womb of a woman with child, so you do not know the work of God who makes everything" (Eccl 11:5).

It was indeed this mysterious, creative Spirit whom my wife and I met while watching and listening to *Up* on its opening night. At the time, it did not dull the pain of our loss, nor did it make the absence in our lives any less present. But somehow, as the film's dominant leitmotiv rang out in the midst of an otherwise darkened theater, we began to hear the gentle and diffused sound of hope—a hope rooted not in the state of things as they are, but a hope in that moment when God's Spirit will be wholly present in the created order. For it is only in that day when God's very self dwells with humanity (Rev 21:3) and, in turn, we too encounter God's presence in its fullness that "death will be no more; mourning and crying and pain will be no more" (Rev 21:3-4). Perhaps, then, the music in Pixar's film simply invited the two of us to experience affectively, albeit briefly and obscurely, a reality that is one day to come—a day in which we will not only see but we will also hear the images of God's unbridled love for us.

3

THE FORM OF FILM MUSIC

With a bit of playful abandon, we opened our discussion with a demonstration of the ways in which film music presents us with possibilities for theological dialogue that would otherwise remain inaccessible. In the midst of this extended illustration, we intentionally set aside a detailed examination of the interpretive methodology that allows us to unpack the power and meaning of music in film. However, in the current chapter we address this methodology more directly by considering not only *how* we might attend to music as an essential part of our theological engagement with film, but also *why* we should do so.

As I suggested in our consideration of Pixar's films, music contributes something integral to both the form and the experience of narrative film. Yet I also intimated that music possesses a unique capacity for raising theologically pertinent questions and presenting us with theologically informed conceptions of life and the world. Therefore, in an effort to expound upon and even bolster these claims, I want to outline a few basic approaches to film music analysis that will provide us with the necessary means for arriving at a more robust understanding of how music functions meaningfully and, thus, theologically in our encounter with film. However, given the current dearth of theological reflection on film music, it seems that we are in need of more than simply a musically aware

methodology. We first need a cogent argument for why we should pay any attention to film music at all.

WHY FILM MUSIC?

Because Film Is Audiovisual: A Historical/Ontological Rationale

Often, those who discuss the importance of music in film begin with an almost perfunctory reference to the now clichéd adage that "silent film was never silent."[1] Presumably, they focus on the silent era not only because it is here that the affinity between music and the moving image is apparently made most evident, but also because it explains in part why music has perdured in contemporary film. If film was birthed in music, so the argument goes, then we can safely assume that music is, and always has been, an indispensable element of film, "silent" or otherwise. Thus, any historically informed approach to film would likewise assume not only the centrality but also the ubiquity of music in the cinematic experience throughout time.

Interestingly, certain notable film historians have recently contested the notion that silent cinema was "never silent," suggesting that actual film exhibition practices were quite diverse.[2] However, even if we take these historical critiques into consideration, the simple fact remains that many of the earliest films were indeed accompanied by music—and intentionally so. Despite arguments to the contrary, music was not incorporated into film exhibitions simply to drown out the distracting noise of early projection equipment or to quell the fears of a primitive audience.[3] Rather, music played a fundamental role in the exhibitions themselves. For example,

> "[o]n 28 December 1895 the Lumière brothers presented, for the first time ever, a series of short films to an audience at the Grande Café in Paris. At this screening a pianist also provided the first musical accompaniment for a film, and

from that moment on films have had a not-so-silent partner of musical accompaniment."[4]

While it is important to recognize that not every exhibition contained musical accompaniment of this kind, music was at the very least *involved* in the screening of films from the advent of the cinema.[5] What is more, these exhibition practices were in fact relatively stable, especially within individual institutions such as vaudeville, musical theater, and traveling lectures. Indeed, immediately following the Lumière brothers' first screening in 1895, music was routinely featured during public film exhibitions of various kinds and in diverse contexts.[6] It therefore seems that we are justified in speaking of a relatively constant and equally pervasive impulse within the emerging industry to include music in film exhibition—an impulse that was not only present at the birth of film but was quickly recognized as standard practice. In other words, even in spite of radical changes in technology, aesthetic sensibilities, and economic concerns, the one thing that has remained consistent is that, from the time of the first film exhibition in 1895, "music and movies have been all but inseparable."[7]

Although space precludes a full consideration of film's origins and its historical development, the history of film music deserves our attention because this narrative implicitly invites a theological response. Time and again, music seems to force its way into the cinematic world as a central element in the filmic experience. Yet, historical accountings alone are unable to answer the larger questions that continually arise regarding the relationship between music and moving images: Why do humans so often derive significance from experiences in which music is present? What is "missing" from film that music somehow supplies? Why do we "need" music at all?

In addition, the historical development of film music raises important questions concerning the very "being" of film as an artistic medium. In fact, one of the basic motives for incorporating a musical analysis in theological

engagements with film has to do with what film essentially "is," and thus, the fundamental manner in which filmgoers perceive and experience movies. We are concerned here with a seemingly simple question: "What is cinema?"[8] Yet in seeking an answer to this question, many have noted the supposed "visual" bias that pervades contemporary culture—an epistemological privileging of seeing over hearing: "To say 'I see,' after all is to mean that one knows or understands, whereas 'I hear you' implies less a rational comprehension than an empathetic, emotional form of agreement."[9] Thus, any discussion of the cinema's ontological constitution must take into consideration the visually oriented assumptions of our broader filmgoing culture.

Recently, though, a handful of filmmakers and film theorists have worked to correct this image-bound understanding of film. Michel Chion, a French composer, filmmaker, and film studies professor, is a key figure in this shift toward a more sound-oriented conception of the cinema. Chion contends that film is fundamentally an "audiovisual" medium. Rather than simply addressing the eye, movies place the "audio-spectator" in a specific mode of perception, which he terms "audio-vision."[10] Even though no "natural" relationship exists between the images and sounds that together comprise our cinematic experience, audio-spectators willingly enter into a kind of symbolic relationship known as the "audio-visual contract."[11] By consenting to the terms of this contract, the audience agrees to accept that the images located on the screen and the sounds emanating from the theater's speakers form a single entity. In short, audiences do not simply see and hear a film, they see/hear it.[12]

Thus, Chion claims that the primary relationship between image and sound is one of "added value"—a uniquely audiovisual event in which sound enriches a particular image.[13] Furthermore, for Chion, added value works reciprocally. That is, "[s]ound shows us the image differently than what the image

shows alone, and the image likewise makes us hear sound differently than if the sound were ringing out in the dark."[14]

On the one hand, Chion is putting forth a distinctly audiovisual conception of film. Yet, on the other hand, his work betrays an ontological ambivalence. That is, even while he advances the notion that film is fundamentally audiovisual, from an ontological perspective, "film sound is considered as a 'plus,' an add-on."[15] The image, then, maintains aesthetic centrality and ontological primacy over and above sound. For Chion, film is essentially a medium comprised of "images, plus sounds."[16]

To be sure, Chion's insights are helpful insofar as they highlight the importance of sound in our understanding of what makes a film a film. Yet his concept of added value is implicitly reductive. In seeking an abstracted theory to determine what is "essential" to film, Chion unnecessarily overlooks the fact that, historically speaking, cinema has been accepted and understood as an ontologically audiovisual medium. In terms of the audience's perceptions and concrete experiences, film is not solely auditory, nor is it simply visual; it is both. In other words, the sound/image relationship is not reducible to the "value" that sound "adds" to the image. Rather, this relationship gives rise to something new in which neither element is fundamentally prior to the other.

Consequently, I am suggesting that a film is not a mere aggregate of various cinematic elements; it is a wholly new synthesis that issues from the dynamic interaction between the images we see and the sounds we hear.[17] And if theology is to take seriously film's ontological constitution as both "pictured" and "heard," it must not simply "add" sound to its analytical and interpretive repertoire, but must first broaden its understanding of what a film "is." For, by recognizing film's ontological constitution, we are not merely enlarging our methodologies but fundamentally reorienting them toward a conception of film as an essentially audiovisual medium.

Without this basic awareness regarding sound in general and music in particular, we are not only failing to approach film qua film, but we are also failing to capture fully the theological significance of how meaning is truly made in the cinematic experience. Ultimately, then, we must turn our attention more fully toward film music because, from both a historical and ontological perspective, film is a thoroughly and irreducibly audiovisual medium.

Because Film Music Is "For" the Audience: A Functional/Phenomenological Rationale

If our first answer to the question "Why film music?" has to do with what a film essentially *is*, the second rationale focuses on how music *functions*.[18] Here we are not only concerned with how music functions in the construction of a film's narrative world, but also with how film music creates a "point of experience for the spectator."[19] In other words, we are interested in the cultural-aesthetic space where film and audience meet. Thus, our interests are not only formal but also, and perhaps primarily, phenomenological.[20]

As the history of film suggests, music has enjoyed a long-standing relationship with moving images. Consequently, throughout film history various practitioners and theorists have attempted to categorize the manners in which music functions in film. As early as 1949, Aaron Copland—a composer who produced myriad film scores—suggested five general ways in which music functioned in classical film:

> (i) it conveys a convincing atmosphere of time and place;
> (ii) it underlines the unspoken feelings or psychological states of characters; (iii) it serves as a kind of neutral background filler to the action; (iv) it gives a sense of continuity to the editing; (v) it accentuates the theatrical build-up of a scene and rounds it off with a feeling of finality.[21]

It is important to note that these five categories essentially amount to an informal, analytic heuristic for Copland. That is,

these functional categories serve as a framework for interpretation—a particular mode of analyzing and construing both a film's music and the film as a whole.

However, as the medium of film has developed over time, so too have the interpretive frameworks that practitioners employ in order to both understand and capitalize upon the function of film music. Whether it is Roy Prendergast—a composer who seeks to shed light on the aesthetic value of what he believes is a "neglected art"[22] —or Claudia Gorbman—a highly influential film music scholar who suggests that music constructs filmgoers ideologically by promoting the audience's unwitting absorption into the film's narrative[23]—composers, musicologists, filmmakers, and cultural critics alike have attempted to identify the various manners in which music functions meaningfully in contemporary film. Some begin with Copland's earlier categories and then expand upon them, thereby identifying every potential manner in which music might be used. Others seek to distill film music's functions into three or four general but more manageable categories.[24] These ever-expanding and -contracting lists are helpful insofar as they highlight film music's remarkable utility in the construction of cinematic meaning. However, they are also helpful in that they underscore the various ways in which film music exists "for" audience members and their surrounding world, and not simply for the characters and the world of the narrative. That is, music has the ability to turn away somehow from the film and toward the audience, toward "us."

In order to clarify this notion of music existing "for" the audience, I would like to draw our attention briefly to one particular function of film music that seems to pervade all categorizations both past and present, namely, the evocation, signification, and communication of emotion. Due to the difficulty of speaking of filmic emotions in a convincing manner, the significance of music's affective resonance often goes underdeveloped in the film music discourse. Yet, at the same

time, music's capacity both to signify and evoke human emotions is almost taken for granted. Practitioners, theorists, and audiences alike simply assume that music invests film with an emotional depth that it would otherwise lack. From Copland's notion that film music "underlines unspoken emotions," to Prendergast's claim that music increases our "affective response," to Gorbman's concept of music as a "signifier of emotion," in nearly every accounting of how music functions in film, it is generally accepted that music is one of the primary sources of cinematic affect. Some have even suggested that we should reclaim this common thread in our analyses of film, for "music underlines, emphasizes, inflects, underscores the deepest levels of film, structural and emotional."[25]

From a formal or structural perspective, music certainly underscores that which would otherwise be inaccessible to the audience, namely, the emotional and psychological state of the film's characters. Yet, more than simply relaying to the audience *what* the film's characters feel, music tells the audience *how* they are to feel in the cinematic experience. More precisely, film offers filmgoers an "invitation to feel."[26] Rather than insisting on a particular meaning, music invites, persuades, and encourages. It always seems to offer the audience a choice. In doing so, music demonstrates its capacity to exist "for" the audience, for it serves as "the communicating link between the screen and the audience, reaching out and enveloping all into one single experience."[27] As music encourages our emotional response, we are invested in the film's narrative world. Therefore, film music functions not simply to enhance the film's ability to tell a story, but as an affective point of contact for the human beings experiencing that story.[28] It imbues the film with a distinctly affective meaning and, thus, a significance that is deeply rooted in the human condition.

To be sure, this functional/phenomenological rationale is connected to the various ways in which music functions as a

part of the film's formal, narrative structure. Yet, in the final analysis, we are emphasizing the role that music plays in the audience's *experience* of film. Therefore, we are able to suggest that, first and foremost, it is essential that theology develop an appropriate understanding of film music, not only because music is a central element in film's ability to tell its story, but also because music is one of the primary means through which the audience is "fused" with a film and thus shaped by the cinematic experience. When film music "works," our awareness of the world is augmented and, at times, transformed. And whether we construe this identity-shaping effect as salutary or not, without a musically aware approach to film our understanding of this (trans)formative power remains incomplete and inadequate.

Moreover, an analysis of film music's function highlights the phenomenological nature of meaning making. That is, in light of the fact that film music functions at once formally and phenomenologically, its very presence demands that we avoid purely formal analyses and ask questions concerning the film's reception. This turn toward reception suggests that musical analyses have the potential for grounding our interpretations in the concrete experience of film. And by not attending to music, we risk engaging in needless and, at times, misleading abstractions.

Finally, it is vital that we pay more attention to film music because, as we noted above, music is almost universally recognized as one of the primary carriers of emotional meaning. Although there is little agreement on exactly why and how music functions affectively, most agree that music plays a significant role in the audience's emotional engagement with a film. These emotions are accepted and understood as being related in some manner to the power, depth, and meaning that audiences derive from film. Thus, as it often functions expressly "for" the audience, music provides theologians with a helpful key for understanding a film's emotional power and,

thereby, the deeply human meaning that contemporary persons derive from the cinematic experience.

Because Film Music Is Ineffable:
A Theological Rationale

The case I am attempting to make for a more musically aware approach to film has been relatively straightforward up to this point. In short, because film is inherently audiovisual and because film music so often functions "for" the audience, we would do well to attend to music as we engage films theologically. Doing otherwise necessarily inhibits our understanding of both the formal meaning of particular films and the phenomenological power of filmgoing. However, the final rationale I offer for why theologians should pay attention to the music in film has to do with the ways in which film music is capable not only of confronting filmgoers with innately theological questions, but also of expressing theologically informed understandings of life and the world. For, regardless of the particular conceptions or methodologies one might employ in an attempt to understand film music more fully, "nearly everyone agrees that film has substantial aesthetic (or, at least, cognitive) constraint; therefore, music supplements something missing from mechanically reproduced image and sound."[29] Music contributes "something" to moving images—"something" that continually exposes our linguistic and conceptual limitations. And in doing so, music engenders a theologically informed shift in our understandings of both film and the cinematic experience.

Music effects this theological shift in three unique but related ways. First, music expresses that which lies "outside" or "beyond" representation; it imbues film with a "suprareality," granting the audience an "insight" not obtainable through the image's natural mode of representation.[30] Thus, music exposes the limits of representation by indicating what otherwise cannot be represented. As we wrestle with this seemingly intrinsic capacity of film music, we are compelled to ask, "[W]hat is it

about music that has this power? . . . Why has it been regarded since Plato as having privileged access to the soul? Why are 'depth' and 'inner truth' evoked in accounting for the effect of music?"[31] Generally, most film music scholars account for the nonrepresentational excess of music (i.e., its "power" and "depth") through psychoanalytic theory. Yet what is interesting is that they are compelled to give an account of anything at all. For it would appear that film music's ability to expose the limits of representation inevitably leads filmgoers to construct narratives (psychoanalytic or otherwise) that address that which lies beyond our representations. That is, it effects a shift in both our language and our conceptual frameworks, drawing audiences into a decidedly theological realm of meaning making.

Second, music, more so than any other filmic element, points to that which is not present or that which cannot be contained by the image. That is, music addresses the ineffable—that which our language and conceptual frameworks are unable to contain but, which, nevertheless, yields a categorical power over our lives. In certain instances, film music is able to suggest the presence of "vastness" and "grandeur."[32] However, music also has the capacity for engendering an experience of communality.[33] It somehow "cements" our selves to the narrative, and bonds individual audience members to each other. This experience draws so near the ineffable that some even speak of music's "magical" quality—its ability not only to exorcise the audience's fear at seeing "living effigies" who are utterly silent, but also to fuse individuals to one another through the intoxicating effects of synesthesia.[34] Thus, as it points to the presence of an unspeakable and unknowable "vastness," or the quasimagical power of a communal experience, the music of film directs filmgoers toward an overtly theological construal of their cinematic experiences.

Finally, film music is called on to fill in "spiritual" gaps or to suggest a mythical force in the world. We might speak of

this function of music in terms of a "restoration of plentitude." By restoring this perceived "lack" in the medium, music floods each film with a sense of human "wholeness." It supplies the film with a sense of fullness and humanity, filling the spiritual gaps inherent in the image.[35] Indeed, the very presence of sound is often described as "adding life to the picture."[36] Yet, upon closer inspection, the "life" that music provides must be located in the realm of mystery, for it communicates a meaning that we are unable to analyze. Rather than operating in a straightforward or obvious manner, film music functions to signify a mysterious life that pervades the whole of our experience. By filling the image with this "mysterious life," music is able to function mythically, signifying what lies beyond signification. It can even "intuit connections that are beyond immediate rational comprehension."[37] In doing so, film music routinely provokes what can only be described as theological reflection. That is, it does more than simply raise existential questions that require theological "answers." Rather, it functions in an intrinsically theological manner, confronting audiences with spiritually, mythically, and, indeed, theologically informed understandings of life and the world.

That music is recognized as already functioning in this decidedly theological manner is reason enough to integrate an analysis of music in our engagements with film. However, when combined with the historical/ontological and functional/phenomenological rationales that we have developed, it would seem that a consideration of music in film is not simply advisable but essential. By neglecting film music, theologians are simply overlooking one of the central elements through which film produces meaning. Yet, if we were to turn our attention more fully to music, we would not only be capable of offering more robust interpretations of particular films, but we would also come to a fuller understanding of the cinematic experience and its theological significance for contemporary life. Thus, in light of this final theological rationale, it would

appear that the answer to the question "Why film music?" has been readily available to us all along. For, as Chion—a film-maker playing the part of a theologian—suggests,

> The movie screening proposes in this way a new ritual [i.e., the ritual of the music-filled closing credits] that we should not take lightly: in a world that rarely allows us time to take stock of things, here is a moment that has been left open, a sort of airlock between the temporalities of the film and that of daily life. . . . One of the few remaining places where we still can experience something religious in our relation to the work of art is a movie theater.[38]

A MUSICAL APPROACH TOWARD THEOLOGICAL DIALOGUE

As each of these rationales makes clear, music plays a vital role in both the form and experience of film. Theologians are therefore in need of more than an ad hoc method of analysis and interpretation that attends to film music only in those moments when it is so pronounced that it is impossible to ignore. That is, we are in need of a conceptual framework that will not only reorient our understanding of what constitutes contemporary film and filmgoing, but one that will also provide a common vocabulary for speaking of the function and significance of music in particular films. Thus, I would like to outline a few basic types of film music analysis that, together, provide us with a new starting point for engaging film theologically.[39] For the purposes of clarity and to highlight the somewhat intuitive nature of this approach, I will organize these modes of interpre-tation into three broad, interrelated categories: "The Contex-tual," "The Affective," and "The Musical Other."

As we consider each of these approaches, I will offer con-crete examples from three particular films, namely, *Ameri-can Beauty* (1999), *Magnolia* (1999), and *Watchmen* (2009). I have chosen these particular films not only because they offer salient examples of how music actively contributes to both

the form and experience of film, but also because a number of others have already identified these films as sources for theological reflection. As such, they provide us with a common point of departure for considering the ways in which our musically aware approach might enhance our theological dialogue with film.

However, as we proceed, we must remain cognizant of two related concerns. First, as I mentioned above, the highly technical vocabulary of musicology serves as one of the primary reasons that theologians have a tendency to neglect or overlook music in film. Thus, our primary aim will be to highlight modes of analysis that have the potential for being readily understood by those lacking specific musical training. Secondly, in light of our emphasis on the reception of film music, we are primarily concerned with what audiences hear in their experience of a film rather than how music is composed.[40] Thus, we will address only those compositional features that most directly impinge upon the ways that audiences hear film music.[41]

These modes of analysis are not intended to be rigid rules by which we come to definitive conclusions regarding the function and meaning of music in film; neither are they intended to be wholly comprehensive. To be sure, film music functions in myriad ways, many of which we will not address here. Yet, the particular music we hear in the midst of our concrete experience of individual films (and even individual segments of films) will invite certain modes of analysis, while other approaches will likely prove to be less than helpful. Consequently, there is no set procedure or program controlling our analysis. What is more, these various analytical approaches are not mutually exclusive; they can and should be used in creative combinations. In an important sense, then, I am outlining a distinctly heuristic framework—one rooted in a process of discovery, trial, and error. Yet, ultimately, I offer these approaches toward film music analysis in the hopes that they

function as a collaborative point of departure for those who desire to engage film music theologically—a point of departure that, in future considerations, may very well require development, critique, or even abandonment.

The Contextual

Of the many ways we might approach film music, certain modes of analysis highlight the fact that music is not only an integral element in the formal structures of a film, but is able to make this integral contribution because it is fundamentally related to the larger musical-cultural context in which the audio-viewer is located. These modes of analysis underscore the embedded and contextual nature of both film and filmgoing, suggesting that we cannot reduce our understanding of film music simply to a "text" or an isolated figure. In other words, we always hear films as situated hearers.

A worthwhile starting point for developing our understanding of the contextual nature of musical meaning would be to consider a film's style topics. Indeed, analyzing film in terms of its use of style topics is a helpful approach because, generally speaking, style topics "are the most common analytical categories used in non-specialist writing about film music, and rightly so."[42] The reason style topics are the most frequently employed category for musical analysis is that they explicitly trade on highly conventionalized and stereotypical musical forms. In fact, filmmakers often depend upon style topics to represent or signify a particular mood, place, or emotion. Musical stereotypes of this kind are so deeply ingrained in our cultural imagination that the briefest allusion to a style topic has the capacity for evoking very predictable interpretive responses from an audience. For example, "A gap-scale tune soaring over a widely spaced chord immediately conjures up images of the untamed West; an anguished atonal cluster portends the monster behind the door; while the sultry wail of a lonely saxophone inevitably marks the entrance of the femme

fatale."[43] Thus, by analyzing style topics, we are not only able to speak more convincingly about the ways in which conventional music functions in film, but we are also made aware of music's capacity to signify on multiple levels simultaneously and to draw meaningful connections between the film itself and the film's cultural context.[44]

Yet, in addition to this somewhat conventional function, music can also lend to the images "a sense of necessity" and provide the film with a "distinctive and definitive shape."[45] That is, music plays a key role in the overall design or form of a film. Indeed, the manner in which music is distributed across a film raises important interpretive questions concerning the relationship between musical form and film form. And while music can certainly affect the large-scale design of a film, from the perspective of the audience, music's formal impact is most often noticeable in the small-scale unity it imposes on a film. The structuring of montage sequences is perhaps the most common way in which music is able to contribute to a film's formal unity. In *Watchmen*, for example, music provides the opening montage with a cohesion that it would otherwise lack. Bob Dylan's "The Times They Are A-Changin'" not only unifies the disparate images thematically, but it also functions as a temporal frame, affording the sequence a "natural" beginning, middle, and end.[46] Without the music, the repeated cuts from one image to the next would lack both coherence and purpose. Thus, as it imposes small-scale unity on montages, music provides the seemingly random juxtaposition of images with formal and narrative meaning.[47]

In addition to providing smaller sequences with a sense of cohesion and time, music often functions as a film's formal frame. For instance, main title and end credits cues "separate the film's time from its surroundings and thus ease the viewer/ listener into and out of the alien temporality of the filmic narrative."[48] By analyzing music on this level, we can identify the manners in which music functions to establish the film's

mood and genre and, as it often flows smoothly into the film's establishing sequence, the way in which it provides a buffer between the outside world and the world constructed by the film's narrative.[49] As a formal frame, music draws us as film-goers into a narrative world and orients us toward the film's story. Moreover, as it accompanies the closing credits, music ushers us back into the "real" world and, at times, reminds us to purchase a soundtrack album on our way out.

In traditional practice, movies typically opened with a main title sequence accompanied by music—a practice that many contemporary filmmakers have continued. Thus, variations to this conventional manner of framing a film are significant. Interestingly, none of the films we are considering in this chapter (*American Beauty*, *Magnolia*, and *Watchmen*) begin with a main title sequence. Rather, each film opens with a "prologue" that precedes the main title proper—a sequence figuratively set apart from the rest of the filmic narrative. While each film supplies integral narrative information in its prologue, these segments stand on the "wrong" side of the diegetic buffer; they exist in the temporality of the "real" world. They confront the audience at a moment when they are not yet fully prepared to engage with the film's story. Thus, these prologues anticipate what is to come and serve as a riddle of sorts—an unanswered question that eventually reemerges through the course of the film.

Yet, while all three films employ a prologue, they each move subsequently into a traditional main title sequence featuring strongly foregrounded music. In each case, music serves as the film's formal frame, but it does so in relation to that which precedes it. As the main title music "eases" the audience into the filmic temporality, vestiges of the seemingly unmoored prologue follow along, shaping both our understanding and our experience of the remainder of the film. Therefore, as we seek to offer a description of the manner in which music is distributed across a film, and how this distribution affects

our theological engagement with film, we must recognize that music's meaning and function are not autonomous, but are intricately connected to both the film's form and the larger cultural context in which the audience's filmgoing is located.

The Affective

The second category with which we are concerned has to do with the particular ways in which music is able to function affectively in both the form and the experience of film. This mode of musical analysis grants us interpretive access into that which often goes unspoken or unseen, namely, the film's tone or mood, the inner workings of a character's psychology, and even the filmgoer's empathic bond with the narrative and the individuals who populate the cinematic world.

The most common and, perhaps, most easily abstracted mode of traditional musical analysis is related to *pitch relations* and their pattern of recurrence through musical time.[50] While this mode of musical analysis often fails to account for the diverse manners in which music functions in narrative film, it still offers a number of insights concerning how we might understand the dramatic function and emotive "power" of music. Thus, two broad categories remain pertinent in regards to the pitch relations of contemporary film music: major versus minor and consonant versus dissonant.[51]

By analyzing and interpreting music according to its major and minor modes, we are primarily concerned with the affective dimensions of film music. This affectivity is related both to the inherent chromaticism of the minor mode and to a series of "cultural musical codes" that are present in every musical exhibition.[52] That is, on the one hand, the minor system both mirrors and draws analogies from the major tonal system, which contributes to its cultural associations with melancholy and sadness. Yet, at the same time, audiences understand and interpret music's contribution to film—whether in a major or minor mode—according to their learned, enculturated

response to music. Thus, by analyzing film music in terms of the major/minor distinction, we are not strictly concerned with the acoustical foundations of these modes. Rather, we are interested in the ways in which music functions as a signifier of emotion within the filmic narrative, as well as the ways in which contemporary persons derive affective meaning from this music. For, regardless of exactly why it does so, the simple fact remains that "in the West tonal music in the minor mode tends to evoke the darker, or at the very least the more serious, side of human emotions . . . [whereas] the major mode . . . ties in with a greater sense of stability and order."[53]

In a similar fashion, the consonance or dissonance of a film's music is also related to issues of affect and, thus, offers further insight into music's distinctive contribution to the particular film in which it is heard.[54] In many cases, the consonant/dissonant pair is strictly, and thus inappropriately, associated with either tonal or atonal music. While atonal music is often rife with apparently unstable figures, atonal dissonance functions uniquely in comparison with the dissonance that occurs in tonal music. More specifically, tonal dissonance points toward some kind of predictable resolution or a discharge of tension, whereas atonal dissonance suggests no such resolution.[55]

In *Magnolia*, for example, the majority of the music is largely tonal. Yet, as the film's prologue demonstrates, atonal dissonance serves a slightly different purpose than tonal dissonance. In contrast to the rest of the film, the underscoring in the prologue is a fragmented amalgamation of sound effects, diegetic noise, and atonal music, much of which is hardly audible and, seemingly, without a discernible, tonal "meaning." In conjunction with the film's "newsreel" footage of a series of "strange-but-true" stories, this highly dissonant music invests the film with a sense—a "feeling"—of alienation and incomprehension. Its lack of any tonal center highlights both the characters' and the audience's desire for meaning in the midst of apparent meaninglessness. Thus, much like its major/minor

counterpart, an analysis that focuses on music's consonance or dissonance is primarily concerned with the affective contribution that music makes to both the film's narrative and the audience's cinematic experience.

This example of atonal music presents us with another helpful avenue for understanding music's affective contribution to film, for film music often derives its meaning not simply from the musical characteristics of its pitch relations, but from *how* a piece of music sounds, that is, its *timbre*. Timbre, or music's distinct "coloring," serves as one of the key elements in how film music expresses a particular mood or emotionality. However, it is important to keep in mind that the timbral qualities we hear in a piece of film music are typically not the result of a purely musical development but, rather, function as a narrative device.[56] In other words, these various musical colors aid in the construction and communication of the film's story. Although the slightest musical change of any kind can have a significant effect on timbral qualities, four categories most directly impact musical color in film: volume, pitch, orchestration, and texture.[57] Even without adjusting the basic tonal structure of a piece of music, a change in any one of these categories often functions in a coloristic manner, "brightening or darkening the mood [of the film] rather than coherently shaping the large-scale tonal motion."[58]

In *Magnolia*, the musical figure titled "Stanley/Frank/Linda's Breakdown" offers an interesting example of the influence that timbral changes have on a film's narrative and, by extension, its mood. As it provides the underscoring for the moment in the film in which Frank, Linda, and Stanley all experience some form of psychic fissure, the music is appropriately titled. Yet, from the perspective of the narrative, each of these "breakdowns" is distinctly different. Frank is exposed for lying about his relationship with his mother and father and for refusing to accept that his troubled past has definitively shaped his present circumstance; Linda is overwhelmed by

the grief she feels over the imminent death of her husband, whom she originally married for money but now deeply loves; Stanley finally wilts under the dual pressures of his childhood celebrity and his demanding father. As the music underscores each of these breakdowns, the subtle changes in color not only reflect the narrative tension, but they encourage a particular mode of audience identification.

The music begins as Frank's interviewer poses the question, "Why would you lie, Frank?" We first hear the rhythmic "clinking" of a xylophone over a sustained, synthesized bass note in an exceedingly low register.[59] The texture of this music is somewhat busy, and the volume rises slowly. Here, the mood set by the music is dark and brooding and suggests that, like Frank, something is percolating beneath his façade of defiance and obstinacy. The scene eventually moves to Linda as she pleads with her lawyer to remove her name from her dying husband's will. The xylophone drops out, and the synthesized bass is replaced by threatening horns sounded in a low register. As she passionately confesses her marital indiscretions and her newfound love, we begin to hear thickly textured strings played at a medium pitch, which, through a change in musical color, mirror the mood of Linda's regret-filled desperation. As the scene shifts to Stanley's breakdown, the music continues its progression from a busy to a thick texture, from brooding to anguished orchestration, and from a low to a high pitch. Here, the mood of the sequence reaches its dramatic peak as the strings move to a noticeably higher, and almost stricken, register. In light of the other narrative information we have received regarding these characters, we recognize that the music exhibits this plaintive coloring because Stanley is the most innocent of the three, and, thus, his breakdown is the most painful to watch. In other words, the music suggests that, unlike Frank and Linda, Stanley is truly a victim.

Through simple changes in timbre, *Magnolia*'s music establishes an affective orientation toward each of the characters'

emotional upheavals. Moreover, as the narrative reaches its dramatic height, the music actually guides the audience's process of identification. Thus, whether we approach this music in terms of its timbral qualities or its pitch relations, we are able to see how shifts in the film's musical coloring function not only to highlight significant narrative moments, but also as the means through which the audience is engaged and emotionally fused with the narrative.

The Musical Other

While each of the above approaches allows for a fuller understanding of the ways in which music contributes to film, "interpretation cannot stop at this stage without falsifying its object."[60] For film music is just that—*film* music. Thus, any mode of analysis or interpretation that fails to address music's collaborative position within the filmic medium deals only in abstractions. To avoid this kind of abstraction, our engagement with film music must involve a consideration of music's relationship with the rest of the film's system, that is, its narrative context.[61] Yet, when pressed with the question of how music relates to the world constructed by the film's narrative, we quickly recognize that music often operates in a realm that is distinctly "other"—a realm that lies beyond the camera's limited frame of reference.

The *leitmotiv* is perhaps one of the most readily accessible examples of how music is able to speak from this realm that exists beyond or outside the images we see. Indeed, given their symbolic power, leitmotivs are one of the most common devices for structuring a film score on a large-scale level.[62] In essence, a leitmotiv is a particular musical phrase or "theme" that is presented and then developed within a film.[63] Often, these independent musical themes are employed simply to signify a specific character or place in the film. But leitmotivs are also capable of overdetermining the meaning of the images we see, reducing the musical figure to a simplistic, symbolic

signpost.[64] In doing so, the leitmotiv potentially undermines the nonrepresentational discourse of music by forcing it to function essentially as language—a system of signification that represents directly and thus, when combined with a film's images, redundantly.

Yet, while leitmotivs are sometimes employed in clichéd and overdetermined manners, this is neither always nor even usually the case. In certain instances, a leitmotiv can actually break free from the constraints placed on it by the image and the narrative, indicating a presence or force not in the image.[65] The marimba figure in *American Beauty* functions in precisely this fashion. Interestingly, while we are informed at the beginning of the film that Lester Burnham is already dead, it is Lester who offers a narrative of the final year of his life. Because he is no longer living, we of course see no images or pictures of this disembodied narrator while the camera offers an aerial "flyover" of Lester's former neighborhood. Instead, we hear only his voice accompanied by the percussive rhythm of the marimba leitmotiv.[66]

As Lester continues to narrate from the grave—a location situated firmly beyond the camera's frame—the leitmotiv is able to break free from its symbolic constraints. That is, given the way it develops throughout the film, we eventually recognize that this music is not directly associated with either Lester or his past life. Rather, it points us toward a realm beyond this life—a realm where Lester's "spirit" or "essence" may in fact "reside" and, thus, a realm that surely cannot be contained or captured by the film's images. In fact, by the midpoint of the film, when Ricky, Lester's young neighbor, expounds upon the overwhelming Beauty that permeates life, the marimba is completely dropped from the orchestration. Instead, we hear plaintive strings and a lone piano.[67] Consequently, the presence and eventual absence of this leitmotiv function to articulate a large formal span in the film and point to the significance of this central scene. Yet, even more, the marimba

leitmotiv functions to mark a shift both in the character of
Lester Burnham and in the trajectory of the film itself. For, as
this leitmotiv is eventually transformed, we realize that the
presence impinging upon the narrative world—and even our
own world—is not Lester, but another presence altogether. In
this way, the leitmotiv in *American Beauty* is far from redun-
dant or overdetermined. Rather, it operates almost mythically,
and perhaps even metaphysically.

Of course, by suggesting that the leitmotiv is capable of
"speaking" from a "location" beyond the narrative, we are
purposefully drawing a distinction between diegetic and non-
diegetic music. In short, I am employing the term "diegetic"
music to denote "music that (apparently) issues from a source
within the narrative," and "nondiegetic" music to speak of
music that issues from a source outside or beyond this nar-
rative world.[68] Thus, by approaching film in terms of this
musical distinction, we are attempting to describe the unique
relationship that exists between a film's music and the narra-
tive world that it underscores.

Although popular parlance often treats a film's nondiegetic
underscoring nearly synonymously with its "soundtrack,"
diegetic music is a highly significant aspect of what audience
members hear in their cinematic experience. Diegetic music
functions first as sound; it fleshes out a film's space. Thus,
as it "sounds" within a particular space, it not only provides
basic depth cues regarding that space, but it also provides spa-
tial continuity between spatially discontinuous shots. But
diegetic music also works affectively, especially with regard to
its relationship with the narrative. That is, music can interact
with a film through either "empathy" or "anempathy." Empa-
thetic music "participates directly in the emotion of the scene,
moves in sympathy with it, envelops it, prolongs and amplifies
it."[69] However, anempathetic music "registers, with respect to
the emotionally intense situation onscreen (physical violence,

madness, rape, death), a palpable indifference, by continuing on its own impassive, mechanical course."[70]

Central to this claim is that anempathetic music, although seemingly at odds with the emotions of the scene in which it is heard, does not undercut or diminish the emotional weight of the film, but actually reinforces it. And it does so by shifting the audience's perspective "from this individual drama to the cosmic indifference of the world. . . . The music plays in spite of it all, without missing a beat."[71] While the audience endures these scenes of violence and madness, the anempathetic music continues unabated, demonstrating a complete indifference toward the unfolding events. And it is the seeming "naturalness" of this musical irony that brings about an emotional response from the audience. We may be indifferent just as the music is, or we may be empathetic toward the tragic events we witness; or, perhaps more likely, we may rail against the randomness of the universe, the mark of its apparent godforsakenness.[72] Either way, the music urges the audience to consider the relationship between the world that the film presents and the larger universe in which it is set—a world that stands outside or beyond the one depicted by the unfolding of narrative events.

In spite of diegetic music's import, however, nondiegetic music generally garners the bulk of our attention. This inclination toward nondiegetic music may be due to the more obvious explanation for the presence of diegetic music—it is bound to a particular source in the narrative world.[73] Yet the presence of nondiegetic music is less clear, especially within a medium that often favors a realist aesthetic. For the very existence of nondiegetic music poses a fundamental question: how, exactly, does this music relate to the film's diegesis? In terms of the function of diegetic music, we might answer this question by pointing to its fidelity to the diegetic world; it faithfully represents a film's space, temporality, and even the calloused

indifference of the world. However, by drawing a distinction between diegetic and nondiegetic music, the question we bring to nondiegetic music is not one of fidelity but clarity. That is, we are concerned with the manner in which nondiegetic music offers the audience a modicum of interpretive clarity.

Interestingly, though, it is the very *un*reality of nondiegetic music that allows it to clarify and, indeed, transform what audiences see and hear in their cinematic experience. It functions primarily to "grant insight into what must otherwise remain unseen and unsaid: psychology, mood, motivation."[74] Thus, nondiegetic music illuminates the image, which would not be what it is without music. Moreover, it suggests that there is more to image than meets the eye. Yet, while nondiegetic music offers the audience interpretive insights not available to us in the "real world," it concomitantly obscures the means through which this clarity is obtained.[75] In other words, nondiegetic music does the interpretive work for us by determining how we understand the film's images, but leaves us believing that the construal is all our own.

In addition to offering this interpretive clarity, nondiegetic music is also unique in its ability to signify what is not in the image at all. This function is related to what has been termed the *"acousmêtre,"* a character implicated in the film's action that is "neither inside nor outside the image."[76] That is, nondiegetic music has the power to speak from a transcendent realm beyond the image, "nowhere more so than when music represents the structuring presence of an absence: the force of the dead on the living."[77] As we noted above, the marimba leitmotiv in *American Beauty* functions in this manner. Yet, the structuring power of this particular figure is related to its work not only as a leitmotiv, but as nondiegetic music. Through the music's interpretive work, we are pointed to something, or in this case, someone who is neither inside nor outside the image. It is the very unreality of this "other" —this presence-through-absence—that allows it not only to affect the happenings

within the diegetic world, but also to offer the audience unrivaled interpretive clarity regarding the film's narrative.

Ultimately, we are making the distinction between diegetic and nondiegetic music in order to answer a basic analytical question: "On what narrative level do we read this music?"[78] This distinction helpfully informs our understanding of how music is related to the film's narrative world and, thus, the unique manners in which diegetic and nondiegetic music contribute to film. Yet this distinction is largely theoretical, and it often collapses in contemporary film. For instance, in the practices of "classic Hollywood," the nondiegetic score was typically orchestral, and the diegetic score usually consisted of popular music.[79] However, in contemporary cinema post-1960, filmmakers have increasingly employed popular, lyrical music in their construction of the nondiegetic score. Consequently, popular music has not only assumed many of the functions of classical, symphonic underscoring, but, given the ease with which it moves in and out of the diegesis, it has also revealed the highly permeable nature of the diegetic boundary.

Interestingly, popular music often functions in a strikingly similar manner to the classical symphonic score. Yet, one of the key differences between orchestral music that is originally composed for a particular film and popular music that is incorporated into a compiled score is that popular music "preexists." It "lies in the realm of the recycled, 'lived again' experience of postmodernism."[80] Thus, as we make a distinction between popular and orchestral music, we are concerned with the ways in which this music brings additional, preexisting meaning to the film. Accordingly, much like the approaches to film music that we have addressed above, we must consider its relationship with the broader cultural spheres in which all contemporary persons are located.[81]

Perhaps more than any other kind of music, filmmakers routinely employ popular, lyrical music in order to situate the narrative in a particular period of time. This music invests

the scene or the film as a whole with a particular meaning that is directly related to a specific set of contemporary cultural associations, and it does so far more effectively than orchestral music. Yet, more than simply identifying the time frame of a film's narrative, popular music also has the unique capacity to serve as a type of voice-over narration, commenting (at times ironically) on the narrative situation.[82] In addition, popular music can function as the musical aesthetic that unites a film, or even draw on the cultural discourse of style and contemporary celebrity.[83]

However, of chief importance is that, if we consider orchestral and popular music in conjunction with the diegetic/nondiegetic pair, we gain a more robust understanding of how music functions meaningfully as it moves between a film's diegetic and nondiegetic worlds. One of the directions in which music can move is from the diegetic to the nondiegetic. Known as an "audio dissolve," this type of transition is often found in musicals, where music played by an instrument in the diegesis quickly dissolves into nondiegetic orchestral accompaniment.[84] In dramatic films, though, which typically draw a clear distinction between diegetic and nondiegetic music, audio dissolves often "mark a transition from the real to the ideal realm."[85]

A musical transition of this kind occurs in *American Beauty*. As Lester watches his daughter perform a cheerleading routine at a high school basketball game, he becomes mesmerized by Angela, a nubile cheerleader who dominates Lester's highly subjective fantasies. In addition to the cinematographic shift from stark to rich coloring, we are made aware of Lester's subjective move from the real world to the ideal realm of his sexual fantasies through a musical transition—one that moves from a diegetic rendition of "On Broadway" to a nondiegetic symphonic underscoring.[86] As the diegetic music returns, we are subsequently returned to the "real" world, which is now indelibly colored by the overly

idealized world of fantasy. Thus, the musical movement not only effects a movement between the "real" and "ideal," but it also signifies a moment of distinct subjectivity.

Music can also move from the nondiegetic to the diegetic. At times, this transition simply justifies the presence of a particular piece of music in a film. With the disclosure of the music's source, its presence in the film is rationalized according to the demands of a realist aesthetic. Yet, at other times, the movement of music from the nondiegetic world into the diegesis can function as a central element in the development of the narrative. Often, the significance of this transition is related to the disconcerting effect it has on the audience.

For example, during a key moment in *Magnolia*'s narrative arch, a popular song by Aimee Mann ("Wise Up") rings out as part of the film's nondiegetic underscoring.[87] We recognize this music as nondiegetic because it has no identifiable source within the diegesis, and, as the scene shifts from one shot to the next, the music remains foregrounded at the same volume level. However, almost inexplicably, each of the disparate characters begins to sing the lyrics to Mann's song, which lends the film a kind of conspiratorial feel. Rather than explaining the presence of the music we hear, or marking a transition from an ideal world to the real world, this shift leaves us in a diegetic limbo. The music undermines the diegetic border and momentarily lifts the characters out of the diegesis. In doing so, it not only affirms the significance of this particular scene, but it also places the audience in a particularly meaningful, albeit unsettling, relationship with the diegetic world—a relationship underscored by the sudden appearance of this musical "other."

Consequently, just as it is with each mode of analysis that we have considered, by accounting for the movement of music through the porous diegetic boundary, we are able to access a number of interpretive insights that would otherwise remain inaccessible—insights that open up new avenues for

theological engagement. And while it may very well go without saying, I want to suggest that when it comes to the presence of a musical "other" that takes filmgoers by surprise and offers them unrivaled clarity regarding their surrounding world, this music is not simply inviting theological dialogue. Rather, it is *already* functioning in a manner that is profoundly and perhaps even blatantly theological.

4

THE FEEL OF FILM MUSIC

Film music is so much more than a simple tool that filmmakers use to communicate a story effectively. It is also, for lack of a better word, "powerful." Music is unique among other filmic elements in that it exists "for" the audience and, thus, has the peculiar capacity to invite, encourage, and even persuade filmgoers to respond to its call. Indeed, at first blush, music's ability to influence an audience is simply a given; most filmgoers can, and often do, attest to the ways that music holds them in its melodious grip. Yet it would seem that music's greatest strength is also its greatest weakness, for when we attempt to speak constructively about film music's power—especially its *emotional* appeal—we are faced with a number of difficulties that are rooted in a long history of both theological and ideological assumptions. Nevertheless, the argument I want to put forward in this chapter is that music's affective power is not a hurdle that we must overcome, but rather is the very means by which filmgoers are able to derive a kind of "spiritual" significance from their encounters with film. As such, film music serves as a concrete point of departure for reflecting theologically on the role that emotions play in modern persons' general awareness of the world and, thus, in their conception of what constitutes a genuine spirituality.

However, I want to suggest something more, for embedded within the theological tradition are a number of helpful resources

for developing a more robust understanding of the "affective spaces" that film music opens up and, by extension, the contemporary impulse to identify these spaces as spiritually meaningful.[1] Indeed, I am convinced that, by listening anew to some old voices in this tradition and by exploring the full breadth and richness of their insights, the Christian community might discover a number of avenues for productively engaging musical emotions rather than simply decrying or disregarding them.

THE "POWER" OF MUSICAL EMOTIONS
Theological and Ideological Difficulties

Film music is above all music, and coming to terms with the filmic experience as a musical experience is the first step in understanding how a film's score wields power over us.

—Kathryn Kalinak[2]

As we attempt to reflect theologically on the affective space that film music opens up, we do so with the recognition that our discussion is located within and directly informed by a rich tradition of theological reflection concerning not only music but also the affectivity of the musical-aesthetic experience itself. Without question, this tradition poses some difficulties for our inquiry that are rooted in a number of assumptions regarding music and musical emotions—assumptions that we will ultimately seek to develop and even challenge. For, historically, the Western theological tradition has approached music in a somewhat ambivalent manner. Although it is central to the devotional life of both individual Christians and the Christian community, many have conceived of the musical experience as problematic due to the embodied and markedly sensual nature of the emotions it arouses. Augustine is perhaps the most influential theologian whose thought displays this ambivalence toward the musical-aesthetic experience. In his *Confessions*, he often speaks of the central role

that music played in his conversion experience.[3] Yet, while Augustine often stressed the God-given value of the created order and strongly believed in the ability of music to elevate the soul toward God, he was equally concerned with the sensual nature of musical emotions and, thus, the potentially harmful effects of music's affective power.[4]

Augustine's approach toward music is important for two basic reasons. First, his primary misgivings about music concern the inherent sensuality of the musical-aesthetic experience. And Augustine recognizes this experience as sensual because it is fundamentally emotional. It provides an occasion for the overflowing of "holy emotions." It engenders "weeping" and "tears." The highly emotional experiences that Augustine had with musical phenomena compelled him, subsequently, to elevate the rational and cognitive elements of music over and against the emotional dimensions, which, as sensual, were incapable of aiding the soul's journey toward God. Thus, Augustine's ambivalence regarding the musical-aesthetic experience is rooted in his particular theology of affect.

Second, from the Christian philosopher Boethius to the Reformers Calvin, Luther, and Zwingli, Augustine's thought has profoundly shaped the Western theological imagination.[5] Consequently, Augustine's ambivalence toward the musical-aesthetic experience remains a prominent feature in Protestant theological reflection, which maintains his suspicion of music's emotional "power." Taking its cues from Augustine, this theological tradition has historically operated with a deep-seated uncertainty concerning emotions and the aesthetic experiences that elicit these emotions.

Thus, it would seem that from the outset, Christian theology is neither equipped nor prepared to engage in the type of reflection on emotions and affective spaces that I am suggesting here. Indeed, in my estimation, this ambivalence concerning music's emotional "power" serves as one of the core

problematics in constructing a theology that might engage the contemporary cultural imagination.

Yet the difficulties we face are not merely theological; they are also ideological. For, whether embracing or denying any kind of theological commitment, many contemporary approaches to music operate with a combination of what might be termed "reinforcement" or "power relation" models as their primary interpretive framework for understanding the film-musical experience.[6] Reinforcement models assume that media such as film not only reflect dominant ideologies but also "reinforce" these ideologies through hidden and even subconscious means. Power relation models, however, assume that film not only reinforces ideologies but also overwhelms audiences by captivating, fascinating, or mesmerizing them. When viewed negatively, these models suggest that, in overpowering audiences, media do not simply reflect but actually perpetuate harmful ideologies in the broader culture.[7] In other words, the "power" of music is construed as something that is primarily destructive.

One of the reasons for why these particular frameworks dominate contemporary conceptions of film music's power is that they align with the basic assumptions of "critical theory"—a tradition of thought that is highly influential both on a popular level and among film musicologists.[8] Because critical theory locates the analysis of film (or any cultural form) within a "context of wider social structures, and wider cultural processes of power, ideology, oppression, and mystification," critical theorists seek to expose and see beyond the hidden workings of ideology in everyday cultural and social life.[9] That is, they attempt to reveal the ways in which contemporary persons "uncritically" embrace these harmful and oppressive ideologies and, thus, disseminate a series of beliefs and interpretations of the world that have a deleterious effect on human life and culture.[10] In the terms set forth by critical theory, the music of Hollywood films is particularly effective at imposing

itself upon otherwise passive audiences because it operates "transparently." By effacing its constructed nature and thereby escaping the direct attention of the audience, the music in Hollywood films encourages individuals to confuse ideology with reality. Filmgoers are in effect "duped" by the "invisibility" and the supposed "naturalness" of music's presence in film.[11]

Interestingly, though, as we have already noted, there is an almost universal recognition among filmmakers, theorists, and filmgoers themselves that, from both a formal and a phenomenological perspective, one of film music's primary functions is to engage audiences emotionally. Yet, when viewed through the lens of critical theory, the emotions that film music evokes are construed primarily in terms of their ideological function. As it "bathes the listener in affect," music creates a type of affective space that audiences enter, but it is a space that can only construct audiences ideologically.[12] In other words, it is not really a "space" at all, for music essentially "fills up" the cinematic experience with a predetermined and ideologically motivated meaning. Through its emotional appeal, music lowers the audience's threshold of belief and increases the spectator's susceptibility to suggestion. Even more damning, because of music's transparency, filmgoers are wholly unaware of the fact that they are uncritically consuming these oppressive and harmful ideologies.[13] Thus, music affectively fuses the spectator to the spectacle and, in doing so, overpowers the audience.

On the one hand, by drawing upon reinforcement or power relation models, we are helpfully reminded that the practice of filmgoing is necessarily located within larger structures of ower, and is therefore implicated, sometimes uneasily, in these power structures. Yet, on the other hand, for reasons that will become readily apparent, we need to identify an interpretive framework that allows for a more robust understanding of film music's affective appeal—a framework that attempts to construe the power of music more *positively*. Critical theory certainly has a contribution to make, but it does not adequately

reflect the fundamental commitments of our project, for it fails to address the full scope of film music's deeper significance, which is to say nothing of its apparent "spirituality." Thus, the argument I want to make regarding film music's emotional power is that, despite its historical ambivalence, the theological tradition provides us with a number of resources for understanding this contemporary phenomenon in terms of its *value* for human life and spirituality. To bolster this contention, though, we must move from a largely theoretical discussion concerning interpretive frameworks and speculative theological categories to a more concrete examination regarding the ways that film music moves us, inspires us, and even, on occasion, offers us an invitation to feel.

MOULIN ROUGE!
Music as Ideology or Source of Salutary Meaning?

As we attempt to understand film music's emotional power more fully, Graham Ward presents himself as a helpful dialogue partner.[14] In particular, his analysis of Baz Luhrmann's *Moulin Rouge!* (2001) sheds a unique light on our discussion, and it does so for a number of reasons. First, Ward interprets the film primarily through the lens of critical theory, operating with many of the same assumptions we briefly outlined above. Second, though, Ward is a theologian who is contributing to the ever-expanding discourse concerning the relationship between theology and film. That he is also involved in the "radical orthodoxy" movement is not incidental, for it is in critical theory's understanding and subsequent critique of modern culture that many theologians in the radical orthodoxy movement find valuable resources for "[reconfiguring] theological truth . . . in the face of the secular demise of truth."[15]

Finally, Ward's consideration of *Moulin Rouge!* is particularly helpful because music figures prominently in the film and thus calls for the type of musical analysis we have outlined in previous chapters. Therefore, as we turn our attention

toward the music in *Moulin Rouge!*, we will not only further the claim that a robust engagement with film requires an awareness of a film's music, but we will also identify the ways in which we might arrive at a constructive, theological understanding of film music's affective power.

The Commodification of Emotions

Moulin Rouge! charts the conception, development, and eventual demise of the relationship between two lovers—Christian, a young poet and soon-to-be playwright living amidst Parisian bohemians at the end of the nineteenth century, and Satine, a beautiful courtesan working in the Moulin Rouge. However, for Graham Ward, the film is not about the youthful exuberance that new lovers exude or even the joy of discovering and embracing the bohemian values of truth, beauty, freedom, and love. Rather, *Moulin Rouge!* is ultimately about the *impossibility* of love—an impossibility rooted in the modern world's consumed and consuming impulses. That is, according to Ward, the primary theme that courses through the film's visually and musically hyperactive veins is one of rampant and unchecked capitalism. Thus, a tragedy lies at the heart of *Moulin Rouge!*, and that tragedy has everything to do with the power of ideology.

Ward attempts to support this claim by suggesting that the "tango scene" reveals the cinematic core of the narrative and thus serves as the primary lens through which the rest of the film might be interpreted. Indeed, the tango scene "represents one of the great tonal shifts in the film. The comic and the burlesque turn to the violent and the raw."[16] What is more, by highlighting what he terms the film's "multilayering," Ward suggests that the audience is actually implicated and even participates in the tango's violence, dehumanization, and commercialized sexuality. That is, the tango scene's potent combination of music, dance, and camerawork engages the audience sensually—through sight, hearing, and touch—and

allows the film to "overwhelm" and even "assault" the audience. Consequently, "disengagement is impossible," for the music in *Moulin Rouge!* leaves filmgoers with no other choice but to participate in the ideology of the narrative.[17]

To be sure, Ward's central interpretive claim is that *Moulin Rouge!* is a film about prostitution—the supreme expression of a fetishized and commodified humanity.[18] But his larger point is that the film is not simply *about* prostitution. Rather, in an important sense, the film prostitutes itself. That is, due to the sensual overloading of Luhrmann's filmmaking techniques, the audience actually becomes complicit in the film's economy of exchange and intercourse. As the music overpowers audiences affectively, it engenders a sensually driven desire for something believed to be real that is in fact merely a fetish. And by evoking this affective response, the tango scene draws the audience "into the maelstrom, the madness of uncontrolled desire."[19] Tragically, without even being aware of it, filmgoers are imprisoned by the fantasies of their consumer-desire—just like the patrons of the Moulin Rouge.

Yet, for Ward, it is our very imprisonment in the film's simulacra that engenders a desire to "transcend" the façade of the Moulin Rouge. Here, he suggests, we are able to engage the film theologically. As Satine looks down at Christian from the Duke's balcony during the tango scene, we glimpse her desire to touch something authentic (i.e., love) in a world of commercialized unreality. However, Satine's longing and desire for authenticity will never be fully realized, for

> [i]t is this desire to touch the true, to live the transcendentals of truth, beauty, freedom and love, in the midst of their evident and inevitable betrayal that constitutes the human tragedy. The tragedy lies in the impossibility of attaining what human beings most deeply long for. This tragedy is right at the heart of *Moulin Rouge!* and this scene in particular."[20]

Put differently, in a world dominated by capitalist ideology, we truly desire love; but what we fail to realize is that love is no longer one of our options.

Significantly, according to Ward, this desire for love (and its attendant impossibility) is most fully voiced through the film's songs. However, with one exception, the lyrics for all of the songs in *Moulin Rouge!* are compiled from preexisting, contemporary, popular music. And for Ward, it is clearly the "recycled" nature of this music that signifies the film's lack of authenticity. Rather than offering filmgoers a glimpse of transcendence or revealing a deeper reality lying beneath its surface, this preexisting popular music simply reiterates

> the rage of trying to speak of truth, beauty, love, and freedom in a world sinking beneath the clichés and jargon of a culture glutted by its own mass production and its continual reproduction of fairy-tale endings.[21]

Thus, the transcendence voiced by these "silly little love songs" is simply an illusion. While the recycled lyrics supposedly celebrate love's deep and abiding significance for humanity—its "spiritual" dimensions—nothing actually exists beneath their superficiality. In the end, as it is with Christian himself, the songs of *Moulin Rouge!* fail to "rise above the banalities, seductions and theatricality that threaten continually to engulf [them] and [their] appeal to transcendental, eternal values."[22] Even the refrain we hear throughout the film—"the greatest thing you'll ever learn is just to love and be loved in return"—does not win out. For, according to Ward, "[i]t is death that has the final word. . . . If love has the last word it is, tragically, only in and through death."[23]

Ultimately, Ward suggests that, through its use of recycled, popular music, the film fails to find a language that can speak innocently or authentically about truth, beauty, freedom, and love.[24] Nonetheless, he goes on to suggest that this inability to speak authentically serves a purpose—one that is related to the emotional power of popular music. That is, because the

music's affectivity fails truly to rise above the reality it objec-
tifies, and because it likewise fails to disclose anything sub-
stantial beneath its contrived surface, it exposes the limits
of our contemporary, late-capitalist culture. Thus, for Ward,
the music in *Moulin Rouge!* not only reveals the impover-
ished notions of transcendence that typify the modern world's
spiritual bankruptcy, but it also suggests that the true path to
redemption is marked not by the fantasies of consumer-desire
but by "suffering, pain, and downright sordidness."[25]

The Musicality of Emotions

As noted above, one of the values of critical theory is the
reminder that, from its production, to its distribution, to its
reception, a film is never a "neutral" cultural artifact, for it
is caught up in a series of power structures that affect and,
in many ways, determine the way audiences receive films.
Thus, in his theological engagement with *Moulin Rouge!*,
Ward's conclusions concerning the ways in which audiences
are implicated affectively in the film's cultural politics are
often insightful. Yet, at the same time, Ward's interpretation
suffers from a fundamental limitation. Namely, he fails to
offer a truly *musical* analysis of *Moulin Rouge!*. To be sure,
Ward certainly demonstrates an awareness of the film's music
when he decries the "recycled" constitution of the score's lyri-
cal content and even highlights certain timbral aspects of the
soundtrack. However, *Moulin Rouge!* is literally brimming
with music, and given this overt musicality, it would be diffi-
cult to offer any interpretation of the film that did not, in some
way, address the film's music. Therefore, in conversation with
Ward, I would like to present an explicitly musical analysis of
Moulin Rouge! in order to demonstrate the ways in which a
more pronounced awareness of music enhances our ability to
understand both the film itself and its emotional power.

Central to Ward's claim regarding the ideological underpin-
nings of *Moulin Rouge!* is that the tango scene represents the

core of the film's narrative. He notes that the significance of this scene is marked by the fact that the Argentinean not only speaks and sings in an "entirely different register," but that the texture of his voice shifts from "mellifluously operatic" to a "forceful grating."[26] Thus, the "rawness" of the Argentinean's voice sets the tango scene off from the other scenes and signifies the film's "dark side."[27] Yet, this is simply not the case. In fact, prior to the tango scene, we hear the Argentinean's voice only sparingly—when Toulouse-Lautrec's theater company decides upon the words to "The Sound of Music," when they present the story of *Spectacular Spectacular* to the Duke, and when the Argentinean excoriates Christian for falling in love "with a woman who sells herself." As each of these narrative moments reveals, the texture of his voice remains grating from the beginning of the film to the end. Moreover, the register of his voice is equally low throughout the film, with the lone exception coming from the segment just prior to the tango in which the Argentinean's voice briefly takes the place of Christian's as he sings of his undying love for Satine. Thus, the minor shifts in the register and texture of the Argentinean's voice are not demonstrable enough to signify the centrality of the tango scene.

However, Ward is indeed correct in asserting that the tango does reflect a "tonal shift" in the film. And he is also correct in suggesting that the tango scene represents a significant turning point in the narrative. However, if we attend to the musical parameters of the scene, specifically the pitch relations and timbre of the music, we not only recognize that the film's tonal shift is not related to the Argentinean's voice, but we also discover that the scene can only be understood in relation to the music that precedes it. For, just before we are presented with the violence of the tango, we hear "Come What May," Christian and Satine's secret love song to one another. In contradistinction to the discernibly minor mode of "El Tango de Roxanne," "Come What May" is played in a major mode.[28] In addition, the orchestration of the two songs is distinctly

different. Whereas the lovers' secret song is underscored with a full orchestra and features soaring strings and bright horns, the tango is underscored with little more than a piano, double bass, and dual violins. The violins in particular are strained and affected, featuring a seemingly pained tremolo.

Both the pitch relations and the timbral qualities of this music function as signifiers of emotion. They draw on affective musical codes by which audiences understand and interpret music's contribution to the film's narrative. Consequently, the reason we "feel" the tonal shift that occurs at the beginning of the tango scene is that the film's music has moved from a demonstrably major mode with full orchestration to a minor mode with comparatively thin orchestration. Thus, the "color" of the entire film shifts, but not because of the Argentinean's voice. Rather, we perceive his voice as grating because the mode and texture of the film's music now "feels" dark, unstable, and harsh. And this music feels all the more dark, unstable, and harsh when it is directly preceded by the "bright," "stable" mode and "smooth" texture of the lovers' secret song. In other words, the visceral power and violence of the tango scene are only powerful and violent in relation to that which precedes them. Consequently, even if we agree with Ward and identify the tango scene as the core of the film's narrative, we can only do so by viewing this scene in tandem with the "Come What May" segment. They are a pair, neither of which can be understood without the other.

Given this musical coupling, I am simply unable to concur with Ward's claim that the film's primary theme is that of prostitution and the *impossibility* of touching the true, the good, the beautiful, and the real. Nor am I able to suggest that *Moulin Rouge!* viscerally and affectively "imprisons" its characters and its audience in a fetishized production, leaving them with nothing but an unrealized desire to reach beyond the film's façade of violence and dehumanization. Rather, I would like to suggest that, in light of the position and

function of the film's music, we must move beyond Ward's ideologically oriented interpretation. To be sure, Ward is correct in suggesting that the tango scene is perhaps the first place in the film where *Moulin Rouge!* deals directly and explicitly with prostitution. Thus, in no way can we discount the fact that a certain cultural politics of fetishization and commodification sets the stage for the unfolding of the narrative. As a courtesan, Satine is violently and inhumanely objectified. Commercializing structures of power, or as Ward suggests, "the economies of exchange and intercourse," have consumed both her body and, indeed, her love, transforming "she" into an "it," her very being into a sexual commodity. Yet, in contrast to Ward's assertion, from a musical perspective the film does not celebrate this harsh reality; rather, it allows this commercialism and consumer-desire to serve as the very medium through which love—true, good, beautiful, and *free* love—might emerge.

As we noted by pointing to the sharp contrast between the modal and timbral qualities of the two songs, the significance of "El Tango de Roxanne" is only realized in relation to "Come What May." However, we are able to identify these two songs as a pair not simply because of this tonal shift but also because of the sudden appearance of the lovers' song amidst the tango. During the tango scene, just as Satine is about to submit herself to the commodifying forces of the Duke, the music of "El Tango de Roxanne" abruptly halts.[29] Into this silence, we not only hear Satine voicing the lyrics "come what may," but the orchestral music of the lovers' song returns. This abrupt shift between musical modalities and textures is rather dissonant. It is a return to the major mode of "Come What May" in the midst of a thoroughly minor musical piece. This dissonance, much like the modal and timbral shifts in the music, functions according to affective categories. It evokes a feeling of optimism and hope, which, from within the dark and hopeless void of the tango, is impossible to ignore.

Ward suggests that, in this scene, Christian's lyrics of
"'please believe me when I say I love you' struggle to rise above
the destructive passion" of the tango.[30] However, in making
this claim, he fails to recognize that the lovers' song that Sat-
ine sings does not simply "rise above" the tango; it stops the
tango dead in its tracks. And this musical interruption carries
narrative implications. As the tango resumes and the Duke
attempts to wield the full weight of his commercial power by
raping Satine, she is spared. Le Chocolat, a rather minor char-
acter, prevents the Duke from reducing Satine to an object of
consumption. Thus, from within a world marked by the con-
sumer-driven impulse to fetishize and thus dehumanize the
objects of our desire, Le Chocolat responds to that which the
music already underscores and anticipates, and he returns to
Satine her humanity.

As the music in both the "Come What May" scene and
the tango scene trades on these distinctions between major
and minor modes, consonance and dissonance, and timbral
qualities, its primary appeal is emotional. And as Ward has
rightly noted, along with the film's breathtaking visuals, this
music involves the audience in a participatory manner, engag-
ing us viscerally and affectively. Yet, while we may be able to
accept Ward's claim that the film's music works affectively
to "fuse" the audience with the narrative, what we are "drawn
in to" musically is not a world marked by the impossibility
of love, but one in which the profound and mysterious pres-
ence of the lovers' song somehow emerges even in the midst
of violent, dehumanizing forces. In this way, the film's music
underscores and even discloses something about the world of
the Moulin Rouge that would otherwise remain inaccessible.
Through largely affective means, the music reveals a "sur-
plus" in the images we see—a surplus in need of interpreta-
tion.[31] In other words, there is more to the images of violence
and commodification than we see, and this "more" is signi-
fied by the film's music.

The tango scene might, in fact, serve as an interpretive key for the rest of the music in *Moulin Rouge!*, especially as it concerns the film's use of preexisting popular music. For, as the "Come What May" refrain appears in the midst of "El Tango de Roxanne"—a remake of The Police's "Roxanne"—we literally and figuratively hear love's song unexpectedly bursting forth from out of this recycled, clichéd music. And in doing so, we are drawn in to a world where love is more than a lingering possibility that will soon be extinguished by uncontrolled desire. Through expressly affective means, the music of the tango scene signifies the capacity for love's voice to be heard, not simply in spite of commodifying forces, but, at times, in and through those very structures of commodification.

To be sure, the violence and chaos of the tango unceasingly attempt to suppress the lovers' secret song. But as this repeatedly reemerges from out of the seeming madness of life, we recognize the delicate beauty of Christian and Satine's love, for it is a love that is manifest in the midst of and even through the simulacra of mass-produced commodities. The presence of this kind of love does not erase the pervasive and deadly effects of rampant consumerism, but neither does death have the final word. Rather, the lovers' song speaks to "life's faint joy amidst and within what is bleak and unpromising."[32] Thus, in light of an expressly musical analysis, we must move beyond Ward's interpretation of both this particular scene and the film as a whole.

However, we might bolster this musical interpretation by pointing to the ways in which the film also articulates the possibility of love and the deeper significance of the human condition through visual imagery. Not only are the segments of the film that celebrate Christian and Satine's love saturated with the passionate color of red, but the first and last "images" we see (and hear voiced in song) are the words imprinted by Christian's typewriter. The film begins as we see Christian typing the words that we hear repeatedly in a musical refrain: "The

greatest thing you'll ever learn is just to love and be loved in return." Similarly, the film ends with Christian capturing his final reflections on paper: "But above all things, [this is] a story about love. A love that will live forever. The End." Through a combination of word, image, and song, this narrative inclusio brackets the film, not with the themes of commodification and death, but with love.

Christian and Satine's love is indeed messy, chaotic, and overwhelming at times. Yet, it is love nonetheless. In the "Elephant Love Medley," Christian is able to proclaim authentically in and through "recycled" music that "love is a many splendoured thing; love lifts us up where we belong; all you need is love." For Christian and Satine, love endures—come what may. Thus, *Moulin Rouge!* is not a film about the prostitution we see. It is a film about the love we hear and feel—a delicate love that, according to Christian, "will live forever."

EMOTIONS AND MEANING MAKING
Responding to Our Cinematic Experiences

In dialogue with Ward, we have discovered that a musically aware analysis of *Moulin Rouge!* provides us with an alternative interpretation—an interpretation that challenges the assumption that music simply overwhelms audiences emotionally and thus compels them to participate in the many ills and failures of mass culture's exploitative façade. For, in addition to the film's rich visual imagery, the music of *Moulin Rouge!* functions primarily to signify and underscore a "surplus" of meaning in the images that we see—the real presence of love and beauty even in the midst of ideological forces. The very constructed nature of the film's music allows filmgoers to interpret "against the grain" of ideology, establishing a "communicating link" between the film and audience that is marked by love rather than death. Thus, I have suggested that what appears to be ideologically problematic is, through

the contribution of music, transformed into a potentially life-giving and love-affirming experience.

However, this interpretation addresses only one aspect of the cinematic experience. That is, I have developed here a particular construal of the ways in which the music of *Moulin Rouge!* offers an affective "invitation" to the audience and, thus, suggested a number of possibilities for how an audience might accept and understand the film. Yet, if we are to take seriously the notion that "meaning" emerges through the interplay between both the film's form and the film's reception, we must also consider the ways in which actual audiences accept and understand their experience of the film and how they conceptualize music's emotional "power."

Let us briefly consider, then, the ways that filmgoers respond to this film and ask how the public discourse surrounding *Moulin Rouge!* not only informs our understanding of the film's music but also serves as a concrete point of departure for reflecting theologically on the role that emotions play in the lives of contemporary persons. We turn in this section to the sometimes unwieldy but eminently democratic responses of the filmgoers who contribute to the IMDb and Rotten Tomatoes websites.[33] Although individual filmgoers in these online "communities" respond in a variety of ways, we can identify three recurring themes among these responses that are pertinent to our discussion: intersubjectivity, musical affectivity, and the "spirituality" of emotions.

Intersubjectivity

The first theme we are able to identify among the responses of those who viewed *Moulin Rouge!* is related to the highly subjective nature of aesthetic judgment and meaning making. *Moulin Rouge!* is an apparently polarizing film, and the film's music plays a key role in determining whether audience members deem the film to be aesthetically pleasing or not. Among those who did not respond favorably to the film, disdain for the

music is particularly evident. One contributor to the *Moulin Rouge!* discussion group on IMDb suggests that the music was "cheesy and ridiculous. . . . I guess the songs were well-matched to the story; both were shallow and clichéd."[34] By pointing to the clichéd and superficial nature of both the music and the film, this particular critique demonstrates the highly active nature of meaning making, for rather than being overwhelmed by the film's visceral invitation and entering unwittingly into a world of commodified artifice, this particular viewer chose to reject the invitation altogether.

Interestingly, though, among those who responded favorably to the film, many also pointed to the music as a key factor in forming their aesthetic judgments. Contributing to the Rotten Tomatoes "community" reviews, Rebeshka states, "I know many critics complain about the soundtrack and how there are absolutely NO original songs in the entire musical (except 'Come What May'), but that's actually one of the qualities I enjoy about 'Moulin Rouge!' . . . This movie has been one of my favorites for a while. . . . Bottom Line: Visually stunning with refreshingly unexpected music."[35]

Here we find support for our suggestion that the film's music, although "recycled" and preexisting, contributes something to the film that the images alone are unable to signify. That is, this reviewer's critical appreciation of the film is in no way precluded by the "clichés and jargon of a culture drowning in its own mass production."[36] She is able to articulate the "quality" (i.e., the beauty) of the film in and through these clichéd songs, and even derives a sense of pleasure and meaning from them. Moreover, she is fully aware that, by suggesting that the music invests the film with this type of aesthetic value, her understanding of the film's music runs counter to common (mis)conceptions regarding the aesthetic limitations of preexisting music in film.

As Rebeshka's review intimates, however, aesthetic judgments are accepted and understood not simply as subjective

but as intersubjective. For, among the reviewers who offer judgments regarding the aesthetic value of the film, individuals continually voice the validity of others' responses, even when their own responses are diametrically opposed. For example, on IMDb, "luffielove" states, "I was watching it [*Moulin Rouge!*] at one point with a group of people and one of them couldn't relate to it at all, they felt no connection with the story so they didn't find it powerful or heartbreaking. I guess it just depends on who you are, what you like, etc."[37]

Consequently, it seems reasonable to suggest that audiences conceptualize their responses to *Moulin Rouge!* and the music therein in highly subjective terms. However, as they locate these concrete aesthetic experiences within a larger community of filmgoers, there exists at least an implicit recognition of the intersubjective nature of these judgments. That is, "my" experience of a film, although legitimate in its own right, derives meaning in some way from the experience of others. This process of active, intersubjective meaning making reflects our claim that the music of *Moulin Rouge!* allows for a plurality of meanings and interpretations that cannot be reduced to a mere matter of ideology. Just as there is more to the film than what we see in the images alone, so too are there further levels of significance dwelling beneath the pop-superficiality of the music. Yet, insofar as it remains intersubjective, this meaning is negotiated within the parameters set forth by both the film itself and the surrounding filmgoing community. In other words, the music of *Moulin Rouge!* might be experienced meaningfully in *many* ways, but not in *any* way.

Musical Affectivity

The second theme has to do with music's affective appeal. Almost without exception, for those who affirm the quality or aesthetic value of *Moulin Rouge!*, the music "plays on" the filmgoer's emotions: "[*Moulin Rouge!*] brings me back to years gone by (the music chosen speaks for itself). . . . Tears

of happiness and sadness both filled my eyes as I ventured through the journey of Satine (Nicole K.) and Christian (Ewan M.) Well done!!~ STANDING APPLAUSE!!"[38]

According to this reviewer, the film's music is understood as opening up an affective space that audience members inhabit. By inhabiting this space, individuals recognize that they are in some way implicated in the narrative. The music provides them with the means for participating emotionally in the story. It functions as an affective guide for "venturing through the journey of Satine and Christian." Yet this "fusion" of the audience with the film is not a passive matter, nor is it fundamentally destructive. Rather, certain individuals return time and again to this affective space with the express intention of experiencing a deep-lived intensity of feeling. In fact, certain discussion threads revolve around nothing more than the ways in which *Moulin Rouge!* consistently evokes an emotional response. A few examples from the thread titled "Okay, Who Else Cried?" will suffice here:

> I used to watch this movie EVERY DAY for about a year and even when I watch it now I still cry.[39]

> I watched this movie three times in 24 hours and cried all three times. Maybe I'm just emotional.[40]

> Oh god, I cry every time I watch this movie. . . . I cry in the end when Satine is on stage and she starts singing their song. And of course I cry when Satine dies at the end.[41]

It is interesting to note that, in most cases, these filmgoers conceptualize as valuable and constructive their repeated entry into the affective space that *Moulin Rouge!* opens up. In an important sense, the film provides an emotional orientation for their lives. However, given the subjective nature of these experiences, the responses regarding the benefits of the film's emotionality are highly personalized. In a way that directly reflects the musically oriented interpretation we offered above, some reviewers suggest that, through affective means, the film

consistently provides an occasion in which they might experience the reality of a fragile love in the face of death:

> I cry and get goosebumps and that 'lump' in my throat every single time I watch this movie, it's so heart breaking. In my personal opinion I think it's one of the best movies I have ever seen in terms of love story.[42]

Others, though, point to the capacity for the film's music to evoke an emotionally laden sense of nostalgia. As one of the reviewers above noted, the film's music recalls the "years gone by" and serves as a means for experiencing anew a prior moment of affective significance. These numerous responses suggest that the affective space opened by *Moulin Rouge!* serves, for many individuals, as a prime location for the construction of meaning. Emotional responses, then, are far more than a by-product of a film's manipulative conventions; they are accepted and understood as a fundamental component of the meaning-making process. Thus, according to those who have conceptualized their individual responses to *Moulin Rouge!*, the deep-lived significance of their cinematic experience is directly related to how the music feels.

The "Spirituality" of Emotions

The third and final way we might thematize the responses of those who viewed *Moulin Rouge!* concerns the "spiritual" dimensions of the film's music. Significantly, this theme is also related to the music's affective dimensions. That is, reviewers point to both the emotionality and the sensuality of the film as identifying marks of a loosely defined "spirituality." This progression toward spiritually loaded language typically follows a certain pattern of conceptualization. First, as we have already discussed, viewers note the intensely emotional nature of the film and the film's music. Second, individuals recognize their affective response in light of the sensual and physiological changes brought about by the film's music. For some viewers, the song "Come What May" in particular causes their body to

"tingle."[43] Others suggest that this specific song has the capacity to make them "melt. And cry. And shiver."[44] It is "heart-melting," "tender," and even "sexual."[45] These highly affective and sensual responses resonate with our interpretation of the ways in which "Come What May" functions in the film. For, as it emerges from within the sensually charged tango, both the modal and timbral qualities of the song draw on affective categories to signify the power and depth of love between Christian and Satine.

Third, individuals often call upon "spiritual" language to articulate the significance of the decidedly embodied responses that the film's music evokes. For some, the music of *Moulin Rouge!* is simply "uplifting"; it draws them out of their otherwise dispassionate lives.[46] Yet, for others, their experience of the music is "like being in heaven."[47] That is, it serves as a moment of "Transcendence with a capital *T*," an encounter with "something independent of and outside ourselves and our cultures, even if it is known from within."[48]

Equally often, though, this spirituality is construed in purely immanent terms. The film's music "comes from within, from your heart, and from your soul."[49] Thus, the experience of the music of *Moulin Rouge!* is accepted and understood as "spiritual" because it connects to the inner recesses of our fundamental humanity—to our "soul." Again, this notion of music's connection to our "soul" reflects our suggestion that the music of *Moulin Rouge!* is able to disclose something deeply and authentically human in and through the apparent superficiality of the film's recycled lyrics. This response to the film's music might best be understood in terms of another kind of transcendence—"transcendence with a lowercase *t*," or "the human possibility of exceeding our human limitations, of experiencing wholeness within brokenness, of glimpsing how life was meant to be but is not."[50] To be sure, individuals conceptualize this "spirituality" in varied ways and, at times, employ the language of "spirituality" inconsistently. Yet it is

significant that these reviewers are not only willing to identify their cinematic experience as a spiritual experience, but that they relate this spirituality to the music's affective appeal.

THE CINEMATIC EXPERIENCE AND THE CONTEMPORARY CULTURAL IMAGINATION

Although *Moulin Rouge!* may very well be serving as a source of affective meaning in contemporary life, it is certainly not the only location where individuals inhabit an affective space. Rather, the ways in which these filmgoers have conceptualized their experience of the music in *Moulin Rouge!* are indicative of broader trends in contemporary culture. Increasingly, contemporary persons are turning toward the affective spaces opened up by a number of aesthetic experiences as locations for meaning-making activity. From our consumption and use of everyday goods, to the choices we make in home décor, to the clothing we wear, a general aesthetic impulse permeates the contemporary cultural imagination.[51] And the practices that are associated with these aesthetic impulses are considered meaningful insofar as they provide spaces in which individuals might engage their world emotionally.[52] We might even go so far as to say that affective experiences serve as one of the defining aspects of our contemporary cultural imagination. That is, modern individuals construct their identities and make sense of the world in and through their emotions.

As our musical analysis of both the formal structure and the reception of *Moulin Rouge!* suggests, the cinematic experience appears not only to offer a concentrated distillation of this contemporary cultural imagination, but also to serve as a concrete location in the contemporary world where individuals are explicitly constructing meaning in direct relation to this imagination. For, in the cinematic experience, contemporary persons are engaging in meaning-making activity and forming their basic awareness of the world in and through the affective space this particular aesthetic experience opens up.

What is more, and perhaps most importantly, they are ascribing "spiritual" significance to this affective experience.

Consequently, we are now faced with the question of what we are to make theologically of film music's affective power and the apparently "spiritual" meaning that individuals derive from their emotional engagement with film. That is, our consideration of the music in *Moulin Rouge!* raises questions concerning how this affective space might serve as a location for theological reflection. Moreover, it presses us to consider how one might go about doing this constructive theological work in a way that will resonate more fully with the contemporary imagination.

In contrast to the approach I have outlined, Graham Ward's work represents a form of theological reflection that begins with the assumption that film is capable of "overwhelming" the audience through its powerful, emotional appeal. However, if one of the Christian community's primary aims is to engage in theological work that might connect with modern persons and, thus, to speak in terms that relate to their fundamental awareness of the world (i.e., how they "imagine" or "perceive" the world), we are in need of a more fitting approach toward music's affective appeal.

Thus, as we move forward, we must identify the means through which we are able to address, from an expressly theological perspective, not only the ways in which individuals accept and understand the significance of their aesthetic experiences, but also the positive dimensions (perceived or otherwise) of the affective spaces that contemporary persons actively and meaningfully inhabit. With this aim in mind, I would now like to turn our attention toward the thought of the late eighteenth-century Protestant theologian Friedrich Schleiermacher and consider how his understanding of religious and aesthetic affectivity might serve as a helpful resource for engaging in this manner of theological inquiry in the contemporary world.

THE THEOLOGICAL IMPORT
OF MUSICAL EMOTIONS

The sum total of religion is to feel that, in its highest unity,
all that moves us in feeling is one . . . to feel that is to
say that our being and living is a being and living in and
through God.

—Friedrich Schleiermacher, *On Religion*[53]

Schleiermacher's exploration of emotions and human affectivity initiated a monumental shift in Christian theology. In a somewhat radical departure from the theology of his day, he suggested that true religion resists both theoretical and practical systematization, for the essence of religion is "neither thinking nor acting, but intuition [*Anschauung*] and feeling [*Gefühl*]."[54] It is to *feel* that our living and being is a living and being in and through God. Yet, in Schleiermacher's estimation, religious *Gefühl* (i.e., "feeling") is more than a simple and fleeting emotionality; it is more than mere sentiment. Rather, it concerns the whole of ourselves as persons-in-relation to the universe; it is a feeling and intuition of the Infinite embodied in the finite.[55]

By highlighting this robust notion of "feeling" (*Gefühl*) as the fundamental element of human self-consciousness, Schleiermacher created nothing less than a new vocabulary for Protestant theology.[56] In doing so, he essentially developed a "theology of affect" that not only reflected the influences of the Moravian piety in which he was raised, but also challenged the Protestant tradition's historical ambivalence toward emotional experiences. Moreover, by speaking in the affectively oriented language of his Romantic culture, he discovered a key for commending religion to his age—a cultural context that shares many similarities to our own "post-romantic" culture.[57] This constructive theological project did not only reflect Schleiermacher's deep-lived experience of faith, it also provided the means by which he was able to make the Christian

faith intelligible to those individuals who derived significance from their emotional experiences—whether these experiences were explicitly religious or not.

Given his interests in the religious dimensions of both emotions and the aesthetic experiences that occasioned these emotions, Schleiermacher's understanding of *Gefühl* provides us with invaluable resources for reflecting theologically on the "power" of film music and the affective space it opens up. For, in a certain sense, we are attempting to understand how the cinematic experience might already be functioning in a "religious-like" manner in the contemporary context and thus how it might align with Schleiermacher's nuanced and at times complex notion of *Gefühl*. Perhaps more importantly, though, we are also concerned with how Schleiermacher's conception of *Gefühl* provides us with the means for relating contemporary cultural practices such as filmgoing to the larger project of God in the world. Thus, by drawing on Schleiermacher's insights, we are making an effort to speak constructively regarding the ways in which God may already be present, active, and in conversation with contemporary persons in and through the affective spaces they inhabit.[58]

Emotions as an Immediate, Intersubjective Awareness of the World

In his seminal work *On Religion: Speeches to Its Cultured Despisers*, Schleiermacher makes clear that, by "feeling," he is not referring to any reduced or simple understanding of emotions.[59] Certainly *Gefühl* involves our affective lives. Yet Schleiermacher employs the term *Gefühl* as a means for speaking about something far deeper and more significant than a fleeting emotionality. *Gefühl* is the inward, immediate awareness of the whole of our selves in relation to the Infinite. It is not a detached or free-floating awareness. Rather, it is an immediacy that is targeted toward the "universe" or the "World-Spirit" (i.e., to God).[60] More than a moment of simple

affectivity, *Gefühl* contributes something fundamental not only to our knowing and being in the world but also to the way we "make sense" of the world. It involves a precritical awareness of the world as a whole and its significance for our lives.

In addition, Schleiermacher suggests that our feelings are not just oriented toward our individual lives but toward the communal "whole." That is, our experience of *Gefühl* does not remain on the level of pure subjectivity. Rather, from within the affective space opened up by certain aesthetic experiences, these deep-seated feelings issue in a basic awareness of the world (i.e., a general hermeneutical orientation) that is mediated by our affections and is markedly intersubjective. In an important sense, for Schleiermacher, *Gefühl* is very basically the "feeling of what happens" in and among persons-in-relation.[61]

In a corresponding fashion, we identified a few prominent themes through our analysis of the ways in which audiences responded to the music in *Moulin Rouge!*. The first of these themes was the highly subjective nature of a filmgoer's aesthetic judgments. The second theme was related to the ways in which audiences conceive of their emotional responses as the central element in their meaning-making activity. Music in particular played a key role in determining not only whether viewers appreciated the film aesthetically but also whether they were able to derive meaning from the film's affective appeal. However, even while ascribing to the overwhelmingly pervasive notion that "beauty is in the eye of the beholder," viewers readily acknowledged the larger community of interpretation that framed their judgments.

These "on the ground" responses inform our discussion in two related manners. The first is that, given the very existence of film discussion boards—contemporary locations where filmgoers gather together in virtual communities and attempt to make sense of what occurred in their viewing of a

film—it would seem that, on occasion, the cinematic experience is functioning as an affective space in which individuals are, in some small way, structuring their lives.[62] As the viewer responses to *Moulin Rouge!* make clear, this process of meaning making is highly affective. Especially among those who repeatedly viewed *Moulin Rouge!*, many turned to the affective space opened up by the film's music to either experience a consistent and ritualized intensity of emotions or to evoke an emotionally laden sense of nostalgia. In either case, though, this experience appears to be functioning as a means through which individuals orient and structure their basic awareness of themselves and the world in which they live.

However, although highly personalized, audiences conceptualized their meaning making as an intersubjective process. That is, meaning is made in relation to the "other." And more than any other element in *Moulin Rouge!*, audiences identified the music as the means through which the film is able to effect this form of intersubjective awareness. Viewers construed their affective response to the film's music in terms of a broader community of filmgoers either because they were simply aware that other individuals were critical of the film's use of recycled popular music, or because their emotional response to the music diverged in degree or kind from those with whom they watched the film. Either way, the music's affectivity engendered an awareness of the "other" and thus an intersubjective form of meaning making.

For this reason, we might suggest that, as it opens up affective spaces through which individuals are able to construct an intersubjective awareness of the world, film music has the potential for providing contemporary individuals with an experience of religious *Gefühl*—an immediate, affective awareness of the whole of their lives in relation to the world. That is, in light of music's affective appeal, the practice of filmgoing has the capacity to function in a religious-like manner. It is meaningful on a deeply human level, for it provides filmgoers with

a space in which they are able to construe and construct the world in, with, and through their emotions.

Yet perhaps we can say more. For, as Schleiermacher suggests, music in particular has the unique capacity for opening individuals up not only to the "other," but also to "something higher still."[63] Thus, what we feel in the emotions that film music evokes is not a purely inward-looking sentimentality but an affective awareness of the "o/Other." Indeed, we may be able to know certain objects through observation and logical analysis, but we can only "know" other persons affectively, through an intersubjective fusion of whole human beings. And, according to Schleiermacher, through the fundamentally human process of "knowing" the "other," we are necessarily drawn into an awareness of the "Other." That is, our experience of musical *Gefühl* is targeted not only toward the human other but also toward something higher still—the universe, the Infinite, and perhaps even God.

To be sure, our emotions might certainly be misdirected and disoriented, thereby marring our intersubjective constitution. As Graham Ward rightly suggests, without our knowledge or consent, our emotions *might* be manipulated and controlled by the hidden workings of ideology or unseen structures of power. Yet, from a theological perspective, conceiving of these emotions as the *source* of the human malady denies the affective and intersubjective nature of our basic awareness of the world. Consequently, rather than decrying the ill effects of music's emotional power, we would do well to acknowledge and perhaps even appreciate the ways in which the contemporary practice of filmgoing is serving as a location in which intersubjective beings are affectively drawn into a fundamental awareness of the human other and, ultimately, the Divine Other.

Emotions as a Communal Womb of Expression

Schleiermacher goes on to suggest that as we become aware of the universe through immediate feeling, we are compelled to

communicate this *Gefühl* to others.[64] Yet, given the difficulty of articulating something that resides beyond the constraints of language, Schleiermacher prefers the term "expression," which denotes not a transfer of knowledge per se but a "capacity of spirit"—a capacity for communing affectively with others. In other words, *Gefühl* issues in an impulse toward community; we yearn not simply to feel, but to feel along with others. For this reason, Schleiermacher suggests that music and the musical-aesthetic experience are uniquely suited for cultivating this expressive capacity. Thus, music becomes the "communal womb" in which individuals grow in their ability to express the ineffable.[65]

Interestingly, though, according to Schleiermacher, any formal stipulations concerning the practices in which this expression occurs restrict and confine one's capacity for affective communion, for the expression of *Gefühl* cannot be contained by any particular form without being reduced in some fashion.[66] This generous notion of religious expression is helpful in that it provides us with the means for speaking of the salutary rather than the destructive potential of the "communal womb," or "bath of affect," or "affective space" that film music establishes. For example, according to our analysis of how filmgoers accept and understand their experience of *Moulin Rouge!*, the film's music provides an affective space in which individuals and groups of individuals not only express an intensity of feeling but also grow in their ability to commune affectively with others. This capacity of spirit is cultivated even further as individuals share their expression of *Gefühl* in the communal womb established by the film's music. In fact, in many cases, filmgoers conceive of their affective response to the music in *Moulin Rouge!* as an embodiment of that which is too deep for verbal articulation, namely, love. It is here that Schleiermacher's notion of *Gefühl* provides us with the language for speaking of film music's affective appeal in constructive terms. For, according to Schleiermacher, this

musically structured space serves as a location in which individuals commune with one another in ways that, on the one hand, are impossible to articulate, yet, on the other hand, relate to the core realities of human life.

In this respect, we might also point to the ways in which the practice of contemporary filmgoing is necessarily related to the larger project of God in the world. For, as individuals inhabit this affective space and commune with others through a shared experience of the power of love, they are cultivating their capacity for plumbing the depths of human existence and meaning. In other words, they are growing in wisdom. Of course, much like we discovered in our analysis of Pixar's films, the development of this wisdom is decidedly heuristic; it emerges over time through a process of trial and error. Nonetheless, it is a deep-lived wisdom that suggests that our feelings are *ultimately* significant, and not simply because they offer a moment of sensual pleasure. Rather, as we develop this wisdom within music's communal womb, we grow in our capacity, as Schleiermacher would say, to "feel" our lives in their "highest unity." That is, we are provided the capacity "to feel . . . that our being and our living is a being and a living in and through God."[67]

Emotions as an Occasion for Revelation

Third and finally, Schleiermacher suggests that the essence of religion is not simply feeling, but feeling *and* intuition—a *Gefühl* and *Anschauung* of the existence of all finite things in and through the Infinite. Whereas "feeling" is an inward and immediate awareness of how the whole of our selves is affected by the existence of the Infinite in the finite, "intuition" is our perception of the divine operating on our lives through our lived experiences. Thus, what we are aware of in our most elemental feelings is, in fact, the movement and operation of God in our lives. According to Schleiermacher, while our perception or "intuition" of this movement

is located firmly within the material world, it remains an intuition of a distinct "Other." In other words, while he often employs seemingly pantheist language in truth, his theological method reflects a nonreductive pan-en-theism.[68] For this reason he is able to claim not only that "every intuition and every original feeling proceeds from revelation," but also that "the Universe is ceaselessly active and at every moment is revealing itself to us."[69] As a disclosure of the Infinite in the finite, of the whole in the particular, our emotions actually unveil a depth and scope of human meaning that can be found through no other means.

It is for this very reason that religious *Gefühl* finds its closest analogy in musical *Gefühl*. For, as it signifies that which cannot be contained by words or images, music evokes an immediacy of feeling that, in certain respects, reflects our genuinely religious experiences. Because of this close affinity between religious and aesthetic experience, music functions as a constructive metaphor for religious experience. Yet, religion also serves as the most appropriate metaphor for the musical-aesthetic experience. Given the ineffable nature of the musical-aesthetic experience, music finds a "concrete" referent in religion's feeling and intuition of the "World-Spirit." Thus, both religious and musical *Gefühl* offer an occasion in which the Other-who-is-beyond-description is revealed through immanent means. They are both, in short, revelatory encounters—experiences in which the divine actively impinges upon our concrete existence.

In our discussion regarding the various responses to the music in *Moulin Rouge!*, one particularly interesting theme seemed to reemerge continually. That is, in their efforts to speak of the significance of their experience of the film and its music, individuals repeatedly turned to what can only be termed "spiritual" language. Remarkably, these viewers were not only willing to identify their experience of the film as spiritual, but they directly related this spirituality to the emotive

power of the music. Thus, among average audiences, the common conception seems to be that, insofar as music affects one's "heart," it also affects one's "soul."

In this way, Schleiermacher speaks directly to the heart (and soul) of the contemporary situation. According to Schleiermacher, the impulse to frame one's experience in "spiritual" terms is quite reasonable. There is simply no better language for speaking of the depth of meaning that individuals are able to access through music and musical *Gefühl*. Moreover, this "religious," "spiritual," and even "theological" language is particularly amenable for speaking of one's experience of film music because, just like its musical counterpart, true religious *Gefühl* points beyond itself. As an immediate awareness, a communal womb of expression, and an occasion for revelation, *Gefühl* points beyond the limits of imagistic and verbal representation and signifies that which cannot be contained by images or words alone. In fact, we might even go so far as to say that filmgoers *must* employ the language of "spirituality" to describe their encounter with film music, for they are attempting to speak of an experiential depth that exceeds the limits of the film's primary mode of representation.

Yet, in light of Schleiermacher's formulation of religion as the dynamic interplay between feeling and intuition, we would be remiss if we did nothing more than identify this practice as "religion-like." For, if we fully develop Schleiermacher's conception of religious *Gefühl*, we might say that contemporary persons employ religious language not simply because it serves as an apt metaphor for their film-musical experience, but because the affective space opened up by film music offers an occasion in which people discover that God is already a part of their ordinary lives. Musical *Gefühl* is not simply a feeling that is something "like" religious experience; rather, it is a feeling of the self in relation to the One-who-is-always-already-present. That is, it is an encounter—a feeling

and intuition of God's very presence in and through the concrete particularities of our lives.

And while we must admit that he is somewhat uncomfortable with the notion of a general spirituality that underlies both aesthetic and religious experiences, Schleiermacher's formulation of religion as both feeling and intuition points us toward not a general spirituality per se, but a general *revelation*. That is, his work on the religious dimensions of human affections raises questions concerning the self-disclosure of the Spirit of God in cultural forms that exist outside of the church and without reference to Jesus Christ. Consequently, as we continue to explore the theological significance of film music, we will attempt to develop a more robust understanding of how the Spirit may be present and active in and through the affective spaces opened up by this pervasive cultural form. In doing so, we may even suggest that film music does not simply excite or inspire our emotions; it in-Spirits them.

5

THE PRESENCE OF FILM MUSIC

A young woman once attended a film discussion group that I was hosting. Although I had never met her before, in a moment of seemingly perfunctory self-disclosure, she revealed that "on her best days" she was agnostic, but that she typically lived her life according to a type of intellectual atheism. Nevertheless, she was present and actively participating in a gathering that was explicitly connected with the "twenty- and thirty-somethings" ministry of which I was the lead pastor and director. On the particular evening that she arrived, we had chosen to discuss Marc Forster's *Stranger than Fiction* (2006). A subtle yet surprisingly endearing film, *Stranger than Fiction* tells the story of what is supposed to be the final few weeks in the life of Harold Crick, a man who, by all rational accounts, is schizophrenic. Harold hears voices. More specifically, he hears the voice of an omniscient, third-person narrator—one that not only describes every mundane detail of his life "accurately and with a better vocabulary," but also suggests that his death is imminently approaching.

As the film charts Harold's transition from an isolated, fragmented, and otherwise lonely IRS agent to an integrated human-being-in-relation, it continually raises questions concerning the value, purpose, and meaning of those everyday experiences that are at once profound yet seemingly banal, transformative yet shrouded in mystery. Is there an all-knowing someone or something ordering

our life and investing it with a larger meaning? Or is our fate simply predetermined? Is there an "O/other" that is present and active in the minutiae of our existence, calling out to us from a location beyond our immanent frame? Or are we just crazy? Are we simply hearing voices?

Prior to our discussion that evening, we once again watched the film's closing scene. Strictly speaking, it is a simple montage. However, rather than signifying the passage of narrative time, this particular series of images depicts the film's various characters as they embrace their newfound connectivity. As the montage proceeds, sound effects drop entirely from the soundtrack and the voice of the narrator comes to the foreground, her words serving as a concluding reflection for the whole of the film:

> Sometimes, when we lose ourselves in fear and despair, in routine and constancy, in hopelessness and tragedy, we can thank God for Bavarian sugar cookies. And fortunately, when there aren't any cookies, we can still find reassurance in a familiar hand on our skin, or a kind and loving gesture, or a subtle encouragement, or a loving embrace, or an offer of comfort. . . . And maybe the occasional piece of fiction. And we must remember that all these things—the nuances, the anomalies, the subtleties, which we assume only accessorize our days—are in fact here for a much larger and nobler cause. They are here to save our lives. I know the idea seems strange. But I also know that it just so happens to be true.

Without question, these words and images invite a theological response. Yet they are not the only means by which the film confronts the audience theologically, for the film's final segment commences not with a particular image or a spoken word but with music. The scene begins as we hear the sound of a guitar vamping on an E major chord in 4/4 time. The occasional variations of second and third intervals that are played over this chord are constantly resolving into perfect fourths and fifths, imbuing the scene with a feeling of consonance and wholeness. As the guitar eventually shifts between E major and A major

chords, the orchestration develops a thicker texture, eventually including strings and brass instrumentation and even vocals. This music functions not only to invest the scene, which is filmed in slow motion, with a progressively rhythmic and "natural" movement, but also to lend a sense of cohesion to the otherwise disjointed cuts. Through both its mode and its timbre, the music colors the final minutes of the film with an uplifting and optimistic quality. Moreover, as the music underscores a compilation of shots that feature both the film's principal and secondary characters, it expresses their essential interrelatedness. In conjunction with the voice-over and the accompanying images of the montage, it signifies an unseen and unspeakable force that both undergirds and surrounds each of the characters' lives, a benevolent and hope-filled force that draws them into a deep-lived connectivity, quite literally "saving" them from a meaningless life of unrestricted autonomy. Thus, through the dynamic interaction that takes place between the film's music, narration, and images, we finally recognize that Harold Crick can indeed thank God for acting in and through the seeming banalities of his life.

I will forever remember the conversation that ensued in the wake of our screening of *Stranger than Fiction*. Because the final scene was allowed to frame our understanding of the film as a whole, much of our discussion focused on the unexpected means through which God is present and active in the world. Like many first-time participants, the agnostic woman who had joined us spoke very little during the formal discussion. However, immediately prior to her departure, she approached me and recounted the recent series of events that eventually culminated in her attendance on that evening. With a sort of amazed enthusiasm that I failed to understand fully at the time, she recalled the recent camping trips she had embarked upon in the foothills of Colorado's Rocky Mountains. In the few months before our conversation, every time she would go camping, she had a recurring dream. In her own estimation, this dream was

particularly vivid because of its setting; it would always begin
with her awaking in her tent to the sound of a voice calling her
name. She would arise and follow the voice toward the stream
where she had set up her campsite, seeking out the source of its
emanation. Yet, without fail, she was unable to identify who
or what was calling her name, for, as soon as she would arrive
at the bank of the stream, the voice was gone. After a series of
identical dreams, she could no longer go camping. There was
something about the mountains—something about her being
in intimate communion with nature—that allowed this voice
to intrude upon her subconscious. It was both mesmerizing and
disconcerting. She said that she felt much like Harold Crick in
her dreams, shouting at the heavens, "Shut up you stupid voice
. . . shut up and leave me alone!"

However, so compelling was this voice, so indelibly had it
impressed itself upon her psyche, that she began to seek it out
during her moments of consciousness. In spite of her life-long
agnosticism, she confessed that she had decided to join one of
her friends at church as a last-ditch effort to understand the
meaning of her dreams. Little did she know, we were simply
discussing a movie on the night she chose to attend—a movie
that just so happens to be about a man who hears a voice. The
final words she ever spoke to me reoriented not only my under-
standing of the power and meaning of film, but also my con-
ception of film's role in cultural dialogue: "I want to thank
you for showing this film and for having this conversation
tonight. Because now I know who it is that has been speaking
to me all this time."

For this particular woman on this particular evening,
Stranger than Fiction was functioning theologically. That is,
it provided an occasion for revelation—an epiphany through
which she made sense of her lived experiences. But this was
only part of her story. For God was present, active, and quite lit-
erally speaking in and through not only this product of human
creativity, but also her quasimystical experience of the created

order and her own elevated self-/subconsciousness. And while it is surely an isolated anecdote, part of the argument I want to put forward is that this young woman's "spiritual" experience is in no way anomalous. Indeed, even while traditional religious practices seem to be in a state of decline in the Western world, a spiritual impulse nevertheless permeates our contemporary, (post)modern culture. And as these loosely defined experiences of "spirituality" become increasingly prevalent, Christian theologians must consider more fully how an ostensibly "secular" practice like filmgoing relates to the larger project of God in the world. Moreover, theology must rethink its approach toward these deeply meaningful encounters that most often take place outside of the church and without any explicit reference to Jesus Christ, especially if it is to speak in terms that are intelligible to individuals who, like this woman, are already engaged in conversations with God in and through their experiences of creation, human conscience, and culture. Thus, in this and the following chapter, I want to suggest that, if we locate our understanding of film music within the larger theological framework of general revelation, we will be able to speak constructively of the ways in which the cinematic experience might serve as a *theologia prima*—an immediate, first-order, revelatory experience.

MUSIC AND PAUL THOMAS ANDERSON
Moving beyond Representation

All good art and literature begin in immanence. But they do not stop there. . . . The questions: "What is poetry, music, art?" "How can they not be?" "How do they act upon us and how do we interpret their action?" are, ultimately, theological questions.

—George Steiner[1]

Much like my agnostic acquaintance, composers, filmmakers, critics, and listeners alike recognize that, whether heard in a theater or in a concert hall, through the headphones of an iPod

or through speakers equipped with Dolby Digital Surround, music is rife with meaning. Yet, given the apparent immediacy of the musical-aesthetic experience coupled with music's nonlinguistic, nonrepresentational character, this meaning remains largely mysterious, even mystical.[2] In the presence of music, our words and conceptual frameworks simply fail, for music has the innate capacity to refer to something beyond itself, to indicate, signify, and "represent" that which must go without representation. That is, by contributing "something" to moving images that routinely exposes the limits of linguistic and imagistic representation, music addresses the ineffable. In doing so, film music not only confronts audiences with theologically informed understandings of life and the world, but grants them access to an entirely new register of meaning that necessarily calls for a theological construal.

Because this kind of reasoning often lends itself to unnecessary abstractions, I want to turn our attention to the work of Paul Thomas Anderson—a filmmaker whose use of music invites the kind of theological dialogue with which we are primarily concerned. But why Paul Thomas Anderson? This question implies more than a simple concern with the number of accolades or the critical approbation his films and filmmaking have received. Rather, it strikes the heart of a form of film criticism that has recently fallen upon hard times, namely "auteur criticism." In short, auteur criticism takes into consideration the person (or persons) standing behind a particular movie and attempts to understand this work in light of the unique, creative "vision" of the film's auteur or author.[3] However, given the highly collaborative nature of the filmmaking process, many have suggested that auteur criticism is fundamentally unhelpful and even misleading. From producers, writers, and cinematographers to actors, editors, and sound engineers, myriad individuals contribute creatively to the production of a film, thereby calling into question the very notion that we might discern a coherent vision or voice behind a film.

Nevertheless, more often than not there is some organizing force behind a film, whether that creative influence originates from an individual director, writer, or producer, or a larger collection of individuals at a studio or corporation. Thus, it might be more appropriate to speak of some films in terms of a collective or corporate auteur. However, in certain instances, an individual filmmaker is able to exert a tremendous amount of control over the film's final form, especially when he or she functions in more than one creative capacity. In these cases, it is reasonable to draw on an auteur's larger body of work, understanding a particular movie in light of the filmmaker's characteristic style and creative vision.[4]

By analyzing a film in light of a filmmaker's oeuvre, we are once again highlighting the significance of audience reception. More specifically, we are dealing with the expectations that filmgoers bring to a particular film. That is, the notion of a filmmaker as an auteur is important only insofar as audiences believe it to be important; we are able to construe the films of certain filmmakers in terms of their prior work because we expect their thematic and stylistic consistencies to inform our understanding of each movie they create. In contemporary cinema, a handful of filmmakers garner this manner of audience expectation through the creative control they bring to bear on their movies. Paul Thomas Anderson is one of them.

Although a relatively young filmmaker whose output is still meager when compared to more prominent auteurs such as Woody Allen or Quentin Tarantino, Anderson has emerged as one of the more promising cinematic voices in recent years. He writes, directs, and even produces his feature films, which affords him an abundance of creative control that few contemporary filmmakers possess. However, what is perhaps most significant for our discussion of Anderson as an auteur is the central role that music plays in his particular style of storytelling. Music, for Anderson, is not a mere addition to an otherwise unrelated cinematic "vision" (i.e., to an autonomous

"imagetrack") but actively shapes the film from the beginning stages of production. So fundamental is music to his cinematic language that, in many respects, we might classify a "Paul Thomas Anderson film" according to the manner in which music structures its richly textured narrative, uniting the film as a whole both affectively and thematically. Yet the music we hear in an Anderson film is significant for another reason. That is, he often calls on music to signify something that cannot be restricted to the film's visuals alone, something that extends beyond the limited representational capacities of moving images. In other words, his music functions theologically; it addresses the inexpressible and sometimes overwhelming dimensions of our lived experience.

Of course, not all of the music in Anderson's films functions in this explicitly theological capacity. Thus, as we are largely concerned with developing a more robust understanding of film music's apparent propensity to confront audiences with theologically informed perceptions of the world, we will limit our discussion and analysis to the particular ways in which Anderson uses music in his films to move beyond representation, that is, to indicate a formative presence that cannot be contained by a film's images. We will specifically focus here on his three most recent works to date, *There Will Be Blood* (2007), *Punch-Drunk Love* (2002), and *Magnolia* (1999).[5] However, rather than attempting a psychoanalysis of Anderson's films or drawing on his personal biography as a means for gaining insight into the cultural and historical context of his work, our consideration of Anderson as an auteur will focus on the ways in which his use of music expresses certain assumptions about the nature of reality and our life in the world—assumptions that are often theologically loaded and, consequently, provoke theological exploration. In particular, I want to highlight three ways in which music not only functions in these films according to Anderson's unique cinematic style, but also bears an expressly theological meaning that nonmusical analyses are simply unable to access.

MUSIC AS A PERVASIVE PRESENCE

Among the many themes that consistently arise in Anderson's work and resonate with his creative voice as an auteur, the most prominent is the redemptive quest for human connection, relationship, and integration in the midst of a disconnected and increasingly disintegrated existence. Each of Anderson's films deals in some way with the interconnectedness of human life and the consequences that arise when we deny our basic relationality. In *Punch-Drunk Love*, for instance, Barry Egan is the owner and lead salesman of a novelty plunger business. Given his seeming introversion and lack of social skills, Barry makes an unlikely entrepreneur. In addition to his somewhat awkward disposition, he is the lone brother of seven sisters who constantly berate, belittle, and mock him. He suffers under their endless derision and "tough love," which not only exacerbate his feelings of angst but also drive him deeper into a despairing sense of isolation. Even as one of eight siblings, Barry is alone in life, in business, and in love. And it is only through his relationship with Lena, who appears as if from another realm, that "Barry is saved from disintegration."[6]

However, if we turn toward an expressly musical analysis of *Punch-Drunk Love* and approach the film's music in terms of its primary leitmotivs, we are able to understand more fully *how* it is that Barry arrives at some semblance of redemption and integration in the midst of his fragmented existence. Although others have suggested that the "soundtrack" often behaves like a character wielding sharp objects and noisemakers, this somewhat reduced conception of what constitutes the film's soundtrack only concerns one of the film's musical figures—the percussive, atonal underscoring that is often foregrounded to such a degree that it competes with our ability to hear the film's dialogue.[7] However, this music, which features a cacophony of percussion instruments and electronically manipulated sounds and vocals, is in fact secondary to the film's dominant leitmotiv, the "Punch-Drunk Melody."

And while this central melody is the first music we hear, the film actually begins in the midst of a vacuous silence, perhaps reflecting Barry's existential state as he sits alone in his office. In this opening segment, Barry witnesses a succession of inexplicable events: a violent rollover car accident, a cab dropping a harmonium on the street outside the warehouse where he works, and the aforementioned appearance of Lena.[8] Significantly, the film's first musical notes are heard as Barry brings the harmonium into his office and attempts to discern how to operate such an odd instrument. In a soft, unassuming fashion, the "Punch-Drunk Melody" begins, a sweet and simple waltz that issues not from the harmonium itself, but from Jon Brion's orchestral underscoring.

Although Brion develops this leitmotiv throughout the film, it does not symbolize a character or a place in any strict sense, for its appearance is not tied to a particular individual or location. Rather, this theme functions independently from what we see in the images, indicating a mysterious presence that is implicated in the narrative world. It signifies a force that runs counter to narrative appearances; just like the car wreck and the appearance of both the harmonium and Lena, this music emerges without explanation. It appears despite the fact that literally nothing has been revealed at this point about who Barry is, why he is dressed in a blue suit, and why his behavior is so undeniably strange. Still, "[t]he leitmotif says: listen to me, for I am telling you something significant."[9] Consequently, we as the audience are forced to construct a larger narrative— one that the film does not provide—in order to make sense of this obviously meaningful music, for its ultimate significance resides beyond our immediate comprehension. Just like Barry, we too ask questions that the narrative neither poses nor answers. Why is this music here? How does it work? What does it mean?

The first notes that Barry successfully strikes on the harmonium are dissonant in relation to the "Punch-Drunk

Melody." However, the orchestral underscoring does not simply press on unknowingly; it actually anticipates Barry's eventual participation. In response, as if sensing the nondiegetic leitmotiv himself, Barry plucks out a clumsy rendition of the basic melody that was heard only seconds before. In this moment, something is present with Barry, something that is not found in the images we see. Here, the music is functioning to indicate the presence of something that is quite literally inviting him to play along. It calls out to him from a realm beyond the world of the diegesis, urging him toward a harmonious relationship with the melody. We hear this same leitmotiv as Barry and Lena are on their first date, as they experience their first kiss, and as he carries the harmonium from his warehouse to Lena's apartment—all moments in which Barry increasingly realizes his desperate need for integration, relationship, and, indeed, love. Finally, we hear the "Punch-Drunk Melody" at the end of the film as Barry sits in front of the harmonium in the middle of his expansive warehouse. Rather than discordant, though, the notes that Barry plays on the harmonium are now in full accord with the melody we hear in the underscoring. As mirrored in his newfound relationship with Lena, he has fully entered into a relational union, not with the nondiegetic underscoring per se, but with the mysterious presence that this music signifies. As a result, he has taken his first steps toward becoming an integrated human being.

Thus, in *Punch-Drunk Love*, Anderson calls upon music not simply to enhance the visual elements of his films, but to indicate a pervasive presence that stands outside the film's primary representation. As a marker of his particular cinematic style, Anderson employs music in this fashion in his other films as well. For instance, the music in *Magnolia* presents us with a coherent understanding of life that is rooted in our profound interconnectedness with one another. Similarly, the music we first hear in the opening segment of *There Will Be Blood*, which we will outline in more detail below, portends

the presence of an immitigable force (perhaps fate) with which Daniel Plainview must contend. Although contributing to discrete narratives, a consistent voice emerges through Anderson's distinctive use of music, informing our understanding of each of his films.

Here, then, is where our musical analysis provides us access to otherwise unrealized interpretive possibilities. For the music in *Punch-Drunk Love* works against the notion that Barry can simply manufacture meaning or make sense out of the chaos of his life through his own agency. Indeed, even the inharmonious underscoring that some have identified as the film's "soundtrack" signals Barry's inability to find intimacy or connection on his own. This music is not merely a redundant symbol of Barry's inner turmoil, for it is noticeably absent from every scene in which his overwhelming rage causes him to break pane-glass doors, destroy restaurant bathrooms, and punch holes in his office wall. Rather, unlike tonal dissonance that naturally moves toward resolution by "releasing" or "discharging" tension, the atonal dissonance of this music finds no resolution. As it routinely accompanies those segments of the film where Barry attempts to produce meaning, integration, and relationship artificially, this music signifies the way in which Barry's life has collapsed in on itself. However hard he tries, he simply cannot create meaning out of chaos.

Thus, the particular ways in which Anderson employs music throughout his films express a number of assumptions regarding life and the world—assumptions that are not only theologically motivated but are simply inaccessible to theological dialogue without a careful consideration of music. Anderson's films certainly raise questions concerning the fundamental interconnectivity of our life in the world. That is, in Anderson's movies, humans are, at their core, relational beings, and to deny this relational constitution is to deny the very thing that makes life meaningful and good. However, when we recognize how

music functions in his films to indicate a presence that cannot be contained in the image, we realize that, for Anderson, integration only comes through an act of willful surrender. Barry finds meaning and wholeness not through his own efforts, but as he gives himself over to the pervasive presence that envelops all the pieces of his fragmented life. In contrast to many modern, "enlightened" notions of human life and meaning, we are not the sole agents of our reintegration and redemption. Indeed, the music in *Punch-Drunk Love* suggests that we are far more dependent upon this larger, mysterious force than we realize. Thus, the music in his films urges us to consider not simply why seemingly random events happen, or how we might unravel their mysteries, but whether we will respond and ultimately surrender to the unmistakable presence that relentlessly impinges upon our lives, calling us toward wholeness and integration with its sweetly sung melodies.

MUSIC AS AN IMMANENT TRANSCENDENCE

A second but related way in which Anderson employs music according to his particular cinematic style is by calling upon music to signify the presence of an immanent transcendence. That is, in a seeming paradox, while the music in Anderson's films functions to indicate the presence of a transcendent Other, it does so through purely immanent means. A similar gesture is present in the work of Gustav Mahler, a composer who believed that "music must always contain a yearning, a yearning for what is beyond the things of this world."[10] However, this transcendence for which music yearns can only be glimpsed in and through the immanent structures of the composition. Thus, in Mahler's music, the "breakthrough" of the "Other" into musical form is "not immanent yet arises from immanence"; it is both "alien to the composition and inherent in it at the same time."[11] In other words, music's excess of meaning is rooted neither in its radical otherness nor its pure materiality, but in its "immanent transcendence."[12]

In a parallel fashion, while the music in Anderson's films functions to indicate a pervasive presence within the diegetic world, this presence cannot be reduced to a mere elevation of human self-consciousness or a heightened awareness of the basic interconnectivity that unites a film's characters. Nor is this musical presence simply an offscreen character that remains entirely bound by the immanent frame.[13] Rather, Anderson often turns to music in an attempt to express the presence of something wholly "Other"—something that has a decidedly transcendent source and thus lies beyond the film's primary representation, yet emerges in and through immanent means as a transformative force in the world.

In *Magnolia*, for example, the sudden and unexpected deluge of frogs that signals the film's climax "seems symbolic . . . of a higher force whose reasons may not be understood but whose effects can be seen."[14] Yet the amphibious downpour itself is not a symbol of this higher power; it is simply an effect of the mysterious force that necessarily resists visual representation, but is nonetheless present and active in the narrative world. Consequently, in light of the symbolic limitations inherent in the film's images, it is the music that, more than any other element in the film, not only points to an ordering presence in the world but also allows this presence to emerge immanently. As *Magnolia*'s largely empathetic, nondiegetic underscoring envelops the interwoven stories of the film's nine principal characters and lends the otherwise disjointed scenes a sense of cohesion and unity, it indicates the presence of a structuring force that is inexplicably drawing these characters toward integration and, potentially, redemption.

Significantly, though, this redemptive, integrating force is made manifest through immanent means. As Aimee Mann's "Wise Up" crosses through the diegetic boundary and each of the film's characters unexpectedly join together in singing the song's lyrics, the ordering force that was once only present in the film's "background" (i.e., the underscoring) now makes itself

fully known in the film's foreground. In striking contrast to the deluge of frogs, this presence does not intrude miraculously "from above" as if falling from the sky, but, rather, emerges "from below," arising from out of the murky banalities of these characters' lives. The music in *Punch-Drunk Love* functions similarly. Although the "Punch-Drunk Melody" resides in a realm that transcends Barry Egan's limited frame of reference, it emerges as a formative presence in his life, whispering to him in and through his concrete experiences of the world. In other words, as with the music in *Magnolia*, this particular melody suggests the presence of an immanent transcendence.

In both *Magnolia* and *Punch-Drunk Love*, the immanent transcendence that music brings about is almost palpable; its presence saturates these films to such a degree that characters actually sing and play along in concert with its melodies. However, in *There Will Be Blood*, the converse is true, for Anderson calls upon music in this film to intimate a force at work in the world that runs counter to narrative appearances. That is, the film's music expresses the presence of a structuring influence in a world that is, at least on the surface, entirely devoid of transcendence.

Very basically, the film charts the rise and demise of Daniel Plainview, a self-professed "oil man" who is relentlessly driven by his insatiable thirst for more. At the same time, it also depicts Plainview's contentious relationship with Eli Sunday, the young, charismatic pastor of Little Boston's "Church of the Third Revelation" whose deep-seated ambition and avarice are only matched by Plainview's. Interestingly, though, in spite of this overt religious imagery and Christian symbolism, *There Will Be Blood* presents us with a world in which the divine is conspicuously absent, or perhaps more accurately, it presents us with a world in which humanity has rendered the divine inconsequential.

If we approach *There Will Be Blood* in terms of the relationship between musical form and film form, then the

musical cues in both the main title and end credit segments serve as a helpful frame of reference for understanding how a transcendent Other might emerge and even "break through" this wholly immanent world. The music we hear during the opening segment of the film features an unintelligible mass of strings that slowly fuse into a single, monolithic unison. This wall of sound, written by Jonny Greenwood, the Radiohead lead guitarist who composed the film's score, is highly dissonant.[15] Like much of the music in the film, it features turn-of-the-century orchestral instruments that one would naturally expect to hear in a movie set in the early twentieth century. However, because of the unique manner in which these instruments are played—the violin strings are harshly plucked and slapped with the bow—the music emits the "wrong" kind of sound. These inharmonious strings eventually settle on the note of F sharp, only to devolve back into a discordant incoherence.

By orienting the audience toward the narrative and serving as a buffer between the outside world and the diegesis, this main title music performs two related functions both quickly and effectively. First, as it introduces the character of Daniel Plainview, the forced coalescence of strings portends the eventual collapse of Plainview's soul.[16] In an important sense, his fate is both foretold and sealed before the film's first frame; his life simply unfolds according to the trajectory set forth by the music we hear. Second, though, the opening music establishes the overall tone of the film, ushering the audience into a world that has been radically and perhaps violently compressed—a world reduced to pure immanence. From within the space this music creates, the film's explicit religious symbolism and its depiction of the rampant (mis)appropriation of religious practices for capitalistic ends only compound the sense that the divine has not so much departed from this world as it has been methodically and forcefully marginalized. Consequently, as the film unfolds, God figures equally in the single-minded

pursuits of both the oil man Daniel Plainview and the preacher Eli Sunday, which is to say, ironically, not at all.

Plainview's character thus offers a concretization of this approach to life and the world—a thoroughly modern, disenchanted notion of human significance in which humanity has displaced God as the fundamental shaping force in the world. However, as the music not only serves as the mark of a world in which transcendence has been thrust to the periphery but at the same time indicates the presence of an ineluctable force at work in the world, it points to a basic paradox: even in the midst of a purely immanent frame, transcendence remains mysteriously yet undeniably present, if only on the margins. Significantly, we hear this same music not only during the main title sequence but also as Plainview drags his crippled body over a barren and rocky landscape to collect payment for the silver he is mining. It returns once again as he buries the man he has murdered for posing as his brother and potentially threatening his fragile empire. Thus, it accompanies those moments when Plainview asserts his autonomy and attempts to seize control of his rapidly decaying life, stamping out anyone who might challenge his dominion. In doing so, the music does not only offer an immanent critique of his claim to total sovereignty, it also subverts this claim, for its persistent, lingering presence signifies the inexorable: Plainview might gain the whole world through his obsessive machinations, but he most certainly will lose his soul.

In light of the way in which the opening music frames the film as a whole, the music in the end credits sequence bears an added significance. In the film's closing scene, following an extended dialogue in which Plainview speciously agrees to engage in business with Eli Sunday on the condition that Sunday admit that he is "a false prophet and that God is a superstition," Plainview bludgeons Sunday to death with a bowling pin. He then utters a final pronouncement, an apparent gloss on the last words of Christ: "I'm finished." Notably, this

segment of the film takes place in complete musical silence. Yet, immediately following Plainview's declaration, the third movement of Brahms' Violin Concerto in D Major breaks into the silence, continuing unabated as the film fades to black and the closing credits roll. Given the stark brutality of the murder, the decidedly jubilant, even "glorious" feel of Brahms' composition is particularly affecting. In relation to the scene, the music is working anempathetically. Much like mechanically produced diegetic music foregrounded during scenes of violence, the lively concerto moves along as if it were indifferent to the human condition.

However, as this music appears in only one other location during the film—the dedication of the oil derrick in Little Boston—it directly links Plainview's act of murder with his drilling for oil, treating both the spilling of the land's blood and the spilling of human blood equally. Thus, as it exhibits an apparent lack of concern toward such acts of violence, this anempathetic music reinforces the senseless absurdity of Sunday's death. In the end, his demise is no more significant than the act of digging up mud. Furthermore, the music registers the mundane completion of Plainview's lifelong contention with Sunday and, indeed, his lifelong contention with the divine. In killing Eli, whose Hebrew name literally means "my God," Daniel simply follows the path that the music set out for him in the opening scene. That is, he effectively removes God from his lived experience of the world.[17] As the violin concerto anempathetically ushers the audience back into the world beyond the diegesis, we recognize that this fatal struggle carries no larger, cosmic significance, nor does it bring about any sort of redemption for either character. Rather than the overcoming of death through self-giving sacrifice ("It is finished"), we simply have death and dying ("I'm finished").

If we strictly follow the conception of "breakthrough" as the appearance of a transcendent Other in and through the immanent structures of a composition, then the concerto

should actually mark a redemptive moment in the film, which, as we have noted, it does not. Thus, by suggesting that Anderson uses music in this film to indicate the presence of an immanent transcendence, we are slightly augmenting the musicological conception of breakthrough. It perhaps goes without saying that Anderson could have just as easily employed different music in this segment, or perhaps no music at all. For example, in the final scene, he might have chosen music with a somber mood that was more reflective of the gravity of Plainview's actions. Empathetic music of this kind would likely have imbued the film's finale with a sense of tragedy, leaving the audience to ponder whether Plainview came to realize that in slaying Eli (and thus both God and God's false prophet) he had in fact destroyed the last vestiges of his own humanity. The film's tragedy would then be related to Plainview's belated and ill-fated realization that, while God may be an illusory superstition to which fearful people cling, the divine is still necessary for human existence. In this case, however, the musical breakthrough would be neither transcendent (because the Other is shown to be merely illusory) nor immanent (because empathetic music at this point in the narrative would conflict with the parameters established by the rest of the film's music).

However, the Brahms concerto remains consistent with the film's immanent structures, and it does so precisely because of its apparent indifference toward the human condition. Anempathetic music often expresses an inability or reluctance on the part of the "cosmos" or "world-spirit" to intervene in mundane human affairs; nature blindly and unrelentingly moves along even in the face of our abhorrent hostility toward one another. Yet, as the music in the film's opening scene suggests, the energizing force that is present in the *There Will Be Blood* is neither unable nor unwilling to intervene; indeed, it has firmly set the course for Plainview's ultimate demise. Thus, from within the immanent structures of the film, the

anempathy of the Brahms concerto does not express cosmic indifference per se, but rather the spirit's willingness to grant Plainview (and modern persons in general) the desire of his heart, namely, an existence unfettered by transcendence—one in which humanity has wholly displaced God as the ordering, shaping, and creative force in the world.

Here then is where the breakthrough into the film's representation occurs. Rather than offering clarity into the heart and mind of Daniel Plainview, the music's ambiguity and duplicity—its simple refusal to explain itself—only add to the disconcertion we feel as an audience. A brief glance at the IMDb discussion boards reveals sharply divided impressions of the film as a whole, its final scene, and the appearance of the concerto.[18] However, what is generally agreed upon is that this particular choice of music evokes a profound sense of disease among filmgoers; it simply "feels" wrong. In some fundamental way, it conflicts with our deep-lived experiences of the world. Yet, in a surprising twist befitting a film like *There Will Be Blood*, our basic dissatisfaction with a world where transcendence has been stamped out serves as the very space in which the Other (re)emerges or breaks through, not as one who was lamentably absent, but one who was present all along.

As signified by our reaction to the music in both the main title and end credit sequences, our *inability* to look upon Plainview's godless life with indifference reflects the presence of something (or someone) that subtly yet relentlessly calls our attention to the emptiness of such a state. What is more, as it throws us back into the "real" world, our dissatisfaction with the end credits music forces us uncomfortably into the position of Daniel Plainview, namely, railing against the apparent senselessness of a world that *we* have created, that *we* have ordained, and over which *we* have ultimate control. Thus, the more that the music disturbs us, the more that we sense the presence of an immanent transcendence—an Other who, from beyond the margins of our immanent frame, rushes

back into the void, filling the spiritual gaps in both the film and our own lives.

Admittedly, though, without an awareness of how music is functioning in Anderson's films, one would likely never consider the potential emergence or in-breaking of a transcendent Other in *There Will Be Blood*. In fact, in the absence of any musical considerations, the film becomes simply a parable—a straightforward exploration of the nature of evil or a cautionary tale told through visual metaphors. To be sure, the film beautifully depicts Plainview's descent from ambitious entrepreneur to self-obsessed misanthrope, and in the process it calls upon a number of breathtaking visuals to accomplish this task. Yet without an awareness of the film's music, our understanding of the film remains limited, dependent solely upon the implications of its oil-as-blood and landscape-as-wilderness metaphors, its symbolic depiction of evil, and its representation of religious figures. Consequently, if we focus only on its explicitly religious or theological content, our understanding of the film's appeal to any kind of "spirituality" or religious meaning remains bound up in the symbolic, the representational, and the iconic.

However, as we attend to the ways in which Anderson uses music to signify the presence of an immanent transcendence, we are able to access a level of cinematic meaning that lies beyond the limits of visual representation. Through music, Anderson's films present us with theologically informed understandings of the world that, at times, run counter to narrative appearances. The music opens out onto questions not simply of the deadly consequences of greed and ambition, but of the role of transcendence in human affairs: In a world over which humanity has assumed absolute control, where do we encounter the divine? Is God simply indifferent to the human condition, or is God somehow present in and through our suffering?

What is more, by turning to the film's music, we are not only presented with a host of new possibilities for

understanding the ways in which film addresses the transcendent, but we also gain a new perspective on contemporary conceptions regarding what transcendence is and how it breaks through our immanent frame. In Anderson's films, the music suggests that meaning, redemption, and wholeness are found neither in pure immanence nor through the heavy-handed intrusion of a radically transcendent Other. While the source of human meaning may be ultimately transcendent, it is only capable of effecting a transformation of the human condition if it emerges immanently, rewriting our lives from the interior. For Anderson, even in the midst of a wholly disenchanted world, the divine is present and active. In this way, he reveals a basic dissatisfaction with the modern distinction between the noumenal and phenomenal worlds, the removal of the divine from our sensate experience, the separation of the sacred and the secular. Thus, through his use of music, Anderson both critiques and moves beyond what, at first glance, appear to be two competing visions of the world: "one in which God exists and one in which God is conspicuously absent."[19]

MUSIC AS "REVELATORY"

Finally, a third way that the music in Anderson's films bears an expressly theological meaning has to do with its "revelatory" capacity. By suggesting that his music functions in this manner, we are intentionally moving from strictly formal considerations to questions of reception. That is, as they respond to the ways in which Anderson employs music to indicate a pervasive presence and an immanent transcendence in his films, filmgoers often identify their experience of these films as "spiritual," "transcendent," and even "revelatory." In fact, in many instances, they point expressly to music as the primary element in the film that shifts the cinematic experience into this spiritual or transcendent register. As the range of responses to the music in There Will Be Blood suggests, not all filmgoers consider Anderson's films to be functioning in a

revelatory manner. However, for those that do, the music plays a key role in opening them out into something larger, something unexpected yet profoundly meaningful.

It is important to note that while reflecting on their cinematic experience and contributing to the public discourse concerning Anderson's films, filmgoers often fail to articulate clearly what they mean when they use terms like "revelatory" or "spiritual."[20] This lack of precision is to be expected, though, for much like the young agnostic woman who heard a mysterious voice calling to her in her dreams, both our immediate experiences and their larger significance are difficult to put into words. Indeed, it would appear that a large part of the reason filmgoers identify their experiences as meaningful is precisely that these encounters with film are both ineffable and inexplicable. While categorically enlightening on a very basic level (i.e., revealing), the full depth of meaning of these "revelatory" experiences remains hidden and mysterious. Although profound, they resist our attempts to explain, analyze, and rationalize. They are "decisive but illegible."[21] However, as filmgoers attempt to give voice to an experience that stretches the limits of language, a number of common themes emerge, two of which I would like to outline here.

First, when speaking of Anderson's films and the music therein, individuals are inclined to use the term "revelatory" to describe their experience. That filmgoers consciously choose to employ this particular terminology is both intriguing and significant for our discussion. Moreover, the conception of Anderson's music as "revelatory" unites the responses of both professional film reviewers and "average" audience members who are participating in Internet-based discussions. For example, Alex Ross, a contributing author to *The New Yorker*, believes that the music in *There Will Be Blood* is so distinctive and so rooted in the filmmaker's "personal language" that the "effect is revelatory: an entire dimension of the film experience is liberated from cliché."[22] Expressing a strikingly similar

sentiment, a contributor to the Rotten Tomatoes community suggests that the film is "a complex man's simple story rendered hugely, horribly, and wonderfully in equal measure, and it's revelatory as hell."[23]

On the one hand, these revelatory experiences are spoken of in terms of an awakening or an elevated awareness of one's self, an immanent experience that issues from out of the depths of an individual's self-consciousness (i.e., transcendence with a lowercase "t"). Thus, the music in *Magnolia* reflects Anderson's attempt as a filmmaker to "take his audience on a revelatory journey. It contains moments of considerable beauty, terror, and insight."[24] On the other hand, filmgoers are equally inclined to speak of these experiences as a type of spiritual or mystical encounter with something transcendent (i.e., Transcendent with a capital "T"). *Magnolia*, for instance, is considered a "transcendent piece of work; the movie blossoms on a spiritual whim."[25] Likewise, *Punch-Drunk Love* is not only "heartbreakingly ordinary" but "like every Anderson film is . . . transcendent."[26] Consequently, according to a number of filmgoers, Anderson's films in general and their music in particular somehow presage a reality or a significance that transcends the immanent frame of the cinematic world yet at the same time arises from within the immanent structures of the film.

Second, it is important to note that these experiences, although decidedly "spiritual" and even "revelatory," do not always contain explicitly "religious" content in any traditional sense. Rather, as we suggested in our analysis of the reception of *Moulin Rouge!*, filmgoers often conceive of a film's spirituality and, indeed, its transcendence in affective and even sensual terms. For example, according to a number of responses, the music in *There Will Be Blood* is particularly affecting and thus offers filmgoers a spiritually significant or, in some cases, a revelatory experience. Experiencing *There Will Be Blood* is akin to being "gut-punched." The film's music is therefore "neurologically revolutionary, as if we're seeing with our ears

and hearing with our eyes in a whole new way."[27] However, "[W]hat throws you at first glance emerges . . . as a master plan. [The film] restores your faith in the power of movies."[28] The film's "magnificently unsettling music . . . that is impossible to forget" is "breathtaking," "heart-pounding," "emotionally draining," and ultimately, "revelatory."[29] Thus, it would appear that, for many individuals, the spiritual significance of *There Will Be Blood* is rooted less in a concern with that which is revealed (i.e., the "content" of the revelation) than in the affectively laden experience itself.[30] That is, Anderson's films are considered both meaningful and revelatory because they offer an immediate, affective, first-order experience of the larger essence that constitutes our life in the world; they open the filmgoer out into the presence of something "transcendent."

Consequently, without a basic awareness regarding how film music functions on both formal and phenomenological levels, we are limited in our ability to understand the ways in which these films are already functioning theologically or in a revelatory capacity. Just as one reviewer suggested, the music in Anderson's films is considered to be revelatory because it liberates "an entire dimension of the film experience."[31] This response helpfully encapsulates my basic claim, for when we incorporate a consideration of a film's music into our theological reflection, an entirely new register of meaning opens out before us, thereby making possible a type of theological dialogue and a depth of theological engagement that would otherwise be inaccessible.

However, even as we recognize the ways in which film music signifies the presence of an immanent transcendence and, in doing so, "liberates" this wider range of meanings, we are faced with the basic difficulty of speaking about a phenomenon that has been undervalued and even denigrated in traditional theological reflection, namely, the subjective human *experience* of revelation. Theology simply lacks a developed framework for understanding first-order theological

experiences that take place outside of the church and without reference to any explicitly religious content such as the person and work of Jesus Christ. Therefore, the primary question we will take up in the following chapter concerns how one might best understand theologically the ways in which film music functions as a potential occasion for genuine revelation.

6

THE SPIRIT OF FILM MUSIC

If film music does indeed possess the capacity to mediate a first-order encounter with some manner of t/Transcendence, then we have come to the place where we must reflect theologically on whether God truly does reveal Godself through anything and everything. That is, in light of the ways that this particular cultural product is functioning in the contemporary world, we must thoughtfully consider what it actually means that the heavens above us "declare" the glory of God (Ps 19) and the rocks beneath our feet cry out in praise to God (Luke 19:37-40). Much like the biblical authors, our lived experiences prod us to make sense of the fact that human creatures are somehow capable of clearly seeing and understanding their Creator through creation (Rom 1:19-20), innately intuiting the source of life through human conscience (Rom 2:14-15), and even discerning the presence and activity of the divine Spirit in and through human creativity (Exod 31:3-4)—through art, aesthetic experiences, and presumably "secular" forms of culture such as filmgoing.

Significantly, each of these biblical claims has to do in some way with what theologians have traditionally termed "general revelation." By framing our discussion of film music's theological import in terms of this particular concept, we are not only faced with questions regarding the general spirituality that permeates

our experiences of everyday life, but we are also pressed to consider how broadly we are willing to conceive of God's activity in the world. That is, we are principally concerned with how God might be present, active, and moving in and through those experiences of life that occur outside the confines of the Christian community and without reference to the "special" revelations found in the biblical witness and the life of Jesus Christ.

Due in part to the indefinite, nondescript, and even ephemeral nature of that which is disclosed—mere hints and intimations of the divine—general revelation has been relatively underrepresented within the Christian theological tradition. Yet, in order to engage in a mutually enriching dialogue with film and filmgoers, a more robust understanding of God's general revelation is needed, for, as our analyses of the music in both *Moulin Rouge!* and Paul Thomas Anderson's films suggested, contemporary persons are increasingly willing to identify their concrete moviegoing experiences as "spiritual" and even "revelatory." Our ability to speak intelligibly about the Christian faith in the contemporary world therefore depends upon what we make theologically of these diffuse and ill-defined experiences of revelation. Consequently, the aim of this chapter is to locate the spiritually charged experience of filmgoing within a larger theological framework, considering it in terms of the general revelatory presence of the Spirit of God in the world.

I am by no means the first to suggest that general revelation might serve as a helpful framework for understanding the relationship between film and theology.[1] However, given the unique characteristics of musical-aesthetic experiences in general and film music in particular, I want to speak of general revelation primarily in terms of the indwelling presence of God in the created order. In other words, I am proposing that, in order to arrive at a fuller understanding of film music's revelatory potential, we would do well to broaden our understanding of

revelation, picturing it in terms of God's inspiriting presence rather than simply the disclosure of knowledge about God.

GENERAL REVELATION
A Very Brief History

From a historical perspective, the theological discourse concerning "general revelation" presents us with a number of related yet qualitatively distinct terms for conceiving of God's active involvement in the world outside of the covenant community (i.e., the people of Israel or the Christian church). Theologians have traditionally drawn a rather sharp distinction between a "revealed" knowledge of God and a "natural" knowledge of God. The former is typically considered "special" revelation in that God communicates directly with humanity through the particular means of Hebrew and Christian Scripture and liturgy. The latter is a "general" revelation made available to all humanity; it arises innately through human conscience and through our rational observance of the created order. Following Thomas Aquinas (and, by extension, Aristotle), those in the Roman Catholic tradition have often spoken of this natural knowledge of God in terms of a "natural theology," or an "ascent, by the natural light of reason, through created things to the knowledge of God."[2] That is, by observing the character and behavior of the created order (the *sensibilia* of nature), which reflect the traces of God (*vestigia Dei*) that remain from the original creative act, one is able to attain, through unaided human reason, a fundamental knowledge of a "Prime Unmoved Mover," a "First Cause," and a "Divine Designer" of "Absolute Perfection."[3] In short, "natural theology proves to innate human reason that God *is*, and that God *is one*."[4]

In a parallel fashion, following Augustine (and by extension Plato and Plotinus), many in the Reformed Protestant tradition conceive of general revelation in terms of "common grace." According to Paul's words in Romans 2:15, although

they are unaware of the special revelation that God delivered to the people of Israel, Gentiles have the law of God "written in their hearts," and their "conscience bears witness" to this law. Seeking to be faithful to the biblical witness, the Reformed Protestant tradition has historically affirmed that there exists a "sense of divinity" (*sensus divinitatis*) implanted in every human mind.[5] Yet, given their concern with the pervasive effects of sin, many Reformed theologians have also suggested that humans are unable to cultivate this basic intuition. That is, our innate *sense* of God is incapable of leading us toward a *saving knowledge* of God.

In spite of this sinful state, though, common grace enables individuals to "intuit eternal changeless principles, including the existence and character of God."[6] While remaining distinct from the "natural theology" of Roman Catholicism, this conception of common grace similarly affirms a basic knowledge of God that arises through both human conscience and careful observation of the created order. Thus, at its best, the general knowledge of God that is attained through human reason and enabled by common grace simply serves as the necessary preamble for embracing the saving knowledge of special revelation. Yet, at its worst, it functions only to condemn, leaving a depraved humanity "without excuse" (Rom 2:1).[7]

The division between human reason and divine revelation that is apparent in both the Catholic and Reformed traditions reached its peak during the various European Enlightenments, eventually resulting in the elevation of reason over and against revelation. On the one hand, those who embraced the philosophical rationalism of Descartes suggested that humans were capable of acquiring a true knowledge of God based upon discursive reasoning alone. From this perspective, "supernatural" revelation was not only superfluous but fundamentally *irrational*, for "[n]o supernatural disclosure from without could supplant the plain, perfect, and unchangeable religion of reason and nature."[8] On the other hand, in the wake of Kant's *Critique*

of Pure Reason, other theologians questioned whether humanity's observations of the phenomenal world could ever lead to a true knowledge of God. For, just as God does not appear in our sensible experience through supernatural revelation, neither does human reason afford us a knowledge of that which lies beyond the phenomenal world.

The effect of Enlightenment thought on the trajectory of subsequent theological reflection in the West cannot be overstated. Indeed, as it concerns our understanding of revelation, even our supposedly "postmodern" culture has inherited a form of Enlightenment rationality. However, following the publication of his commentary on Romans, all contemporary theological reflection concerning general revelation takes place in the shadow not just of Kant and Descartes but of Karl Barth. Significantly, Barth's theology was both dialogical and polemical, and always constructed "in contradistinction" to something or someone.[9] In large part, Barth's theological project was an intentional response to what he believed was a betrayal of the gospel by his former teachers who gave their approval for the First World War. In Barth's mind, the necessity of his vehement protest was demonstrated as the German church supported Hitler's rise to power through an appeal to a "natural theology." Thus, Barth launched an intellectual assault not only against the liberal Protestantism of his early mentors but also against Roman Catholicism and other dialectical theologians, attacking any theological reflection that he believed either started "from below" or considered humanity's religious experience to be its "decisive and primary concern."[10]

Barth's polemic reached a critical climax in his debates with Emil Brunner concerning "natural theology."[11] As dialectical, "neoorthodox" theologians who were standing at the forefront of a new wave of (Protestant) theology, Barth and Brunner effectively redefined revelation, conceiving of it not as the communication of an abstract body of knowledge of which humans were previously ignorant, but as "self-revelation,"

that is, as the disclosure of God's very self through the incar-
nate word of God.[12] However, whereas Brunner believed that a
"point of contact" exists between God and humanity by which
humans are able to receive and experience this divine revela-
tion, Barth asserted that revelation is only ever an act of God's
direct self-revelation; it is in no way dependent upon any form
of human involvement, nor is it mediated through reason, con-
science, emotions, nature, or culture.[13] Moreover, for Barth, the
sole means through which God communicates with humanity
and thus the only source of revelation is found in the event
of Jesus Christ. In other words, all revelation is restricted to
the incarnation of the word of God. Thus, "[i]f God had not
descended so far into these depths that He met us as one of
ourselves in all the distance and nearness of a human form,
there would be no revelation."[14]

As it relates to our consideration of general revelation,
Barth's eminently transcendental conception of revelation
effectively radicalized the infinite qualitative difference
between God and humanity, thereby establishing a stark
antithesis between divine revelation and human experience.
For Barth, the Spirit of God is so completely and wholly Other
that there is an utter discontinuity between the Creator and
the creation. Given this basic assumption, Barth could not
abide any theology that posited human subjectivity as a com-
ponent of divine revelation.[15] Therefore, along with the natural
theology of the Thomistic/Roman Catholic tradition, he also
denounced the general revelation espoused by the Reformed
tradition and his fellow dialectical theologians, treating them
both as essentially synonymous concepts.

It is important to note that Barth was correct to resist
those theological formulations that spoke of revelation as
something that occurs apart from the presence and activity of
the Spirit of God. Yet, by failing to distinguish between a pure
rationality on the one hand and God's illumining presence on
the other, Barth unnecessarily diminished the significance

of the Spirit's ongoing activity in our experience of life in the world. In addition, Barth further diminished the presence of the Spirit in human experience by restricting revelation solely to the Christ event.[16]

Barth's conception of revelation proves instructive for our discussion, not only because of the influence he has exerted on subsequent theological reflection, but also because his thought both reflects and encapsulates two of the basic difficulties that have beset the historical discourse on general revelation. The first difficulty is that "knowledge" (i.e., epistemology) and "salvation" (i.e., soteriology) have together formed the primary theological matrix through which revelation and revelatory experiences are conceived and understood.[17] As noted above, the operating assumption standing behind both the Roman Catholic conception of natural theology and the Reformed Protestant notion of common grace is that revelation first and foremost concerns humanity's relative knowledge of God. Likewise, even though Barth understood revelation to be the disclosure of God's very self in the revelatory act, "God's revelation is . . . His knowability."[18] Thus, his rejection of general revelation was actually focused on the basic inadequacy of the knowledge mediated through creation, reason, and culture, and the fundamental superiority of the knowledge mediated through the Christ event. Moreover, Barth restricts God's revelation to the incarnation of the Word because, in contrast to general revelation, the knowledge it mediates is salvific; God is savingly known only through the self-revelation of Jesus Christ.

Without disputing his final conclusion regarding the efficacy of Christ, this (over)emphasis on God's revelation as nothing other than "saving knowledge" constricts our ability to speak convincingly concerning the ways in which God is active in the world where Christ is not explicitly "made known." Furthermore, the prioritization of these epistemological and soteriological concerns not only runs the risk of

reducing salvation to a matter of knowledge, but it necessarily precludes a full consideration of the many alternative yet equally valuable and life-giving manners in which the Spirit is present with humanity through creation, conscience, and even culture.

A second difficulty that this overemphasis on "knowledge" and "salvation" presents is the tendency for theologians to overlook and even denigrate first-order experiences, questioning whether these experiences are able to serve as either a genuine source for constructive theological reflection or an encounter with the divine. According to many within the Christian theological tradition, as our experience of general revelation necessarily fails to produce a "full" or "saving" knowledge of God, the knowledge these experiences do afford is purely illusory and without merit.[19] Thus, by treating our experience of the Spirit's general revelatory presence with suspicion, we effectively diminish God's role in the broader culture's (and our own) meaning-making activity, even to the point of separating them completely.[20]

In light of this seeming ambivalence in the Christian tradition concerning the theological import of our experiences with creation and human creativity, the primary question we must face is how we might locate our understanding of film music within the larger framework of general revelation while at the same time moving beyond the traditional strictures of knowledge and salvation. The basic answer I want to put forward is that, in order to truly understand, articulate, and, in an important sense, appreciate film music's seemingly mysterious presence and how it relates to the larger project of God in the world, we must recast our conception of general revelation in terms of the Spirit's indwelling presence. That is, if Christian theologians are to speak intelligibly concerning those meaning-filled cultural experiences that take place outside of ecclesial or institutional boundaries, occur without reference to Jesus Christ, and yet are accepted and understood

as "revelatory," they are in need of a more robust pneumatology—one that recognizes the ongoing revelatory presence of the Spirit of God in the world.

GENERAL REVELATION AS THE SPIRIT'S INDWELLING PRESENCE

As Barth's *locus theologicus* shifted over time, his theological vision concerning the possibilities of general revelation expanded. In fact, one of Barth's last acts was to offer a criticism of his life's work, suggesting that his fear of subjective experience was no excuse for failing to develop a theology of the Spirit in his *Church Dogmatics*.[21] Yet Barth also offered a final word of warning concerning the risk of repeating his predecessors' mistakes and simply equating pneumatology with anthropology once again. He suggested that perhaps only a "gifted young person" who was "very grounded, spiritually and intellectually" would succeed where he had failed and be able to develop a theology of the Spirit that resisted the "perplexing" yet seemingly inexorable tendency for pneumatology to collapse into pure subjectivism.[22] While we might certainly name others who have embarked upon similar endeavors, the work of Jürgen Moltmann, a former student of Barth's, presents us with a pneumatologically oriented theology much like the one that Barth envisioned yet never realized.[23]

In an important sense, Moltmann presents us with an expressly Trinitarian pneumatology—one that highlights the Spirit's revelatory role as the divine energy of life who is present in and through our experiences of the created order.[24] According to Moltmann, because we encounter the Spirit's real presence in the whole of our deep-lived experiences of life in the created order, it is possible to perceive and experience God in all things, and all things in God.[25] Thus, his work provides us with a number of helpful resources for expanding our understanding of general revelation to include and even emphasize the indwelling presence of the Spirit in creation,

conscience, and culture—a presence that is necessarily made manifest outside ecclesial boundaries and whose efficacy reaches beyond the Word.

Interestingly enough, this understanding of the Spirit's indwelling presence is well represented within the biblical witness. Specifically, the grounds for the possibility of perceiving God in all things and all things in God originate from an "understanding of the Spirit of God as the power of creation and the wellspring of life."[26] As Psalm 104:29-30 suggests, "When you take away their breath [*ruacham*], they die and return to their dust. When you send forth your spirit [*ruachaka*], they are created, and you renew the face of the ground." God's Spirit or *ruach* is not only the perpetually creative force of life but also God's energizing and sustaining presence. It is the very breath of life in both human beings and other created beings, the source from which our own existence or *ruach* springs. The Spirit of God is therefore intimately bound up with the human spirit, for human life is impossible in the absence of God's *ruach*. Although distinct, there is a basic continuity between the human spirit and divine Spirit. In other words, the Spirit's general revelatory presence is both ontological and relational; who we are as human beings is fundamentally constituted by the ongoing, active involvement of the God who is relationally present with us through the perpetually re-creative Spirit of life. As Job 33:4 states, "The Spirit of God [*ruach El*] has made me, and the breath of the Almighty gives me life." Consequently, in light of this biblical testimony, Moltmann suggests,

> "Every experience of a creation of the Spirit is hence also an experience of the Spirit itself. Every true experience of the self becomes also an experience of the divine Spirit of life in the human being. Every lived moment can be lived in the inconceivable closeness of God in the Spirit: *Interior intimo meo*, said Augustine—God is closer to me than I am to myself."[27]

Yet the Spirit's general revelatory presence does not concern simply who we are as human beings, but also the final goal toward which God is moving all of creation. That is, the embodied presence of the Spirit of God—the divine *ruach* who hovered over the primordial waters of creation (Gen 1) and who presently "dwells" in our physical human bodies (1 Cor 6:19)[28]—reflects and anticipates the realization of the ultimate project of God in the world, namely, God's physical indwelling of the created order. As Revelation 21:3 makes clear, "The home of God is among mortals. He will dwell with them . . . and God himself will be with them." The end—the telos—to which all creation is drawn and for which it "groans" (Rom 8:22) is, in fact, a return to our basic constitution: being-in-communion with God's general and universal revelatory presence. Thus, in creating, sustaining, and redeeming the world, the Spirit of God is poured out on "all flesh" (Joel 2:28; Acts 2:17-18) in order that the Creator might finally dwell with creation. As Moltmann states, "That is why the history of the Spirit points toward that consummation which Paul describes in the panentheistic-sounding formula: 'that God may be all in all' (I Cor. 15:28)."[29]

GOD'S IMMANENT TRANSCENDENCE
Ruach and Shekinah

But what exactly does it mean to say that God is "all in all?" In what ways do we experience the Spirit's "indwelling" of the created order? In order to speak of the various dimensions of our experience of the Spirit's pervasive presence, Moltmann draws upon and develops the concept of the Spirit's "immanent transcendence."[30] Moltmann identifies two terms that not only allow him to articulate the dynamic nature of this seemingly paradoxical concept, but also provide him with the means for connecting his holistic, Trinitarian pneumatology with both the biblical witness and the Jewish faith. Thus, the

transcendent Spirit of God is immanent in the world as both *ruach* and Shekinah.

Ruach: God's Creative Breath of Life

From the perspective of the Hebrew Scriptures, the Spirit is conceived as Yahweh's *ruach*, the divine breath of life that perpetually animates the whole of the created order (Eccl 3:21; 11:5; 12:7). The Spirit is the irresistible force of the Creator's power, ushering in both God's wrath and God's life-giving presence (Ezek 13:13; 36:26-27). *Ruach* is at once "God's own creative power to give life, and the created ability to live enjoyed by all the living" (Ps 104:30).[31] In this view, the Spirit's creative work is not subsumed under redemption and thus somehow cut off from our embodied life in the natural world. Rather, Yahweh's *ruach* serves as "the divine wellspring of life—the source of life created, life preserved and life daily renewed, and finally the source of the eternal life of all created being."[32]

Thus, our experience of the divine *ruach* is in no way hostile to the body or sensuality, nor is it detached from the physical world. In fact, if we are to comprehend fully the significance of *ruach* for our understanding of the Spirit of God, we must abandon contemporary notions of "spirit" derived from the Greek *pneuma*, the Latin *spiritus*, and the German *geist*, for these terms carry immaterial and incorporeal associations; they conceive of spirit as something that is antithetical to matter and physical bodies.[33] The notion of *ruach*, however, does not allow for such a cleavage between spirit and body, spirituality and sensuousness, or transcendence and immanence. Rather, it is the creative energy of the divine that is present in our physicality, the transcendent Spirit whom we encounter in and through immanence.[34]

Because our lives are fundamentally energized by the presence of Yahweh's *ruach*, our physical, embodied experiences—although immanent—also have a transcendent side, "so that in the immanence of our hearts we discover a transcendent

depth. . . . This gives our own finite and limited life an infinite meaning."[35] As the divine *ruach* is both God's creative Spirit and the power from which everything that has life lives, every experience of the Spirit's creation and every true experience of the self becomes also an experience of the divine Spirit of life in the human being. Thus, as Yahweh's *ruach* animates the whole of the human being, our sensual, affective, bodily experiences are encounters with a transcendent "depth" that is rooted in the presence of God's Spirit. Indeed, the human being is a much "deeper" creature than we often realize.[36]

It is important to recognize the ineliminable dynamism of Moltmann's concept of immanent transcendence. He is not suggesting, as was Kant, that the Spirit is simply a "transcendental" ground that constitutes our phenomenal experiences. To be sure, his notion of Yahweh's *ruach* as the life energy of created beings involves an experience of the transcendent "depths" of the human person. Yet he repeatedly makes clear that the transcendent depth of our self-encounter is always already dependent on the presence of the *ruach*, which, as the "creative power of God," remains transcendent to all that is created.[37] That is, Moltmann maintains the fundamental distinction between the Creator and creation—the only true "duality" we can speak of within the Christian tradition. *Ruach* is therefore not a pantheistic concept; everything is not God. Rather, this Trinitarian concept of the *ruach*'s immanent transcendence is panentheistic; in the presence of God's Spirit, we experience God in all things and all things in God.[38]

Therefore, in addition to the creative life force immanent in all that is living, Moltmann points to Yahweh's *ruach* as "the confronting event of God's efficacious presence."[39] *Ruach* is not a characteristic of God but a mode of God's divine, pervasive presence in our life and the world. As the psalmist says in Psalm 139:7, "Where can I go from your spirit? Or where can I flee from your presence?" What is more, as it is related to the Hebrew word for breadth (*rewah*), we might interpret *ruach* not

just as a personal presence, but also as the transcendent space in which we live "in" God's Spirit. In Job 36:16, the Creator is depicted as drawing Job out into a "broad place where there is no constraint." Similarly, God provides the psalmist the ability to stand out of harm's way in "a wide open place" (Ps 31:8). We therefore experience the presence of God's *ruach* as the space in which we "live and move and have our being" (Acts 17:28). Rather than an object of our experience, *ruach* is the most silent and hidden presence of God's Spirit, for it is both in us and around us. Thus, as *ruach* forms the medium or space of our experience, we cannot talk "about" the Spirit; "[w]e can only talk *out of* the Spirit."[40] Again, what is important to note is that Moltmann is not reducing pneumatology to anthropology or suggesting that the Spirit is simply the transcendental ground of human experience. Rather, as this multivalent biblical notion suggests, while the divine *ruach* is indeed present in the immanent structures of our lives, "God's Spirit is [also] our transcendent space for living."[41]

Finally, Moltmann suggests that, in biblical thinking, Yahweh's *ruach* is closely related to God's creative wisdom or *hokmah*. Indeed, for Moltmann, "*ruach* and *hokmah*, Spirit and Wisdom, are so close to one another that they are actually interchangeable."[42] Within Wisdom literature, God's *hokmah* is presented as the creative, ordering principle that is immanent in the world. Explicitly recalling the Spirit's creative work in Genesis 1, Wisdom "calls out" to humanity in Proverbs:

> When he [Yahweh] established the heavens, I [Wisdom] was there; when he drew a circle on the face of the deep . . . when he marked out the foundations of the earth, then I was beside him, like a master worker; and I was daily his delight, rejoicing before him always. . . . And now, my children, listen to me . . . Hear my instruction and be wise, and do not neglect it. Happy is the one who listens to me, watching daily at my gates, waiting beside my doors. For whoever finds me finds life." (Prov 8:27-35)

Wisdom is therefore a particular mode of God's personal pres-
ence and, at the same time, the presence of the creative *ruach*
in the world. God's *hokmah* is immanent in the created order
and present in all things, for it is through wisdom that God
"establishes" the earth and creates all that is living (Job 28:23-
28; Prov 3:16; Ps 104:24). "God's Wisdom speaks to human
beings out of creation, so as to bring them into harmony with
that creation, and in this way to make them wise. That is
why the heavens 'tell,' the firmament 'proclaims,' and all his
works 'praise' God."[43] Because Yahweh's *ruach* is immanent
in the world in the form of wisdom, reality is not only char-
acterized by a divine rationality, but humans are capable of
discerning this wisdom. We possess the capacity for "discover-
ing" the wisdom that is present in the world, but wisdom also
"happens" to us—it confronts us and calls out to us from the
structures of the created order. Consequently, in the form of
wisdom, our experience of *ruach* has both objective and sub-
jective dimensions; it is both immanent and transcendent.

Shekinah: God's Indwelling Presence

To develop further the concept of the Spirit's immanent tran-
scendence, Moltmann connects the notion of *ruach* with the
Jewish idea of the Shekinah as the descent or indwelling of
God. Similarly to *ruach*, we experience the indwelling of the
Shekinah as both an inexpressible closeness and a confronting
event of God's presence. That is, rather than an attribute of
God, the Shekinah is the very presence of God in our midst.
Anticipating John's vision in Revelation 21, the Spirit leads
Ezekiel into the valley of dead bones and proclaims,

> I will place my breath [*ruach*] in you and you will live; I will
> give you rest in your own land. . . . My dwelling place [*mish-
> kani*] will be with them [i.e., Israel]; I will be their God and
> they will be my people." (Ezek 37:14, 27)

As the Ezekiel passage suggests, the idea of the Shekinah has its source in the exilic and postexilic theology of Israel. In this theological tradition, the Shekinah is conceived as being originally present with Israel in the ark of the covenant and later dwelling exclusively in the temple's holy of holies.[44] Yet, following the destruction of the temple and the deportation of a large portion of Israelites into Babylonian exile, the Shekinah "dwelled" with Israel in her exile, offering consoling companionship to those who were suffering. Here, the Shekinah is also "the God who suffers with us."[45]

Yet the Shekinah is not only a mode of God's presence in the midst of exile but also a "counterpart in God."[46] Through the indwelling of the Shekinah, we encounter the Spirit of the Trinitarian God as both a divine presence and the reciprocal indwelling of the divine community. Because the Spirit dwells with and in human beings, the human spirit is self-transcendently aligned toward God. Thus, "[t]he soul's self-transcendence reflects God's spirit immanence in the soul. People seek God because God draws people to him. These are the first experiences of God's spirit in the human being."[47] In their impulse toward life—toward truth, beauty, and goodness—men and women sense the gentle and loving movement of the Spirit. What is more, these encounters with the source of life are always intersubjective; they necessarily take place in relationship with the human, the natural, and the Divine Other.

Yet, while the Transcendent God is wholly present in this quasimystical encounter with the Shekinah, this does not mean that God discloses the totality of God's inner-Trinitarian life or that we come to a full or complete knowledge of God. As Paul states in 1 Corinthians 13:12, "For now we see in a mirror, dimly [i.e., 'obscurely'], but then we will see face to face. Now I know only in part; then I will know fully, even as I have been fully known." Thus, through our encounter with the indwelling presence of the Spirit of God—the Shekinah, the divine *ruach*—the infinite difference between the

transcendent Creator and the immanent creation is revealed. This "obscured" encounter does not result in a distorted experience of God, but rather a mediated, indirect experience of God's presence. Through the Spirit, the whole of God is indeed present, but the whole of God remains unknown to us, even hidden, for our present encounter with the Spirit's revelatory presence is but an anticipation of the eschatological moment in which we will see, hear, feel, and know God "face to face."

Ultimately, this movement toward a more holistic understanding of the Spirit of God allows us to conceive of general revelation primarily in terms of the Spirit's indwelling presence in both the created order and our experiences of life. As we do so, we are able to situate our discussion within a broader theological framework, thereby allowing that framework to inform our understanding of those revelatory experiences that occur outside the church and without reference to Christ. Moreover, though, we also discover the means for moving beyond the difficulties of the historical theological discourse regarding general revelation. Thus, as we attempt to make sense of the ways in which film music in particular functions as an occasion for revelation, we are primarily concerned not with the kind of "knowledge" this experience imparts, nor with its "salvific" potential, but with the ways in which the life-giving Spirit of God is present and active in and through the aesthetic experience of film.

However, let me be clear. By approaching film music in terms of the Spirit's indwelling presence, I am not suggesting that these general revelatory experiences mediate no knowledge of God whatsoever or that the redemptive work of the Spirit of Christ is irrelevant. Rather, I am simply suggesting that any and all knowledge of God that one might attain only ever comes about in the presence of the Spirit of God. As we encounter the Spirit in our experiences of life, we come to know God in a participatory and relational manner prior to developing any well-articulated doctrinal formulations about

God. This encounter, while not redemptive per se, is necessarily re-creative, energizing, and life giving, for it depends upon the animating presence of the spirit of life. The source of life who is present in the cinematic experience cannot be reduced or simply conflated with the spirit of redemption without remainder. Thus, rather than denigrating film music's theological appeal due to the supposed inadequacy of the knowledge it mediates, a conception of general revelation that emphasizes the presence of an immanent transcendence in creation, conscience, and culture opens up new avenues for engaging in theological dialogue concerning the real presence of God in our filmgoing experiences.

What is more, by speaking of general revelation in terms of the Spirit's indwelling presence, we not only circumvent the epistemological and soteriological difficulties that have beset modern conceptions of revelation, we also overcome the false alternative between divine revelation and the human experience of the Spirit. Given the tendency of the Christian theological tradition either to conceive of revelation as antithetical to reason or restrict it to God's reflexive subjectivity, a more robust pneumatology allows us to give experience a place in theology, "not as an alternative to but in correlation with the revelatory word of God."[48] Thus, as we attempt to engage in a mutually enriching dialogue with contemporary persons who attest to the revelatory dimensions of their experiences of creation, conscience, and human creativity, we are able to avoid, on the one hand, a reduction of revelation to an experience of self-consciousness and, on the other, a reduction of revelation to a divine event that cannot be experienced. Consequently, when we conceive of revelation first and foremost as the presence of the Spirit in creation, we are able to recognize, appreciate, and articulate the full revelatory potential of a filmgoer's experience of film music, for this immediate, first-order experience may very well serve as an encounter with the divine source of life.

Thus, inspired by Moltmann's theology of the Spirit, we can say that revelation involves so much more than the communication of a knowledge of God that proves salvific; it also involves the experience of living a full and flourishing life, the impulse to revel in the beauty of both the created order and human creativity, and the desire to commune with the larger human community of which we are a part. It is, in short, a revelation "in general"—an immediate experience of the Spirit's energizing presence that is necessarily available to anyone, even (and perhaps especially) those standing beyond the confines of the covenant community who are otherwise unaware of God's "special" revelation.

FILM MUSIC AND THE SPIRIT'S
REVELATORY PRESENCE

Even if this conception of general revelation as the Spirit's indwelling presence is convincing on theological grounds, the question remains as to whether it actually opens up avenues for understanding film music's theological appeal to filmgoers. Thus, recalling our discussion in chapter 5 concerning the mysterious—even revelatory—presence of music in Paul Thomas Anderson's films, I would like to identify three particular ways in which a robust notion of God's general revelatory presence not only allows us to understand more fully this phenomenon from a theological perspective, but also provides us with resources for engaging in theological dialogue in terms of the register of meaning that film music opens up.

Film Music as "Echonic"

As we noted in our discussion of Anderson's films, music is often called upon to signify a pervasive presence that cannot be contained in the image. It therefore indicates a mysterious "something" that stands outside the film's primary mode of representation and, in an important sense, both exposes and conceals the limits of a film's representational capacities.

What is more, this musical presence functions on both formal and phenomenological levels. On the one hand, as we discovered in our analysis of *Punch-Drunk Love*, film music is capable of shaping the narrative from a location beyond the diegetic frame to such a degree that characters respond to its presence. On the other hand, audiences experience this same music as a presence that somehow stretches the limits of our language, and therefore connects in some way with the unspeakable depths of our humanity—our "soul." That is, the film's music is meaningful because its presence, although ineffable, is formative; it somehow intuits connections between ourselves, the film, and the larger world that are beyond rational comprehension. Music functions as both the means by which we are drawn into a presence that pervades the cinematic experience and, at the same time, the presence itself. In other words, as it fills the film's spiritual "gaps," music exists in a realm of mystery, bearing a depth of meaning that resists analysis.

How might we understand this phenomenon theologically, especially in light of the fact that so many filmgoers are already employing theological categories to describe their experiences of film music's ineffable presence? If we consider this particular function of film music in terms of the Spirit's general revelatory presence, specifically drawing on the concept of the Shekinah's indwelling, it may be possible to formulate an answer. If the Shekinah is indeed the indwelling presence of God in our lives and the world, then "each everyday experience," including our experience with film music, is potentially an encounter with the Spirit of God who is present in our midst. Through this particular mode of the Spirit's presence, God is *wholly* present with us, and thus every lived moment can be lived in the inconceivable closeness of God in the Spirit. That is, in and through our experience of film music, we are able to encounter the real presence of God.

In this way, we are approaching film music in a decidedly sacramental manner—one that both reflects and anticipates

God's ultimate project in the world of "dwelling with" (and becoming incarnate in) humanity. However, to understand created reality as a "sacrament," one must sense that "objects, events, and persons of daily life are revelations of grace. . . . [T]hat is, a revelation of the presence of God."[49] When a film's visuals function in this manner, they are often referred to as "icons," images that resonate with what cannot be seen— "non-symbolic 'symbols.' "[50] Yet images suffer from an inherent representational constraint, for an ineffable presence simply cannot be pictured. Thus, by attempting to represent visually what cannot be seen, the very medium of representation is problematized within film.

However, as a nonrepresentational medium, music is far more effective in signifying that which lies beyond the limits of visual representation. From within the film's formal structure, music does not "represent" an ineffable presence; in an important sense, it is that presence. Thus, if we conceive of film music in terms of the Spirit's revelatory presence—a presence that is closer to us than we are to ourselves—we might speak of film music not as iconic but as "echonic."[51] In a parallel fashion to the icon, music does not simply attempt to "symbolize" the nonsymbolic. Rather, music functions echonically in that it draws us into the pure presence of the Spirit of God. In part, the echon is able to function in this manner because it works fourth-dimensionally; as music, it draws us not out of but into time.[52] Using common parlance, we might say that our experience with the echon is a "live event" and is thus a living encounter. As a fundamentally temporal articulation that is imbued by the Shekinah's animating presence, music provides us the means by which we are able to hear, feel, and intuit the Spirit, entering into communion with the divine energy of life. Film music has a "privileged access to the soul" because, as the Spirit is present with and in human beings, the human spirit is self-transcendently aligned toward God through our experience of a film's music. Thus, film music is not God, but

as the Spirit dwells within the cinematic experience, we are able to encounter God in the music and the music in God.

Yet, if we are to take the notion of the Shekinah seriously as the confronting event of God's efficacious presence, we must point out one further characteristic of the echon. For the echonic nature of music suggests that, while God is indeed wholly present in our hearing of a film's music, we hear only through occluded ears. In other words, the Spirit's presence is mediated through the immediacy of the musical-aesthetic experience. Music both discloses and veils God's real presence and in doing so only heightens the mystical character of our experience. We cannot come to a full knowledge of this musical presence, nor can we master it. Thus, music opens up a range of meanings that not only invite theological dialogue but can only be understood in theological terms. For, in the mysterious presence of the echon, we are faced with the same questions that Barry Egan faced as he stood before a battered and bruised harmonium: Will we surrender to this presence? Will we "play along" with its melody, taking profound, unreasoning pleasure in the presence of the Spirit who interpenetrates everything created?

Film Music's Immanent Transcendence

Anderson's films reveal a second way in which music expresses theologically informed understandings of life and the world. That is, film music is capable of indicating the presence of an immanent transcendence. Although our discussion emphasized the music in *There Will Be Blood* in particular, Anderson calls upon music in each of his films to signify an ordering presence immanent in the world, even when the divine has been seemingly stamped out of existence. While the origin of this presence resides in a (nondiegetic) realm that ostensibly transcends the characters' limited frame of reference, it "breaks through" their concrete experiences of the world. In addition, this transcendent Other emerges in and through the

audience's concrete experience of the film. The music is therefore able to signify the presence of an absence—a force at work in the world that runs counter to narrative appearances.

Although the music in many of Anderson's films allows this presence to emerge more directly, the sparse and dissonant music in *There Will Be Blood* demonstrates the inverse possibilities of music's immanent transcendence. That is, in the context of the film's purely immanent frame, the music's anempathy and indifference confront the audience in a highly affective manner, bringing about a profound sense of dis-ease regarding not only the narrative events, but perhaps even the larger world in which we exist. In doing so, the music creates an affective space in which the Other is allowed to reemerge. While the source of this musical meaning is transcendent, it is only through the film's immanent structures that it is able to effect a true transformation. The music invites the audience to inhabit the space it opens up, presenting us with a world in front of the film that we might accept and embrace, or reject and rail against. Consequently, the music in Anderson's films raises theologically informed or determined questions: Is the divine indifferent to the human condition or present with us in our suffering? In an immanent frame, where is God?

Due to the striking parallels between Moltmann's concept of the Spirit's immanent transcendence and the ways in which film music is capable of functioning, it may be tempting to remain on the level of analogy in our theological reflection on this phenomenon. That is, we might suggest that music offers the best analogy for speaking of the Spirit's immanent transcendence, or even that our experience of the Spirit serves as the most appropriate metaphor for understanding our meaning-filled experience of film music. We would certainly not be wrong to draw such analogies. However, in light of our newly formulated conception of the Spirit's general revelatory presence, we can say more regarding how we might best understand film music's immanent transcendence. For, as the power

of creation and the wellspring of life, God's *ruach* is not only
the energizing and sustaining presence of the divine, it is also
the very breath of life in both human and other created beings.
Although ontologically distinct, there is a basic continuity
between the human spirit and the Spirit. Thus, the presence
of Yahweh's *ruach* does not exclude any part of our life, nei-
ther our embodied, sensual experiences nor our fundamental
affectivity.

In this view, the arousal of our embodied emotions within
our moviegoing experiences potentially serves as an encounter
with the transcendent Other—an encounter rooted in the Spir-
it's ongoing presence in our life and the world. Therefore, the
dis-ease we feel as the Brahms concerto rings out over the end
credits sequence in *There Will Be Blood* does indeed reflect the
formative presence of something (or someone) who was present
all along. It is the divine *ruach*—the energizing presence that
not only sustains the seemingly relentless progression of the
"cosmos" and the "world-spirit" but also draws our attention
to the emptiness of a life lived without regard for the O/other.
In this way, as the film's music effects an embodied, affec-
tive response, our experience of the music serves as an actual
encounter with the source of life who is present in our physi-
cality, the transcendent *ruach* who is present in and through
immanence and animates the whole of our lives. Thus, the
music offers more than a mere analogy; it serves as an occasion
for revelation—an encounter with the Spirit of God.

Here, then, is where a more robust notion of the Spirit's
general revelatory presence provides us with the resources not
only for enlarging theology's understanding of the relation-
ship between aesthetic and revelatory experiences, but also for
engaging in dialogue with the wide range of meanings that film
music opens up. Anderson's music in particular functions to
suggest an ordering force at work in a world that, on the surface,
appears to be bereft of transcendence. It thus raises questions
concerning the presence of transcendence in contemporary

persons' experience of the world: Where is God in a world over which we are sovereign? At the same time, the music also functions to provide us with an insightful answer: transcendence is not something that impinges upon the world from above, but is a presence that surrounds our immanent frame; it is the very space in which we live. It is the immanent presence of a transcendent absence.

However, it is only through an awareness of the film's music that we are able to engage in dialogue concerning this particular range of meanings. Moreover, it is only through a more robust notion of God's general revelatory presence that we are able to relate this register of meaning to the larger project of God in the world. Indeed, if we understand film music's immanent transcendence in terms of Yahweh's *ruach*, then we are not restricted to personal conceptions of the Spirit's presence, for the Spirit of God is not only the divine energy of life, but also the transcendent space in which we live. Yahweh's *ruach* is the most silent and hidden presence of God, for it is both in us and around us. The Spirit of God shapes our world even when this divine presence is so pervasive that it appears transparent. Consequently, Anderson's work offers insight, albeit partial and mysterious, into the ways in which the Spirit is present in the modern world. For in his films, the structuring presence of music suggests that we may not be able to talk *about* "the Transcendent" in the midst of a purely immanent frame, but we are always already living *out of* the Spirit's presence.

Film Music as Revelatory

Finally, by approaching film music in terms of God's general revelatory presence, we are able to understand, articulate, and appreciate more fully the revelatory dimensions of film music, especially when this revelation contains no explicitly Christian or even religious content.[53] According to filmgoers, Anderson's use of music effectively shifts the experience of his films into a "transcendent" or "revelatory" register. Yet these

moments of "transcendence" do not always contain discernibly religious content. Indeed, for many, the terms "transcendent" or "revelatory" function as catchwords for speaking of the mysterious, ineffable, and inexpressible quality of their musical-aesthetic experience. Thus, the larger significance of these films and the music therein is rooted not in what is revealed but rather in the intensely affective experience itself. In other words, it is the filmgoing experience that is revelatory. Audiences conceive of this revelatory experience as both an awakening of one's self-consciousness and an encounter with a loosely defined transcendent "Other." In an important sense, then, the responses to Anderson's films are indicative of a larger cultural shift in which the distinctions between ontological and phenomenological notions of transcendence are collapsing. That is, on the concrete level of lived experience, these films open filmgoers out into something both "larger" and "deeper," something unexpected yet profoundly meaningful. It is a revelation that can be experienced and an experience that is revelatory.

Thus, the repeated testimony of filmgoers concerning the revelatory dimensions of film music returns us to the core question of this chapter. That is, how are we to understand theologically these first-order experiences of revelation that take place outside of the church and without reference to any explicitly religious content, such as the person and work of Jesus Christ? If we attempt to understand film music's theological appeal in terms of the christological content it conveys or the certainty of the knowledge it discloses, then we will only ever be able to construe this phenomenon as "less than" or "not quite" revelation. For, as it addresses the ineffable, film music confronts us, not as content to be re-cognized, but as pure presence. It provides us an avenue through which we encounter something irreducibly mysterious—a mystery that cannot be controlled, manipulated, or "understood" in any straightforward manner. It mediates a mysterious presence with which we first

and foremost commune, and only subsequently "reflect upon" cognitively or "articulate" linguistically. Consequently, if theology delimits revelation to the communication of a divine knowledge about Christ that is mediated through the church, it will have nothing to say about the ways in which God is potentially present and active in and through our experiences of film music. However, by broadening our understanding of revelation to include the Spirit's indwelling presence in our experiences of creation, conscience, and creativity, we are able to identify the mysterious presence that film music mediates as the transcendent Spirit immanent in our cinematic experiences. Precisely because it is nonlinguistic and nonrepresentational, music not only fills a film's spiritual gaps, but it serves as the very medium through which this mysterious force is made present. It is, in short, revelatory.

Furthermore, because the affective and intuitive power of music resists discursive reasoning, if we only allow epistemological or soteriological categories to determine the shape of our theological reflection, then we run the risk of denigrating the revelatory possibilities of film music from the very start. Yet, if we approach film music in terms of the Spirit's general revelatory presence, and resist reducing the Spirit of God to only the Spirit of the church and the Spirit of Christ, then we are able to recognize that, while it may not be redemptive per se, the contemporary experience of film music is indeed life giving and re-creative. If the spirit of life is present in, with, and beneath each everyday experience, then the experience of film music contributes something essential to our lives. That is, although not ultimately salvific, the revelation occasioned by film music has the potential for transforming us. It may not mediate an indubitable deposit of knowledge about God, but in no way does this lack of epistemological certainty diminish film music's capacity to confront us with the inexpressible beauty of the Spirit's general revelatory presence. In fact, in many cases, it is music's very *un*certainty that not only

heightens the "mystery" of the musical-aesthetic experience, but also engenders the sense of awe or wonder that so many filmgoers attempt to articulate in theological categories.

Thus, it would seem that the Christian theological tradition has an opportunity to readdress first-order theological experiences. For it is in and through these general revelatory experiences that the Spirit of God is present and active in the lives of contemporary persons. Like the phenomenon of film music, these flashes may be only vaguely spiritual and even lacking in any discernibly Christian content. They may be construed as moments of self-awareness or an elevated self-consciousness. Their meaning may be related more directly to their inherent affectivity and sensuality. Yet, as they reflect the Spirit's immanence in the created order, these meaning-filled moments may actually tell us something about who God is—something that might inform and, at times, even correct current theological formulations. That is, the experience of film music in particular and the cinema in general are potential locations for constructive theological reflection.

What is more, because the Spirit dwells with and in human beings, these moments of self-transcendence may very well be contemporary persons' first encounter of God's Spirit in their lives. Thus, as we turn toward a more robust understanding of the Spirit's general revelatory presence in our experience of film music, we not only gain a fuller understanding of how God is active and moving in the contemporary world, but we are able to identify more appropriate avenues for participating in the ongoing dialogue that the Spirit has already initiated in the broader culture—a conversation that takes place outside of the church and without reference to Christ but is nevertheless shot through with the animating presence of God's *ruach*.

CONCLUSION

Where were you when I laid the foundations of the earth? . . .
When the morning stars sang together, and all the sons of God
shouted for joy?

—Job 38:4, 7 (NRSV)

Who are we to you? Answer me.

—Mrs. O'Brien, *The Tree of Life*

More often than not, we are incapable of articulating the pro-
found depth of the human experience. Certain losses, suf-
ferings, and wounds lie beyond description. The same holds true
for the beauty, joy, and hope that we encounter. Our words simply
fail us. Of course, we still feel compelled to analyze, to dissect,
and to understand the mystifying reality that seems to underscore
the whole of the created order. Yet, even as it captivates us, we are
confronted with the limits of our understanding. That is, while an
acute sense of significance pervades the world in which we live,
life remains mysterious. And in the shadow of this mystery, we
wrestle with, rail against, and even directly challenge that which
cannot be controlled, manipulated, or coerced. "Who are we to
you? Answer me."

In an effort to draw our discussion to a close, I offer here a brief
reflection on *The Tree of Life* (2011), a film that calls upon music

181

not only to give voice to these enduring questions, but also to draw filmgoers into the enigmatic beauty that permeates each everyday experience of human life. In doing so, I hope both to reiterate the core argument I have been developing and convey the manners in which this exploration of film music might give shape to the future of constructive theological inquiry. For, in the end, a musically aware approach to film may very well enhance our understanding of film and filmgoing, but the question remains as to what difference any of this really makes for contemporary theological reflection.

TERRENCE MALICK
Living Abstractly in a Concrete World

My argument has been fairly straightforward: a musically aware approach to film allows for a depth and manner of theological dialogue that would otherwise remain inaccessible. It opens up avenues for engaging in conversations with both the film itself and those contemporary persons who derive meaning (aesthetic, spiritual, religious, or otherwise) from their cinematic experiences. Yet, along the way, I have made a parallel and, perhaps, even more substantive claim. That is, whether it underscores a "children's" movie (e.g., *Up*), features almost wholly recycled popular songs (e.g., *Moulin Rouge!*), or is so glaringly sparse and dissonant that it becomes unsettling (e.g., *There Will Be Blood*), film music is somehow capable of mediating an immediate encounter with the divine energy of life that indwells the whole of the created order. Put simply, this music is powerful, meaningful, and formative—it has privileged access to our soul—because it is capable of serving as an occasion for revelation, a truly religious experience in the midst of what many believe to be an increasingly disenchanted and demythologized world.

Significantly, it is this very movement toward religious experience that marks Terrence Malick's 2011 film, *The Tree*

of Life. Indeed, as one critic has stated, this film is first and foremost a form of prayer. Others have made similar claims, suggesting that their experience of the film was sublime and even epiphanic. Yet, some filmgoers have rejected Malick's spiritually charged vision as overly ambitious and, at times, heavy-handed. Although it won the Palme d'Or prize at the Cannes Film Festival, the film received a mixture of both applause and boos at the conclusion of its first screening. Like those at Cannes, other filmgoers are equally unable to move beyond the apparent absence of any clear narrative arch—the kind of plot-driven fare that comprises the current Hollywood landscape. Tellingly, the small group of friends with whom I watched the film abandoned it less than thirty minutes into our screening, stating that they did not want to "waste their time" on a movie that refused to tell a story.

Of course, if pressed, we can identify the contours of a story in this film, albeit a fragmented and nonlinear one. Set in 1950s Waco, the film follows the O'Briens, a family struggling to cope with the premature death of one of its youngest members, R. L. Against this tableau of suffering and loss, we also catch a glimpse of Jack O'Brien's coming of age story, told through the lens of his familial relationships—his kindhearted brothers, his gracious mother, and his iron-fisted father. But Malick is not principally interested in telling a story. He is interested in something far more grandiose—something more cosmic in scope. Much like Job, the book that is quoted in the film's epigraph, Malick does not attempt to answer the theodicy questions that have long plagued human beings in general and the O'Brien family in particular. How could he? Rather, he dares to thrust us into the very presence of the One to whom these questions are so often addressed. That is, no "answer" is given to life's tragedies, but in and through Malick's masterful interlacing of images and sounds, we do meet the "Answerer."[1] Consequently, *The Tree of Life* offers us not a story per se, but an audiovisual encounter.

Indeed, what is most compelling about this particular encounter is that it is filled to the brim with music. It is simply inescapable. Music bursts forth from the outset of the film as if unbidden, and resounds throughout almost every subsequent frame. In fact, because there is so much music in this film, and because it is working on so many levels, space will only allow for a consideration of one particular piece of music—a central interpretive figure that is distributed across two very different segments of the film. Significantly, during its first appearance, we as the audience are only aware of a few pieces of narrative information. Tragedy has struck. A family has lost a son to war. They will never be the same. In the midst of their palpable grief, the mother, Mrs. O'Brien, directs her questions to the heavens: "Was I false to you? Lord, why? Where were you?" The image then goes dark and we see only a glimmer of light, a seemingly unformed mass of dancing color that comes into and out of focus. It is captivating. It is beautiful. Its presence is completely unexplained.

As if emerging from this mysterious light, the first sounds of "Lacrimosa"—an operatic piece from Zbigniew Preisner's *Requiem for My Friend*—ring out from beyond the diegesis.[2] At first we hear only a single flute, an occasional bell, and a lone female voice repeating a lyrical refrain in Latin: *Lacrimosa dies illa, aua resurget ex favilla, judicandus homo reus. Huic ergo parce Deus. Pie Jesu Domine, dona eis requiem.* This music is firmly planted in the foreground and thus calls attention to itself and its ethereal qualities. In addition, instead of people and trees and rocks and cars, we see images of smoke and clouds flitting between washes of light and darkness. We soon realize that we are no longer in any kind of a world with which we are familiar. Along with this music and these images, we have been fully and wholly abstracted. Yet it is from within this abstracted space that Mrs. O'Brien's whispered voice-over returns—a reminder of the concrete experience of grief, abandonment, and suffering that provided the

impetus for this otherworldly journey in the first place. "Did you know? Who are we to you? Answer me."

In this somewhat audacious (and polarizing) segment, we become witnesses to nothing less than the primordial state of the universe. As the ghostly vapors condense into something only slightly more substantive, the timbre of "Lacrimosa" suddenly shifts, moving from sparse orchestration to a full symphonic underscoring. The volume of the music also increases, and the vocalist follows suit—a sweeping crescendo culminating in a dramatic fortissimo. The orchestral underscoring dances in parallel with the vocal melody, descending in corresponding intervals of major and minor seconds. Yet, given that this shift is primarily dynamic rather than tonal, it is the *texture* of the music that moves most forcefully to the foreground of the film's frame. In conjunction with the sweeping images of space and time coming into being, the once mournful music transforms into an overwhelming testament to the grandeur of the cosmos. In doing so, it gives us only one option: we are meant to be awestruck.

"Lacrimosa" plays in its entirety for three and a half consecutive minutes, demonstrating once again the influence that musical form exerts on film form. As the song draws to a close, the "Big Bang" occurs. The following fifteen minutes of the film depict the formation of the universe, the first life on the planet Earth, the prehistoric creatures that populated this planet, the destruction of those creatures by a meteor, and the renewal of life through the birth of a single human being. Many have rightly noted the beauty of these images, for they are certainly mesmerizing. Indeed, the entire film is a tribute to Malick's artistic vision. Yet, more than simply beautiful cinematography, it is the image/music partnership that propels us into the rest of the film. There is virtually no dialogue and certainly no plot development during this creation segment. If there is a "story" here, it is the story of the whole of the created order. It is the human story writ large, an elemental tale that

we certainly did not initiate and will undoubtedly not bring to a close.

However, even though the music and images draw us into a realm beyond space and time, they do not allow us to remain in this rarified state. "Lacrimosa" will be heard again, but in an entirely different context and in an entirely different register. After the young Jack purposefully shoots his brother's finger with a BB gun, he offers a voice-over reflection on that which lurks inside him, an echo of the Apostle Paul's words in Romans: "What I want to do I can't do. I do what I hate." Although subtle, a single piano gently plays the melody to "Lacrimosa" while Jack articulates this internal fissure and as we observe him and his friends destroying the interior of an abandoned home.[3] Here, the film is no longer dealing with creation and the cosmos and the whole of existence, as it was before. Rather, it is exploring the concrete particularities of *this* young man, living in *this* town, and struggling with *these* destructive inclinations.

In its earlier manifestation, "Lacrimosa" surely portends the human struggle that will inevitably follow the original creative event. But as the melody sounds once more over images of Jack's insidious destruction, it both echoes and concretizes the vocalist's original lament: *Tearful will be that day, on which from the ash arises the guilty man who is to be judged. Spare him therefore, God. Merciful Lord Jesus, grant them rest.* As only this melody could suggest, Jack is not simply engaging in destructive adolescent behavior. He is undoing the very fabric of creation.

Thus, in underscoring both segments of the film, the music links these two realities—the creation of all that is, and a young man's existential musings. The totality of the universe is somehow contained in this single life. And in making this connection, this piece of music offers us a key to understanding the film as a whole. For, as it is with nearly every piece of music that Malick uses in his film, "Lacrimosa"

is nondiegetic. It speaks from a realm that transcends the diegetic world. In an important sense, we might even say that this music is intentionally "supradiegetic," for it issues from a location that transcends the world of the characters *and* the world of the audience. In part, the music is able to function in this manner not only because it stands outside the diegesis, but also because it features lyrics sung in a foreign language— a dead language, to be more exact. Yet, even if one were a Latin scholar, the vocals are mixed in such a way that they are difficult to discern. The result is the creation of a distancing between the film and the audience. That is, the music's mystery—its opaqueness—effectively generates an "other." But the "other" that appears in this film is not the kind of immanent transcendence that emerges in the work of Paul Thomas Anderson. Rather, Malick calls upon music to signify the presence of a *wholly* Other, something more akin to Rudolf Otto's *mysterium tremendum et fascinans*. Speaking from a location that transcends both the film and the audience, this numinous Other is at once compelling, overwhelming, and terrifying. The plight of the human creature is thus swept up and reframed in the grand story of the cosmos.

Here, then, is where "Lacrimosa" grants us a unique insight into the heart of the film. Even though this song plays over images of the early beginnings of the known universe, we are not simply being told a story *about* creation. Instead, the music offers us an invitation to *encounter* the Creator. Using the words of Mr. O'Brien, Malick is begging us to "notice the Glory," to stop for a moment and contemplate the beautiful wonder that is life. And in doing so, he is pressing us toward not only contemplation, but perhaps even devotion. However, this movement toward contemplative devotion—signified not simply by the music but also by the characters' eminently reflective, nondiegetic voice-overs—is not a religious abstraction. To be sure, Malick is offering us a kind of mystical encounter—a prayer of sorts. But his is a grounded mysticism. Rather than a

disconnected and self-serving form of spirituality that has no bearing on our life in the world, Malick calls upon music to tether this contemplative act to the lived experiences of real human beings. That is, the "glory" we encounter when we first hear "Lacrimosa" is only ever glorious in relation to the all-too-human realities that this same song underscores later in the film.

It is therefore not surprising to discover that this particular song was originally written as a memorial to the composer's dear friend. Drawing as it does from a larger cultural context of mourning and loss, "Lacrimosa" functions in this film to suggest that the concrete realities of death, destruction, and suffering are never far from a truly contemplative heart. In some cases it would even seem that these realities are the necessary precursors to a life of devotion. To be sure, the film ends with a final act of joyful surrender by Mrs. O'Brien: "I give him to you. I give you my son." But the music refuses us the luxury of separating this final act of worship from the penultimate question that is seared into this mother's very being: why? In other words, the music in *The Tree of Life* does indeed voice a call to worship. However, at one and the same time, it reminds us that while worship necessarily involves a posture of awe and speechless surrender, we can only truly devote ourselves to the glorious presence of this wholly Other as whole persons—as living, breathing, feeling, hurting, doubting human beings.

MUSIC, FILM, AND DEVOTION

According to IMDb discussion forums, critics' reviews, and even the responses of some of my own filmgoing compatriots, not everyone shares an appreciation for Malick's work. Nevertheless, for those filmgoers who are able to open themselves up to this contemplative work of art, *The Tree of Life* may very well serve as a genuinely moving and even transformative experience. It thus presents contemporary audiences with something far more meaningful than a fleeting and easily digested piece

of entertainment. It offers an occasion for revelation—a truly religious experience in the midst of our (post)modern world. In doing so, this film captures well the significance of our discussion for future considerations of the relationship between film, music, and theology.

One of the first implications of our discussion has to do with a fundamental shift in the way that we approach film as a cultural product. In light of the various manners in which film music directly addresses and even exists "for" audiences, those contributing to the theology and film discourse can simply no longer afford to focus their construals only on the "text" of a film. Indeed, the very concept of film as a text is potentially misleading to the point of error. To be sure, an analysis of a film's final form is a key element in arriving at a more robust understanding of its power and meaning. However, narrative, thematic, and generic analyses alone do not tell the whole story, for film is not simply a text that filmgoers read; it is an audiovisual *event* that they experience. And as our examination of the music in *The Tree of Life* suggests, this "cinematic event" possesses the potential for serving as an encounter with the divine source of life.[4] It is, in other words, a *confronting* event. Thus, by calling out the significance of music's position and function in film, we have arrived at a place in the development of the theology and film dialogue where we must routinely ask questions not only about a film's formal qualities, but also about the ways in which film creates a dynamic space in and through which contemporary individuals find and construct meaning. Anything less is simply a reduction of both film and the filmgoing experience.

However, this shift toward a more phenomenological construal of film carries implications that reach beyond the emerging discipline of theology and film. For, as our discussion has shown, film music has the potential for functioning in an expressly theological manner. It not only raises theologically pertinent questions, it also confronts audiences with theologically

informed understandings of life and the world. Consequently, many contemporary filmgoers are already engaging in a kind of theological reflection in the movie theater. However, this theological work is rarely the sort of second-order intellection and articulation that the theological tradition often favors and even, in some cases, identifies as "theology." Rather, the theology that occurs within the cinematic event is an immediate, first-order experience of God's presence in and through the medium of film. Although often diffuse, ill-defined, and messy, these spiritual experiences are undeniably formative and, in many cases, transformative. They become a part of who we are long after the original event has passed. By recognizing the intrinsic value of these transcendent experiences that are taking place outside the church and without reference to Jesus Christ, the Christian theological tradition not only remains open to the breadth and depth of the Spirit's presence in the broader human experience, but it also recognizes that all living theology proceeds in this manner. That is, we always already approach the theological task as persons who are fundamentally shaped by our concrete, lived experiences—even our experiences with contemporary forms of art such as film. Thus, more than simply enlarging our understanding of a particular cultural product, our examination of film music's meaning-making capacity calls for Christian theology to reclaim first-order experience as a legitimate theological datum.

In a directly related manner, our examination of film music's theological import presses us not only to reclaim the legitimacy of first-order theological reflection, but also to reconsider our basic posture toward public cultural dialogue. More specifically, it seems that we would do well to move toward a more *affirming* approach toward those "spiritual" experiences that are becoming increasingly prevalent in the contemporary world. That is, rather than judging culture or cultural products in terms of a culturally abstracted Christian "truth," we should make every attempt to seek out and

discover what is true within these myriad forms of life. To be sure, by suggesting that we affirm this somewhat generic spirituality, I am in no way claiming that an appropriate Christian approach to theological reflection involves an uncritical embrace of all things "cultural." Certain realities invite a critical response, and necessarily so. However, if the Spirit is truly present and active in the contemporary situation, then theological reflection must involve not only critique but also affirmation and even celebration. For, as the preceding discussion has suggested, film music potentially reflects the presence of the transcendent Spirit who is immanent both in the created order and in what humans make of that creation. Thus, if we operate with the assumption that the Spirit is already dwelling within the broader culture, we are free to move beyond pure critique, celebrating and affirming the ways in which cultural products like film reflect the presence and movement of God in the world.

Assuming a posture of this kind necessarily involves a "yes/and" approach toward cultural engagement rather than a "no/but" approach. That is, rather than starting with a critical condemnation of the ways in which a cultural product fails to reflect fully the tenets of the Christian faith and then suggesting a more "appropriate" or "correct" alternative ("no, but"), it begins with a celebration of how the Spirit of God is active in culture and then emphasizes how a cultural product's meaning might find fulfillment within a larger Christian framework ("yes, and"). In terms of film music, a yes/and response to the Spirit's presence might assume the following form: *yes*, film music is indeed spiritual insofar as it connects to our soul and fills a film's "spiritual" gaps; *and* it is in and through this elevation of our human spirit that the Spirit of God not only meets us in the cinematic event but also breathes life into our deep-lived experiences of the world.

In an important sense, this posture reflects Paul's attitude toward cultural dialogue in Acts 17, in which, rather

than condemning the Athenians for the "false" or "heretical" beliefs that were reflected in their poetry and religious practices, he simply retold their story within a Christian framework. At the same time, though, by employing both the language and the conceptual frameworks of the Athenians, Paul also retold the *Christian* story within a *pagan* framework. In doing so, he managed to speak theologically in a way that was uniquely intelligible to those embedded within this culture.[5] In other words, he carved out a space for the Christian faith in a highly pluralistic culture by first affirming the wisdom his contemporaries had already discovered in and through their experiences of creation, conscience, and creativity. Thus, Paul models a posture of cultural dialogue that not only allows for both theological critique and celebration but perhaps also charts a course for a more constructive and life-giving public discourse in the contemporary world.

Finally, our consideration of the theological significance of music in film compels us to reconsider the *devotional* nature of filmgoing. If film is more of an event than a text, and if this cinematic event is indeed functioning as a contemporary space in which modern persons potentially encounter the living, breathing Spirit of God in their lives, then film has the capacity for engendering what can only be termed devotion. Indeed, *The Tree of Life* offers a compelling case for why we might approach filmgoing as a type of "secular" devotional practice. For, much like this film, contemporary forms of life may not explicitly reference the primary narratives of the Christian tradition. Nevertheless, they function as formative practices from which individuals derive meaning and around which they orient their lives. As such, they parallel and, in the case of *The Tree of Life*, draw analogies from the underlying shape of Christian devotional practices.

Thus, a more robust understanding of film music's theological appeal requires us to expand our conception of the various *forms* that devotional practices assume in the modern world.

In a cultural context that is typified by a profound suspicion of and distinct lack of trust in religious institutions, the devotional practices of these institutions are equally distrusted. It is not simply that established religious traditions have failed to provide a convincing narrative for modern persons (although an argument could be made that this is certainly the case). Rather, our institutions have quite literally collapsed upon us, leaving an equally destructive trail of victimization and abuse in their wake. Yet, just as it does in *The Tree of Life*, the music that we hear in film serves as a welcome reminder that religious expression has not disappeared in the modern world. Instead, it has simply dispersed into various noninstitutional forms. Consequently, in its own unique way, film music is capable of mediating the presence of God in the midst of a culture that simply does not trust the devotional practices of religious institutions.

In order to conceptualize this phenomenon, I have gone so far as to suggest that film music is echonic; it allows filmgoers to move through the film and out into something larger, deeper, and more meaningful. In doing so, film music provokes a sense of awe and wonder at the greater mystery that pervades the whole of our life in the world. Thus, in my estimation, it is no longer enough simply to note the religion-like aspect of filmgoing. Rather, in light of our examination of film music's echonic potential, the questions we must now ask are not only whether a film's music does indeed encourage a posture of devotion, but also how the experience of film music relates to the historically privileged practices of the Christian faith. That is, without discounting or diminishing the supreme importance of devotional practices such as Communion and baptism, we must find ways to articulate the various manners in which the spirit of God is already in conversation with contemporary individuals through film and its music. And perhaps more importantly, we must also come to a place where we can affirm this ongoing, inspirited conversation as a kind of

secular devotion—a practice that shapes filmgoers into whole human beings who more readily see, feel, and hear the Spirit of God in their lives.

NOTES

Introduction

1 A brief glance at the Rotten Tomatoes website reveals a host of similar descriptions concerning *Up*, where, as I write, it is currently receiving a rating of 97 percent among critics and viewers. See http://www.rottentomatoes.com/m/up.

2 Christopher Smith, "Up: Movie Review," *Bangor Daily News*, July 14, 2009, http://www.weekinrewind.com/ (accessed August 15, 2009).

3 As such, this work falls under the larger category of "apologetic theology." I can do no better than William Dyrness' definition: "[A]pologetic theology . . . seeks to develop theological categories, given to us by Scripture and tradition, in conversation with the contemporary cultural situation. It is assumed that whether this is recognized or not, all living theology grows in this way." Dyrness, *Poetic Theology: God and the Poetics of Everyday Life* (Grand Rapids: Eerdmans, 2011), 10.

4 I owe these insights concerning subjective truth and authorship to Jürgen Moltmann, *Experiences in Theology: Ways and Forms of Christian Theology*, trans. Margaret Kohl (Minneapolis: Fortress, 2000), xix.

5 In the second edition to his book *Reel Spirituality*, Robert Johnston suggests that in order to truly understand the power and meaning of a film and thus to participate in a constructive theological dialogue, theologians must attend more fully to music in their engagements with film. Robert K. Johnston, *Reel Spirituality: Theology and Film in Dialogue*, 2nd ed. (Grand Rapids: Baker Academic, 2006), esp. 178–83. Indeed, in his subsequent book, *Useless Beauty*, he follows

through with this suggestion and discusses Paul Thomas Anderson's *Magnolia* (1999) in terms of the film's music. Robert K. Johnston, *Useless Beauty: Ecclesiastes through the Lens of Contemporary Film* (Grand Rapids: Baker Academic, 2004), 74–91. Similarly, in *Reframing Theology and Film*, a book edited by Johnston, Barry Taylor offers a brief introduction to the meaning-making dimensions of film music and argues that a theological construal of film must not only include narrative and visual analyses, but musical analyses as well. Barry Taylor, "The Colors of Sound: Music and Meaning Making in Film," in *Reframing Theology and Film: New Focus for an Emerging Discipline*, ed. Robert K. Johnston (Grand Rapids: Baker Academic, 2007).

6 The two exceptions are Pixar's *Toy Story*, which was first released in 1995, and *The Tree of Life*, which was just released in 2011. I have included *Toy Story* in our discussion not only because it was the first of many groundbreaking films by Pixar, but also because without it our understanding of Pixar's use of music would remain incomplete and even inadequate. As the most recent film, I chose to conclude the book with *The Tree of Life* in order to demonstrate the ways in which our inquiry will move the theology and film discussion forward.

7 We will discuss in a later chapter the rather ambiguous ways in which contemporary persons conceive of and use the term "transcendence." For now, though, it is enough to note that, as Craig Detweiler and Barry Taylor have suggested, beginning with the year 1999— "The Year That Changed Movies"—we have entered "the most spiritually charged era in Hollywood history." Detweiler and Taylor, *A Matrix of Meanings: Finding God in Pop Culture* (Grand Rapids: Baker Academic, 2003), 167.

8 I owe this insight to Nicholas Cook. Although Cook is concerned with music in general, his insights apply directly to our consideration of film music. See Nicholas Cook, *Music, Imagination, and Culture* (Oxford: Clarendon, 1990), 1.

9 "To be told that the beauty or significance of a piece of music lies in relationships that one cannot hear is to have the aesthetic validity of one's experience of the music thrown into doubt; and the manner in which music is described by professionals can only create in the untrained listener a sense of inadequacy, a feeling that though he may enjoy the music he cannot claim really to understand it." Cook, *Music, Imagination, and Culture*, 1.

10 I am affirming here the role that actual audiences play in both

the discovery and the construction of filmic meaning. At the same time, though, the film's actual form in its final state of production is equally significant and even determinative to some degree. It not only serves as the mediating entity between production and reception, but it also structures and delimits the meaning-making process; without an actual film, there is no event and, thus, nothing to which an audience might respond.

11 According to Kay Dickinson, our notions of why certain music does or does not "work" in a particular film is as much related to the ideology of work in late-capitalistic society as it is to any aesthetic criteria. "The attacks on film-music collaborations that 'don't work' open out onto something bigger, I contend: a pervasive anxiety about the very activities that earn us our livelihoods and, often, our senses of duty and its fulfillment." Dickinson, *Off Key: When Film and Music Won't Work Together* (New York: Oxford University Press, 2008), 15.

12 This notion reflects one particular way in which Theodor Adorno's argument has been received in the field of musicology. While it is not an entirely accurate summary of his thought, this reading of Adorno has exerted a significant influence on subsequent evaluations of music in general and film music in particular. However, it must be noted that Adorno was not defending "high" art against "low" per se, but was attempting to map potential avenues for resistance against the pervasiveness of commodification and ideological co-opting. See Theodor W. Adorno, *The Culture Industry: Selected Essays on Mass Culture*, Routledge Classics (London: Psychology Press, 2001).

13 One scholar has recently suggested that, from a historical perspective, "the telling of the story has always reigned supreme, and film music has almost always been at the humble service of the storytelling." James Eugene Wierzbicki, *Film Music: A History* (New York: Routledge, 2009), 3. However, Wierzbicki is here referring to those (sound) films in particular that premiered after the emergence and rise of the narrative film in the early years of the twentieth century. Thus, given the preponderance of story films in contemporary cinema, we are most concerned with the ways in which music contributes to a film's overarching narrative.

14 I am indebted here to Jim Buhler's insights regarding the soundtrack's dialectic structure. See James Buhler, "Analytical and Interpretive Approaches to Film Music (II): Analysing Interactions of Music and Film," in *Film Music: An Anthology*

of Critical Essays, ed. K. J. Donnelly (Edinburgh: Edinburgh University Press, 2001).

15 Buhler, "Analytical and Interpretive Approaches (II)," 39.

Chapter 1

1 Andrew Stanton, "Animation Sound Design: Building Worlds from the Ground Up," *Up* (Emeryville, Calif.: Disney, 2008), DVD.

2 Here I am employing the terms "film form" and "film style" along similar lines to Buhler, Neumeyer, and Deemer, who state, "Film form refers to the overall design of a film, or the temporal articulations of its running time in relation to the deployment of conventional units such as establishing sequences, scenes, chapters (or acts), and so forth. Film style also refers to the treatment of conventional expectations, but the basis of film style is the collection of techniques, practices, aesthetic preferences, and cultural and cinematic expectations that constitute the distinctive way a narrative is 'delivered' in any individual film." James Buhler, David Neumeyer, and Rob Deemer, *Hearing the Movies: Music and Sound in Film History* (New York: Oxford University Press, 2010).

3 Tasha Robinson, "Interview: Andrew Stanton," *The Onion AV Club* video, June 25, 2008, http://www.avclub.com/articles/andrew-stanton,14263/ (accessed June 1, 2010).

4 I will offer a more precise definition of "shared narrative" below. However, it is important to note at this point that in what follows we will be using the terms "shared," "common," and "intergenerational narrative" interchangeably and synonymously.

5 Although they individually assume different roles from film to film, a small handful of filmmakers—John Lasseter, Andrew Stanton, Pete Docter, Brad Bird, and Lee Unkrich—have collectively written, directed, and produced each of Pixar's films. What is more, only three composers have written music for Pixar's films: Randy Newman, Thomas Newman, and Michael Giacchino.

6 In the directors' commentary, expounding upon the original conceit that eventually culminated in the creation of *Monsters, Inc.*, Pete Docter states, "I was looking around for other things like that [i.e., *Toy Story*] that we all experienced as a kid, a sort of a *shared experience*" (emphasis added). Similarly, reflecting upon the ways in which *Finding Nemo* expresses Pixar's larger

"vision" for filmmaking, Andrew Stanton states, "We just want to make a good movie that entertains us that I would want to see that doesn't exclude anybody." Stanton, "Documentary: Making Nemo," *Finding Nemo* (Emeryville, Calif.: Disney, 2003), DVD.

7 As IMDb's rating system continually incorporates new films and adjusts for changes in audience responses, the top 250 films are continually in flux. However, as of May 20, 2010, eight of Pixar's ten films were included in this list of audience favorites. Significantly, the two most recent Pixar films have the highest rating; *Up* being ranked at number 77, and *WALL-E* at number 46. Yet even *A Bug's Life*, which is the lowest rated among all of Pixar's films, has a user rating of 7.3 on a scale of 10. For information concerning the percentage of Americans who watched *Finding Nemo*, see *The Barna Update*, July 10, 2004, , http://www.barna.org/barna-update/article/5-barna-update/191-new-survey-exa mines-the-impact-of-gibson's-qpassionq-movie.

8 See Frank Paiva, "Decade's Dozen," December 31, 2009, http://movies.msn.com/movies/gallery.aspx?gallery=22271&photo=75a4eed7-ece2-4e18-8b11-500bde3b59e0 (accessed January 4, 2010).

9 Please also note that, due to the number of films we are dealing with in this chapter, I will not be able to provide comprehensive summaries of every one. Although I attempt to locate each musical example in a larger narrative context, the reader will greatly benefit from viewing these films prior to reading the chapter.

10 While I am aware of the more strictly philosophical definition of the term "phenomenological," for the purposes of this book, which are expressly theological, I adopt Gerardus van der Leeuw's definition. Leeuw describes his phenomenological approach to theological aesthetics as being concerned "not with beauty as such [in a purely formal sense], but rather with [the] experience of beauty, that is, with art." Therefore, I will be using the term "phenomenological" to highlight the experience of the art of film. Gerardus van der Leeuw, *Sacred and Profane Beauty: The Holy in Art*, 1st ed. (New York: Holt, Rinehart, & Winston, 1963), 6.

11 We will discuss in detail and more clearly define "diegetic" and "nondiegetic" music in chapter 2. For now, though, it is enough to say that "diegetic" music is music that (apparently) issues from a source within the narrative, and "nondiegetic" music is music that issues from a source outside or beyond this narrative world. The same is the case for any other element in a film. The

"diegesis" is the narrative world of space-time that the film creates and the characters inhabit. Consequently, diegetic music exists for the characters and their world, nondiegetic music exists for "us" and our world. Although nondiegetic music is often referred to as "background" music, I will be avoiding this misleading designation, for nondiegetic orchestral music can either be "foregrounded" in a film or it can serve as an aural "background." Thus, I will instead use the terms musical underscoring or nondiegetic music.

12 Hanns Eisler, for example, lamented that the "cheap mood-producing gadget" of closely synchronized music was "so overworked that it deserves a rest, or at least it should be used with the greatest discrimination." Theodor W. Adorno and Hanns Eisler, *Composing for the Films* (London: Continuum, 2007), 7.

13 I am borrowing the idea of mickey-mousing as an effects "sweetener" from Buhler, Neumeyer, and Deemer, *Hearing the Movies*, 85–88.

14 This occurs at 1:28 on the DVD.

15 Buhler, Neumeyer, and Deemer, *Hearing the Movies*, 86.

16 It will be helpful to note here that I am using the term "emotion" in a broad and intentionally loosely defined manner. I am largely indebted to those working the fields of cognitive philosophy and psychology who study emotions through an integrative and multidisciplinary approach. Therefore, I will be speaking of "affect," "emotions," and "feelings" as pieces of a larger affective landscape, which includes physiological changes, feelings, and cognitive processes. As it pertains specifically to the interaction between emotions and film, I have found immensely helpful Greg M. Smith, *Film Structure and the Emotion System* (New York: Cambridge University Press, 2003), and Carl R. Plantinga and Greg M. Smith, *Passionate Views: Film, Cognition, and Emotion* (Baltimore: Johns Hopkins University Press, 1999).

17 By drawing the distinction between music that mimics visual activity and music that mirrors narrative events, we are intentionally resisting the tendency to conflate the idea of "narrative" with that of "image." Indeed, due to the way in which animated films blur the line between music and effects, they offer a prime example of why it is important to distinguish between a film's images, on the one hand, and the film's narrative, on the other, which is formed through the dynamic interaction between a soundtrack and an imagetrack.

18 Royal S. Brown, *Overtones and Undertones: Reading Film Music* (Berkeley: University of California Press, 1994), 108.
19 This scene occurs between 42:05 and 46:37 on the DVD.
20 Listen especially to the segment lasting from 7:51 to 9:41.
21 It must be noted, however, that the filmmakers at Pixar never abandon mickey-mousing entirely, for this practice of positioning music in film is highly effective in the animated genre. Thus, the shift we are identifying concerns the primary means by which these filmmakers most often employ music's signifying capacities in each of their films; whereas their earlier films relied heavily on mickey-mousing, this form of musical signification is demonstrably less frequent in their later work.
22 We will come back to the particularities of Randy Newman's scores below. However, it is interesting that, following *Monsters, Inc.*, *Cars* (2006) and *Toy Story 3* (2010), which just debuted in theaters and thus falls outside the parameters of our discussion, are the only other films for which he wrote the music.
23 Brad Lewis, "Fine Food and Film: A Conversation with Brad Bird and Thomas Keller," *Ratatouille* (Emeryville, Calif.: Disney, 2007), DVD.
24 4:33 on the DVD.
25 Interestingly, Bird's comments on the music in *Ratatouille* are highly reminiscent of the work of Antonio Damasio, who separates the phenomenon of human affectivity into three stages of processing that fall along a continuum (i.e., "a state of emotion," "a state of feeling," and "a state of feeling made conscious"). Following Damasio, we might say that the film's music provides a space in which we subjectively "feel" our "emotions" and perhaps even "process" or become consciously aware of our emotions. Thus, in contradistinction to more illustrative music, which often does the affective work for us in that it explicitly identifies a particular "state of emotion" as meaningful, this music allows filmgoers to feel their emotions and process their emotions on their own terms. See Antonio R. Damasio, *The Feeling of What Happens: Body and Emotion in the Making of Consciousness* (New York: Harcourt Brace, 1999), esp. ch. 2.
26 I am using Royal Brown's terminology here. See Brown, *Overtones and Undertones*, 26.
27 Buhler, Neumeyer, and Deemer, *Hearing the Movies*, 54 (emphasis added).
28 This music occurs at 1:26:51.

29 James Buhler, "Analytical and Interpretive Approaches (II)," 48.

30 Buhler, "Analytical and Interpretive Approaches (II)," 48–49.

31 We also hear a recapitulation of this song at 28:52.

32 From 48:37 to 51:23 on the DVD.

33 Additionally, it is the only film after *Nemo* for which Randy Newman composed the score.

34 As we move forward, it is important to keep in mind Caryl Flinn's critique that music actually offers a false clarity. For Flinn, this clarity is illusory, not because music makes the film unlike the "real" world, but because it so effectively effaces its symbolic work. The "clarity" it offers is thus contrived, because it convinces individuals that they are arriving at and constructing their own meaning when in fact this meaning is dictated by the music. However, as Flinn herself points out, the very unreality of nondiegetic music has the capacity to grant the film clarity while also drawing attention to its constructed nature. As she states, "Scholars argue that the increased sense of artifice in these films undermines classic cinema's project of life-likeness, and hence frustrates dominant ideology's interest in passing itself off as transparent, natural, or real." See Flinn, *Strains of Utopia: Gender, Nostalgia, and Hollywood Film Music* (Princeton, N.J.: Princeton University Press, 1992), 116. As it concerns our discussion, the hyperartificial nature of animated film is so apparent that it too works against ideological transparency. Thus, we are able to speak of an interpretive clarity that is neither wholly dictated by the film's music nor entirely co-opted by ideology.

35 Andrew Stanton, as quoted in Daniel Brecher, "Finding Nemo: Review," August 25, 2003, http://www.soundtrack.net/albums/database/?id=3270&page=review (accessed May 15, 2010).

36 The stinger chord rings out at 1:06:37; the screeching of violins occurs shortly thereafter at 1:06:53.

37 Pete Docter, "*Monsters, Inc.* Director's Commentary," *Monsters Inc.* (Emeryville, Calif.: Disney, 2001), DVD.

38 Buhler, Neumeyer, and Deemer, *Hearing the Movies*, 17.

39 See 8:07 for an example of the former, and 35:45 for an example of the latter.

40 This montage lasts from 07:18 to 11:37.

41 Listen to 1:11:01 on the DVD.

42 The leitmotiv appears in these scenes at 21:59, 1:14:43, and 1:27:34, respectively.

43 One reviewer for *The New York Times* suggested that "the movie
 remains bound by convention. . . . This has become the Pixar
 way. Passages of glorious imagination are invariably matched
 by stock characters and banal story choices, as each new movie
 becomes another manifestation of the movie-industry divide
 between art and the bottom line." Manohla Dargis, "The House
 That Soared," *The New York Times*, May 28, 2009, http://movies
 .nytimes.com/2009/05/29/movies/29up.html (accessed June 15,
 2010).

44 Although it must be noted that, according to some critics such
 as Dargis, Russell's "father problems" somehow make him "feel
 ingratiating enough to warrant a kick." I simply disagree. A
 young boy who is wrestling with his father's absence is anything
 but ingratiating.

Chapter 2

1 Charlotte Haines Lyon and Clive Marsh, "Film's Role in Contem-
 porary Meaning-Making: A Theological Challenge to Cultural
 Studies," in *Reconfigurations: Interdisciplinary Perspectives on
 Religion in a Post-Secular Society*, ed. Stefanie Knauss and Alex-
 ander D. Ornella (New Brunswick, N.J.: Transaction Publishers,
 2007), 122.

2 I have based the following criteria largely upon the work of Lyon
 and Marsh, who go on to state that "the need for texts which
 both children and adults might be able to access, if in different
 ways, remains. 'Noah's Ark' has always had the capacity to func-
 tion on multiple levels, but children's picture-books have not
 usually handled the bit of the story which tells of the destruc-
 tion of most of humanity. The popularity, then, amongst adults
 as well as children, of [children's films] . . . may be less a matter
 of the infantilism of culture than of the recognition that cul-
 tures need common narratives, accessible across ages. The void
 left by the Bible's increasing absence may not again be filled by
 the Bible, but will still need filling." Lyon and Marsh, "Film's
 Role," 122–23.

3 By using the term "thick" interpretations, we are borrowing
 the terminology of Clifford Geertz, who suggested that a robust
 understanding of a particular cultural artifact or cultural prac-
 tice depends upon one's ability to discern the multiple levels of
 signification inherent in that artifact. For Geertz, human beings
 are creatures living in "webs of significance they have spun."

Thus, ethnography is an interpretive search for the meaning of those webs, an elaborate venture in "thick description." See Geertz, *The Interpretation of Cultures* (New York: Basic Books, 1973), esp. ch. 1.

4 In his discussion on the genres of fantasy and animation, Craig Detweiler makes a similar claim. He states, "For fairy tales to work, *evil must be taken seriously*. Fantasy must mirror our world's ambiguity, mystery, and danger." Detweiler, *Into the Dark: Seeing the Sacred in the Top Films of the 21st Century*, Cultural Exegesis (Grand Rapids: Baker Academic, 2008), 223 (emphasis in original).

5 At the time of writing, Pixar's first four films are all rated at an 8.1 or below on IMDb. *A Bug's Life*—Pixar's second film—has the lowest rating of any of the studio's films at 7.3. With the exception of *Cars*, the remaining six films are all rated at 8.1 or higher. We will return to a discussion of the *Cars* anomaly below. Among the films we addressed in the previous chapter, *WALL-E* is the highest rated film at 8.5. However, *Toy Story 3* is currently rated at 9.1—a number that is likely to decline as more reviewers contribute to the overall rankings. Yet if it remains the highest rated Pixar film, it will only lend further credence to our observation.

6 For example, a running joke throughout *A Bug's Life* concerns Francis the ladybug—a seemingly feminine bug who is actually a male. In *Toy Story 2*, as Buzz Lightyear watches Jessie the cowgirl perform an acrobatic feat at the end of the film, the wings on his spacesuit become "erect" with excitement.

7 kinga, "Up, Down, and up Again," January 26, 2010, http://community.nytimes.com/rate-review/movies.nytimes.com/movie/402056/Up/overview (accessed June ,1 2010).

8 SleepingDog, "Up up and Away," November 25, 2009, http://community.nytimes.com/rate-review/movies.nytimes.com/movie/402056/Up/overview (accessed June 1, 2010).

9 I am indebted here to Roberto S. Goizueta. See Goizueta, *Caminemos Con Jesus: Toward a Hispanic/Latino Theology of Accompaniment* (New York: Orbis Books, 1995), esp. 89–100.

10 Goizueta, *Caminemos Con Jesus*, 92.

11 I owe this insight to James Buhler. See Buhler, "Analytical and Interpretive Approaches (II)," 47. Adorno and Eisler, for example, tend to value music that exists in a "counterpoint" relationship with the image over and above music that shares a "parallel" relationship with the image.

12 Heidi White, "Pixar Films," e-mail message to author, June 26, 2010.

13 I owe this basic insight to Jill Y. Crainshaw, *Wise and Discerning Hearts: An Introduction to Wisdom Liturgical Theology* (Collegeville, Minn.: Liturgical Press, 2000). Although Crainshaw is primarily concerned with the relationship between wisdom and liturgy, her consideration of Israel's wisdom tradition and the "sapiential imagination" runs parallel to our consideration of film as a contemporary space in which individuals are able to cultivate wisdom.

14 Crainshaw, *Wise and Discerning Hearts*, 164.

15 Crainshaw, *Wise and Discerning Hearts*, 163.

16 See Jürgen Moltmann, *The Spirit of Life: A Universal Affirmation*, trans. Margaret Kohl (Minneapolis: Fortress, 1991).

17 I owe this insight to Robert K. Johnston, *Useless Beauty*.

18 Detweiler, *Into the Dark*, 237. It may be helpful to note that Detweiler was writing prior to the release of both *WALL-E* and *Up*. Consequently, at the time, the basic shift in Pixar's filmmaking that we have identified was far less discernible.

19 John Vernon Taylor, *The Go-Between God: The Holy Spirit and the Christian Mission* (London: SCM Press, 2004), 39.

20 Although I am aware of alternative interpretations of this passage, I am largely indebted to Ellen Davis for pointing out the significance of the names of Job's daughters. The aesthetic implications that I have identified, however, issue from my own interpretation. See Ellen F. Davis, *Getting Involved with God: Rediscovering the Old Testament* (Lanham, Md.: Cowley Publications, 2001).

Chapter 3

1 Most recently, Mervyn Cooke begins his history of film music in this manner. He states, "As has often been remarked, the cinema has never been silent." Cooke, *A History of Film Music* (New York: Cambridge University Press, 2008), 1.

2 According to Rick Altman, for example, "the notion that silent films were never actually silent has been passed down from generation to generation, always dependent on the authority of the speakers rather than on supporting evidence." Altman, *Silent Film Sound* (New York: Columbia University Press, 2004), 193. Altman suggests that the evidence actually points not to a homogenous practice in which movies were always accompanied

by music, but rather to radically heterogeneous exhibition practices. By questioning the conventional wisdom concerning music's historical relationship with cinema, Altman is essentially challenging the assumption that musical accompaniment "is the only *natural* solution to the apparent dilemma posed by soundless films." Altman, *Silent Film Sound*, 11 (emphasis in original). Thus, Altman suggests that the relationship between music and film, rather than being "natural," is a complex product of variegated practices, contexts, technologies, and economic exigencies.

3 Those who would argue otherwise must answer a rather obvious historical question: if projector noise was the primary reason for musical accompaniment, and audiences were completely comfortable with silence, why did distributors, critics, and audiences continue to demand music when technology allowed for noiseless projection? Claudia Gorbman poses a similar question: "Once projection booths became a standard feature of the cinema, why did music continue? Another point of interrogation: what defined the status of music as less distracting than projection noise? . . . What makes screechy, out-of-tune music more desirable for film viewing than the regular hum and click of a projector?" Gorbman, *Unheard Melodies: Narrative Film Music* (Bloomington: Indiana University Press, 1987), 37.

4 Lauren Anderson, "Case Study 1: Sliding Doors and Topless Women Talk About Their Lives," in *Popular Music and Film*, ed. Ian Inglis (London: Wallflower, 2003), 102.

5 For his part, Altman would likely point out that, while we do know that music was involved in these early exhibitions, we do not know with any certainty exactly *how* these films were accompanied, if at all. However, the historical evidence suggests that films were most likely accompanied in a manner appropriate to the particular venue in which they were screened. I am thankful to James Buhler for this historical insight.

6 "It is also known that a performer on harmonium took part in the London premiere of the Lumière films . . . on February 20, 1896, and that orchestras were involved in Lumière showings at London's Alhambra and Empire theaters over the next several months. In the United States, an ensemble called Dr. Leo Summer's Blue Hungarian Band was on the scene when the first projected motion pictures—not Cinématographe products but films run through an Edison-affiliated device called the

Vitascope—were displayed in New York . . . on April 23, 1896. An orchestra was present too, when a Lumière program premiered in New York at Keith's Vaudeville House on June 28, 1896. . . . Music was being incorporated into public presentations of films within a year of the Cinématographe and Vitascope debuts." Wierzbicki, *Film Music*, 20–21.

7 Brown, *Overtones and Undertones*, 12.

8 This is the primary question that noted French film theorist André Bazin asks. See Bazin, *Qu'est-Ce Que Le Cinéma?* (Paris: Editions du Cerf, 1975).

9 Flinn, *Strains of Utopia*, 6.

10 Michel Chion, *Audio-Vision: Sound on Screen*, trans. Claudia Gorbman (New York: Columbia University Press, 1994), xxv.

11 Chion, *Audio-Vision*, xxvi.

12 Michel Chion refers to this apparent union of sound and image as "synchresis—a phenomenon that is independent of reasoning and also of the question of power and causality." Chion, *Film, a Sound Art* (New York: Columbia University Press, 2009), 38.

13 "By *added value* I mean the expressive and informative value with which a sound enriches a given image so as to create the definite impression, in the immediate or remembered experience one has of it, that this information or expression 'naturally' comes from what is seen, and is already contained in the image itself." Chion, *Audio-Vision*, 5 (emphasis in original).

14 Chion, *Audio-Vision*, 21.

15 Chion, *Audio-Vision*, 143.

16 According to Chion, "even now the cinema has kept its ontologically visual definition no less intact. A film without sound remains a film; a film with no image, or at least without a visual frame for projection, is not a film. . . . [T]he screen remains the focus of attention." Chion, *Audio-Vision*, 40.

17 As Robert Johnston has pointed out, "movies are both 'pictured' and 'heard,' not just described. Thus, there needs to be an expansion of method to include the visual and the aural, if theology and film is to escape its literary captivity." Johnston, *Reframing Theology and Film*, 19.

18 As David Neumeyer has pointed out, "most authors dwell not on the question discussed above—*why* music should be present in film—but, assuming it should, on *how* it functions in relation to film narrative." David Neumeyer, Caryl Flinn, and James Buhler, "Introduction," in *Music and Cinema*, ed. James Buhler, Caryl

Flinn, and David Neumeyer (Hanover, N.H.: University Press of New England, 2000), 13 (emphasis in original).

19 One of the most influential authors in this regard is Claudia Gorbman, whose book *Unheard Melodies* is recognized as one of the fundamental texts in the field. See Gorbman, *Unheard Melodies*, 2.

20 See chapter 1 for a brief discussion on how I am using the term "phenomenological."

21 As summarized in Pauline Reay, *Music in Film: Soundtracks and Synergy*, Short Cuts (London: Wallflower, 2004), 32. Originally from Aaron Copland, *What to Listen for in Music*, 2nd ed. (New York: McGraw-Hill, 1957), 256–58.

22 See Roy M. Prendergast, *Film Music: A Neglected Art; A Critical Study of Music in Films*, 2nd ed. (New York: W.W. Norton, 1992).

23 For Gorbman, Hollywood films construct audiences ideologically in the filmic experience through the aesthetic of transparency. Music works to aid this process by acting as a "suturing device" which lessens the awareness of the technological nature of film discourse and bonds the spectator to spectacle. Moreover, it lowers the audience's threshold of belief. Gorbman states, "Like hypnosis, it silences spectator's censor. It is suggestive; if it's working right, it makes us a little less critical and a little more prone to dream." Gorbman, *Unheard Melodies*, 55.

24 An example of the former is the work of Melissa Carey and Michael Hannan, who build the categories of Gorbman, to determine whether popular, lyrical music functions in a similar manner to classical orchestral music. They identify no fewer than fourteen(!) functions of music in film. See Melissa Carey and Michael Hannan, "Case Study 2: The Big Chill," in *Popular Music and Film*, ed. Ian Inglis (London: Wallflower, 2003), 164–65. An example of the latter is Royal Brown, who condenses the functions of film music into three basic categories: (i) music is a soporific wallpaper, (ii) music serves as an aesthetic counterbalance to the iconic nature of the image, (iii) music turns the image into an "affective image-event." See Brown, *Overtones and Undertones*, 32.

25 Phil Powrie and Robynn Jeananne Stilwell, "Introduction," in *Changing Tunes: The Use of Pre-Existing Music in Film*, ed. Phil Powrie and Robynn Jeananne Stilwell (Aldershot, U.K.: Ashgate, 2006), xix.

26 I owe this insight to Greg M. Smith, *Film Structure and the Emotion System* (New York: Cambridge University Press, 2003).

27 Bernard Herrmann as quoted in Flinn, *Strains of Utopia*, 46.

28 As François Jost suggests, "Du point de vue émotif, la musique ne se contente pas de souligner ou d'illustrer des sentiments. Elle donne au film une dimension tragique. ("From the point of view of emotion, music does not just emphasize or illustrate feelings; it gives the film a tragic dimension.") Jost, "Les Voies du silence" (ET: "The Voices of Silence"), in Richard Abel and Rick Altman, *The Sounds of Early Cinema* (Bloomington: Indiana University Press, 2001), 55 and 277.

29 Neumeyer, Flinn, and Buhler, "Introduction," 12.

30 Prendergast, *Film Music*, 217.

31 Gorbman, *Unheard Melodies*, 6.

32 Chion states, "Through its sonorities and orchestral range, and the horizons suggested by its melodies, music often helps restore the impression of 'vastness' that can become lost through the fragmentation of editing and that realist sound cannot achieve. . . . Often music is brought in to restore the missing sensation of immense natural grandeur." Chion, *Film, a Sound Art*, 409.

33 Adorno and Eisler, *Composing for the Films*, 15 and 48–51.

34 Eisler and Adorno make this claim even while decrying the ill effects of what they term film music's "sham collectivity." Adorno and Eisler, *Composing for the Films*, 48–50.

35 "[Music] is said to bestow a 'human touch' upon the cinematic apparatus, something that the apparatus intrinsically lacks." Flinn, *Strains of Utopia*, 42. It must be noted, however, that Flinn believes this conception of the "restoration of plentitude," which she suggests emanates from romantic notions of music, in fact limits our ability to examine the ways in which music actually functions in different texts. However, in terms of how it describes contemporary perceptions regarding the "humanity" or "spiritual" fullness of music, her analysis is quite helpful.

36 Mary Ann Doane, "Ideology and the Practice of Sound Editing and Mixing," in *Film Sound: Theory and Practice*, ed. Elisabeth Weis and John Belton (New York: Columbia University Press, 1985), 57.

37 James Buhler, "*Star Wars*, Music, and Myth," in *Music and Cinema*, ed. James Buhler, Caryl Flinn, and David Neumeyer (Hanover, N.H.: Wesleyan University Press, 2000), 44.

38 Chion, *Film, a Sound Art*, 159–60.

39 In this section I will be primarily drawing from the analytical
 and interpretive approaches of film music scholars James Buhler
 and David Neumeyer. See David Neumeyer and James Buhler,
 "Analytical and Interpretive Approaches to Film Music (I):
 Analysing the Music," in *Film Music: An Anthology of Criti-
 cal Essays*, ed. K. J. Donnelly (Edinburgh: Edinburgh University
 Press, 2001); and Buhler, "Analytical and Interpretive Approaches
 (II)." Together, these articles serve as the basis for the theoretical
 framework I am presenting here. However, insofar as we are con-
 cerned both with those who are technically trained musicians
 and those who are not, I will also be drawing from their recently
 released textbook on music and sound, which is intentionally
 accessible to those who are unable to read musical notation. See
 Buhler, Neumeyer, and Deemer, *Hearing the Movies*.

40 Rick Altman has rightly suggested that music critics often
 base their analyses not on the "music as heard in the film, but
 on the music as composed." Altman, "Inventing the Cinema
 Soundtrack: Hollywood's Multiplane Sound System," in *Music
 and Cinema*, ed. James Buhler, Caryl Flinn, and David Neu-
 meyer (Hanover, N.H.: University Press of New England, 2000),
 340. While space precludes us from fully employing Altman's
 "mise-en-bande" analysis here, it is important to keep in mind
 that we are locating our analysis of film music within a broader
 understanding of the film's overall sound design (i.e., the interac-
 tion between the film's dialogue, sound effects, and music).

41 For this very reason, I will not be including "tonal design" as one
 of our modes of analysis. Tonal design is essentially the man-
 ner in which the key centers of musical pieces are related and
 structured throughout a piece of music. Neumeyer and Buhler
 are correct in suggesting that an analysis of a film's tonal design
 allows "insight into less obvious aspects of the composer's craft
 and might even give insight into the composer's 'reading' of the
 film." Yet it is the very obscurity of this mode of analysis that
 abstracts it from the filmic experience and, thus, prevents us
 from including it in our discussion. Neumeyer and Buhler, "Ana-
 lytical and Interpretive Approaches (I)," 28.

42 Neumeyer and Buhler, "Analytical and Interpretive Approaches
 (I)," 23.

43 Neumeyer and Buhler, "Analytical and Interpretive Approaches
 (I)," 23.

44 For example, in Zack Snyder's *Watchmen* (2009), as Dr. Manhat-
tan and the Comedian brutally annihilate countless Viet Cong
soldiers, the film foregrounds the principal motif from Richard
Wagner's "Ride of the Valkyries" (see 38:49–39:39 on the DVD).
With its distinctive 9/8 rhythms that conjure images of galloping
horses, its string runs that evoke the movement of wind, and its
hurried pace, this music certainly possesses the characteristic
traits commonly associated with a militaristic engagement. Yet,
perhaps the most notorious appearance of "Ride of the Valkyries"
in film history occurs when it accompanies the Ku Klux Klan's
ride to the rescue in D. W. Griffith's *Birth of a Nation* (1915).
Moreover, in *Apocalypse Now* (1979) the music is used (perhaps
in an ironic reference to Griffith's earlier film) as a squadron of
helicopters attacks a Vietnamese village. Because the scene in
Watchmen takes place during the Vietnam War and depicts a
squadron of helicopters accompanying Dr. Manhattan and the
Comedian, the intertextual allusion is almost unmistakable.
45 Neumeyer and Buhler, "Analytical and Interpretive Approaches
(I)," 32.
46 Dylan's song plays from 5:40 to 11:05.
47 Although space precludes a full discussion of this sort, music
can also contribute to small-scale filmic form by imbuing a par-
ticular scene with a sense of motion. As Neumeyer and Buhler
suggest, "music for action sequences such as chases or battles
lays down a 'temporal perspective' or a defined frame of refer-
ence within which the chaotic actions can intelligibly unfold."
Neumeyer and Buhler, "Analytical and Interpretive Approaches
(I)," 34. For example, in an action scene from *Watchmen*, Nite
Owl and Silk Spectre II raid a prison to free their fellow super-
hero Rorschach. As they engage in fisticuffs with prison guards
and inmates, we hear a rhythmically aggressive, electronic
music played at 140 beats per minute (this segment occurs
between 1:50:15 and 1:51:17). The scene itself moves at a rela-
tively methodical pace, incorporating both live action and slow
motion. Yet the music speeds up the perceived pace of the scene
and intensifies the action.
48 Neumeyer and Buhler, "Analytical and Interpretive Approaches
(I)," 35.
49 Buhler, Neumeyer, and Deemer, *Hearing the Movies*, 165.
50 Commenting on analytical modes that emphasize pitch relations,
Neumeyer and Buhler state, "Even at the outset, one worries that

these emphases miss the bulk of what is at stake in film scores, but traditional modes of analysis are nevertheless indispensable for a thorough musical understanding of individual cues and the higher level structuring of groups of cues." Neumeyer and Buhler, "Analytical and Interpretive Approaches (I)," 19.

51 Neumeyer and Buhler, "Analytical and Interpretive Approaches (I)," 20.

52 In his seminal work *Emotion and Meaning in Music*, Leonard B. Meyer contends that music evokes an emotional response in listeners when their own musical expectations, which are activated by the music they hear, are "temporarily inhibited or permanently blocked." Meyer, *Emotion and Meaning in Music* (Chicago: University of Chicago Press, 1956), 31. According to Meyer, the minor mode is innately chromatic, which means that any melody constructed in this mode has the potential for employing all but two of the twelve tones in a chromatic scale. By comparison, a musical piece constructed in a major mode uses only seven tones and, thus, offers fewer potential directions in which it might move. For Meyer, then, the minor mode as a tonal system is more ambiguous and less stable than the major mode. Thus, as it perpetually inhibits our musical expectations through its rich repertory of potential tones, the minor mode is "not only associated with intense feeling in general but with the delineation of sadness, suffering, and anguish in particular." Meyer, *Emotion and Meaning*, 227. It follows, then, that the major mode, which, for Meyer, is far more stable and ordered, is related to "[s]tates of calm contentment and gentle joy." Meyer, *Emotion and Meaning*, 227.

53 Brown, *Overtones and Undertones*, 6.

54 In music, "consonance" is essentially understood as a "harmonious" combination of tones, whereas "dissonance" is a combination of tones that sound discordant, "unstable," and even in "need" of a resolution. Although theories abound concerning exactly why certain tonal combinations issue in either a consonant or dissonant relationship, what is central here is that, like major and minor modes, the consonant/dissonant pair is primarily an affective category.

55 As Neumeyer and Buhler explain, "[t]onal dissonance entails a resolution to a particular consonance (whether or not the expected consonance follows), so that we experience a build-up and discharge of tension in the dissonance-consonance

pair in a relatively predictable way; whereas atonal music has 'emancipated' the dissonance from its entailment to a following consonance, so that the dissonance has an identity wholly independent of any 'resolution' that may follow." Neumeyer and Buhler, "Analytical and Interpretive Approaches (I)," 23.

56 As Neumeyer and Buhler suggest, "[u]nder many conditions film music, like much music for the theater, will disregard syntax to achieve a certain colouristic effect. . . . But unlike concert music . . . film music receives its dividends from the interaction of the effect with the narrative." Neumeyer and Buhler, "Analytical and Interpretive Approaches (I)," 31.

57 Buhler, Neumeyer, and Deemer, *Hearing the Movies*, 41–52. It may be helpful to note that these categories are found in a discussion of the "musicality" of the soundtrack. This is significant because, when speaking of the timbral qualities of film music, we are necessarily blurring the lines between music and sound. Yet, as these lines are always already blurred in the cinematic experience, it seems inevitable that our analytical modes will, likewise, cross these largely theoretical boundaries.

58 Neumeyer and Buhler, "Analytical and Interpretive Approaches (I)," 31.

59 See 1:31:27 on the DVD.

60 Buhler, "Analytical and Interpretive Approaches (II)," 39.

61 Indeed, Gorbman states, "To judge film music as one judges 'pure' music is to ignore its status as a part of the collaboration that is the film. Ultimately it is the narrative context, the interrelations between music and the rest of the film's system, that determines the effectiveness of film music." Gorbman, *Unheard Melodies*, 12.

62 Neumeyer and Buhler, "Analytical and Interpretive Approaches (I)," 28.

63 As Buhler, Neumeyer, and Deemer make clear, a leitmotiv is "a term that derives from the music dramas of the 19th-century German composer Richard Wagner, where it designates musical themes or motifs associated with people, objects, and even ideas." Buhler, Neumeyer, and Deemer, *Hearing the Movies*, 200.

64 See, e.g., Adorno and Eisler, *Composing for the Films*, 2–3. Adorno and Eisler's primary critique of the (over)use of the leitmotiv in film has to do with their belief that Hollywood films are unable to supply a large enough musical canvas in which these

themes might fully develop, thus making the leitmotiv a symbol devoid of any real metaphysical significance—a significance that was the actual aim of the Wagnerian leitmotiv.

65 Buhler suggests that John Williams' music in *Star Wars* functions in this manner. He states, "The semiotic failure is the mark of the mythic, pointing to a realm beyond reason, beyond language—a realm that in *Star Wars* functions as the domain of the Force." Buhler, "*Star Wars*, Music, and Myth", 44.

66 The marimba figure first appears at 01:10 on the DVD, immediately following the prologue sequence.

67 These strings slowly emerge in the underscoring at 1:01:55, and the piano follows at 1:02:02.

68 Gorbman, *Unheard Melodies*, 22. Others have made this distinction by using the terms "source" and "background" music. Yet, difficulties arise with this terminology when music, which belongs to the narrative world, has no visible source, or when music that is termed "background," while not a part of the narrative world, is foregrounded in a particular scene. Thus, Chion prefers the terms "pit music" and "screen music," which focus not on the music's function but on its symbolic place of emission. Chion, *Film, a Sound Art*, 412. However, we will maintain the "diegetic/nondiegetic" language, not only because it avoids certain difficulties regarding "source" and "background" music, but also because Gorbman's usage has become somewhat standardized.

69 Chion, *Film, a Sound Art*, 430.

70 Chion, *Film, a Sound Art*, 430.

71 Chion, *Film, a Sound Art*, 431.

72 Gorbman suggests that anempathetic music's "very emotionlessness, juxtaposed with ensuing human catastrophe, is what provokes our emotional response." Gorbman, *Unheard Melodies*, 24.

73 Buhler, "Analytical and Interpretive Approaches (II)," 41.

74 Buhler, "Analytical and Interpretive Approaches (II)," 47.

75 As Flinn suggests, "music's current ideological function is . . . to generate the illusion of having none." Flinn, *Strains of Utopia*, 5.

76 Chion, *Audio-Vision*, 129. It must be noted that, for Chion, the *acousmêtre* is an expressly *diegetic* presence. By relating the *acousmêtre* to nondiegetic music, I am appropriating Chion's terminology in order to speak of how some nondiegetic music structures the diegetic world in a similar manner—through the presence of an absence.

77 Buhler, "Analytical and Interpretive Approaches (II)," 51.

78 Gorbman, *Unheard Melodies*, 23.

79 I owe this insight to Buhler, who also notes that this industry distinction further reinforced an interpretive bias that favored nondiegetic symphonic music, inscribing a hierarchy of cultural values in which "high art and aesthetic values are set against low art and commercial value." Buhler, "Analytical and Interpretive Approaches (II)," 43.

80 Ronald Rodman, "The Popular Song as Leitmotif in 1990s Film," in *Changing Tunes: The Use of Pre-Existing Music in Film*, ed. Phil Powrie and Robynn Jeananne Stilwell (Aldershot, U.K.: Ashgate, 2006), 135.

81 Of course, it must be noted that, in some instances, preexisting orchestral pieces are also incorporated into a film's compiled score. Like "The Ride of the Valkyries" in *Watchmen*, when this music is well known, it too carries a culturally mediated meaning into the film. In these cases, the music is likely functioning either as a style topic or along similar lines to popular music. Thus, our understanding of "popular" and "orchestral" must remain fluid and flexible, allowing space for music that challenges this analytical distinction.

82 This particular function of popular music is a holdover from the early days of silent film accompaniment, where a song's title would comment on the film's action. See Claudia Gorbman, "Ears Wide Open: Kubrick's Music," in *Changing Tunes: The Use of Pre-Existing Music in Film*, ed. Phil Powrie and Robynn Jeananne Stilwell (Aldershot, U.K.: Ashgate, 2006), 15.

83 Wierzbicki, *Film Music*, 222.

84 It was Rick Altman who coined the term "audio dissolve" and developed it as a film-musical concept. See Altman, *The American Film Musical* (Bloomington: Indiana University Press, 1987), esp. ch. 4.

85 Buhler, "Analytical and Interpretive Approaches (II)," 41.

86 This shift occurs at 16:16 on the DVD.

87 "Wise Up" plays in its entirety, from 2:18:55 to 2:22:20.

Chapter 4

1 I am borrowing both the term "affective space" and its definition from Clive Marsh. According to Marsh, an "affective space" is simply a location where "human beings . . . explore individually and corporately how they develop emotionally, and [where] this emotional development features as part of their life-structure

as a whole." Marsh, "The Arts, Learning and the Cultivation of Piety: Contemporary Theological Reflections on Schleiermacher's Approach to Pedagogy and Person-Formation" (paper presented at the AAR National Meeting, Montreal, November 2009), 12.

2 Kathryn Kalinak, *Settling the Score: Music and the Classical Hollywood Film* (Madison: University of Wisconsin Press, 1992), 4.

3 "How greatly did I weep during hymns and canticles, keenly affected by the voices of your sweet-singing Church! Those voices flowed into my ears, and your truth was distilled into my heart, and from that truth holy emotions overflowed and tears ran down, and amid those tears all was well with me." Augustine, *Confessions* 9.6.14 in Augustine, *The Confessions of St. Augustine*, trans. John K. Ryan (Garden City, N.Y.: Image Books, 1984), 214.

4 "This sensual pleasure [of music], to which the soul must not be delivered so as to be weakened, often leads me astray, when sense does not accompany reason in such a way as to follow patiently after it. . . . Thus in such things I unconsciously sin, but later I am conscious of it." Augustine, *Confessions* 10.33.49. Some have suggested that this tension in Augustine is due to the philosophical influence of a "Platonic dualism"—one that makes a strong distinction between the sensate and spiritual worlds. For example, although he suggests that Augustine's thought was indeed informed by both Platonic and Neoplatonic philosophical categories, Don Saliers points to the strong, Platonic distinction between body and spirit as the primary source for Augustine's ambivalence. Don E. Saliers, *Music and Theology* (Nashville: Abingdon, 2007), esp. ch. 2. However, while he may have appropriated certain Platonic elements, what emerges in Augustine's thought concerning the musical-aesthetic experience is the distinctly Neoplatonic notion of the disorienting effects of music's emotionality and sensuality. In contrast to Plato's sharp distinction between the "intelligible" or real world of Forms and the "visible" or less real material world, Plotinus, a third-century Neoplatonist philosopher, believed all earthly, sensual forms were emanations from "the One." He states in *Enneads* 1.6.4, "But about the beauties beyond . . . the soul sees them and speaks of them without instruments—we must go up to them and contemplate them and leave sense to stay down here." Plotinus,

Enneads: English & Greek, trans. Paul Henry and Hans-Rudolf Schwyzer, vol. 1 (Cambridge, Mass.: Harvard University Press, 1966), 243. Therefore, according to a Neoplatonic worldview, earthly, sensual representations such as music are actually beneficial insofar as they allow us to ascend through all the visible and invisible beauties of derived reality to the source of all beauty—the Good. They are detrimental, however, insofar as they disorient our journey toward the Good. This distinction is important to make because Augustine was not suggesting that music was somehow less than "real" in a purely Platonic sense. Rather, he was concerned with the sensual and, therefore, potentially destructive nature of music's affective power. According to Augustine, "Music's materiality and sensuality, coupled with its emotional power, easily encourage an unhealthy attachment to this life." Jeremy Begbie, *Resounding Truth: Christian Wisdom in the World of Music* (Grand Rapids: Baker Academic, 2007), 85.

5 I do not wish to overstate Augustine's role in this matter. To be fair, as Albert Blackwell suggests, the Christian tradition's ambivalence toward music predates Augustine. Yet, this ambivalence finds unique expression in Augustine's *Confessions.* Thus, due to his singular influence on subsequent theological reflection and the various iterations that find their source in his thought, I am referring to Augustine as more of a theological "type" that persists throughout the history of Western theology. Although Augustine serves as a salient example of the tensions in theological reflection on music and affect, I do not wish to "blame" him for this tension. See Albert L. Blackwell, *The Sacred in Music* (Louisville, Ky.: Westminster John Knox, 1999), 127–30.

6 I have borrowed the terminology for these categories from Janet Staiger, who actually outlines four models: the education model, the reinforcement model, the mediation model, and the power model. See Staiger, *Media Reception Studies* (New York: New York University Press, 2005).

7 Although I am somewhat unsatisfied with her terminology given the current state of political discourse in the United States, Staiger rightly notes that there are "conservative" and "liberal" versions of both the reinforcement and power relation models, which is significant for our current discussion. She states, "Equally, conservatives and radicals often envision media's relation to individuals in this way—either making good citizens into liberals or libertines (the conservatives' view) or repressing

progressive urges or movements (the radicals' opinion)." Staiger, *Media Reception Studies*, 18–19.

8 A salient example of the influence of critical theory in film music scholarship can be found in the anthology *Music and Cinema*, which attempts to provide an overview of the current state of the field of film music studies. In the introduction the authors state, "[C]ontemporary critical theory informs nearly all of the pieces, just as film music *itself* is at some level a concern of every piece in the collection." Neumeyer, Flinn, and Buhler, "Introduction," 4 (emphasis in original).

9 Gordon Lynch, "Critical Theory and Cultural Studies," in *The Routledge Companion to Religion and Film*, ed. John Lyden (London: Routledge, 2009), 277.

10 I owe this insight to Nicholas Cook. See Cook, *Music: A Very Short Introduction* (Oxford: Oxford University Press, 2000), 102–3. Among those working in the field of critical theory, it is perhaps Theodor Adorno who has most significantly influenced the ways in which film music scholars understand the role of music in the cinematic experience. This influence is in part due to the fact that Adorno was not only one of the key thinkers associated with the Frankfurt School of critical theory but also a musician and musical critic. Along with Max Horkheimer and others in the Frankfurt School, Adorno embraced the Marxist critique of mass media and the effects it had on audiences. Thus, the work of Adorno and the Frankfurt School represents an early iteration of the "power relation" model. It is important to note, however, that when speaking of Adorno's influence, we are speaking in fact of one of the most common ways in which Adorno's work has been received and subsequently appropriated. I will leave it to others to decide whether this common appropriation is entirely fair to Adorno's oeuvre, for while he wrote extensively on the "culture industry" and the effects of music on social organization, Adorno is a complex figure whose thought cannot be easily reduced.

11 "Music is unveiled as the drug that it is in reality, and its intoxicating, harmfully irrational function becomes transparent." Adorno and Eisler, *Composing for the Films*, 15.

12 I have borrowed this phrase from Claudia Gorbman, who states, "The bath of affect in which music immerses the spectator is like easy-listening, or the hypnotist's voice, in that it rounds off the

sharp edges, [and] masks contradictions . . . with its own melodic and harmonic continuity." Gorbman, *Unheard Melodies*, 5.

13 Gorbman, *Unheard Melodies, 5.*

14 Here we will be interacting with Graham Ward's analysis of *Moulin Rouge!* found in his article, "All You Need Is Love: Moulin Rouge or Christian's Tragedy," in *Reconfigurations: Interdisciplinary Perspectives on Religion in a Post-Secular Society*, ed. Stefanie Knauss and Alexander D. Ornella (New Brunswick, N.J.: Transaction Publishers, 2007).

15 John Milbank, Catherine Pickstock, and Graham Ward, eds., *Radical Orthodoxy: A New Theology* (New York: Routledge, 1999), 1. Here we see a prime example of Staiger's insight that there are both liberal and conservative forms of the "reinforcement" and "power relation" models. In addition to his contributions to *Radical Orthodoxy*, Ward has also authored a book on the relevance of contemporary critical theory for the study of Christian theology, in which he challenges the very separation of critical theory and theology as a product of cultural politics. See Graham Ward, *Theology and Contemporary Critical Theory*, 2nd ed. (New York: St. Martin's Press, 2000).

16 Ward, "All You Need Is Love," 168.

17 Ward, "All You Need Is Love," 172.

18 "The film is lavish in its attention to this commercialization, these multiple economies of exchange and intercourse within which the marketability of the film itself is situated. Through the camera's lingering and lavish attention to the sumptuous, the film celebrates its own commodification and commercialization. The filmmaker, too, prostitutes his talents, as Christian himself does, for a price." Ward, "All You Need Is Love," 169.

19 Ward, "All You Need Is Love," 169.

20 Ward, "All You Need Is Love," 173.

21 Ward, "All You Need Is Love," 173–74.

22 Ward, "All You Need Is Love," 175.

23 Ward, "All You Need Is Love," 175.

24 Ward, "All You Need Is Love," 176.

25 Ward, "All You Need Is Love," 177.

26 Ward, "All You Need Is Love," 169.

27 Ward, "All You Need Is Love," 168.

28 "Come What May" is in C major, while "El Tango de Roxanne" shifts between G minor and E minor.

29 This occurs at 1:23:08 on the DVD.

30 Ward, "All You Need Is Love," 174.

31 I have borrowed the notion of a "surplus in need of interpretation" from James Buhler, "Analytical and Interpretive Approaches (II)," 49.

32 I owe this insight to Robert Johnston. See Johnston, *Useless Beauty*, 21.

33 By doing so, we are intentionally culling from a number of non-fieldwork sources that either provide ethnographic data for further analysis or illustrate key aspects of our argument. Much like Christopher Deacy and Craig Detweiler before us, we will primarily attend to these Internet-based resources (i.e., the Internet Movie Database and Rotten Tomatoes) in order to access the various ways in which audiences understand their filmgoing experiences. Among those contribution to the scholarship on theology and film, these two notable scholars have turned to reviewer postings on IMDb as a source for audience response data. See Deacy, *Faith in Film: Religious Themes in Contemporary Cinema* (Burlington, Vt.: Ashgate, 2005); and Detweiler, *Into the Dark*. In addition to Deacy and Detweiler, Staiger's work in media reception studies offers support for my use of these ethnographic sources. She states, "No approach to meaning-making and effects avoids doing textual analysis of something: movie reviews, ethnographic notes, individuals' statements, focus group remarks, statements about memories, the objects spectators are looking at and listening to." Staiger, *Media Reception Studies*, 13. Others within film music studies have also turned to the IMDb as a "sterling reference source." See Cooke, *History of Film Music*, xx.

34 mcornett, "I Don't Get This Movie," October 16, 2009, http://www.imdb.com/title/tt0203009/board/thread/148814171?d=149 583012&p=1#149583012/ (accessed November 1, 2009).

35 Rebeshka, "Moulin Rouge!," August 26, 2009, http://www.rotten tomatoes.com/user/rebeshka/reviews/ (accessed October 15, 2009).

36 Ward, "All You Need Is Love," 173.

37 luffielove, "*Goose Bumps!!*," July 1, 2009, http://www.imdb.com/title/tt0203009/ (accessed October 15, 2009).

38 Sarah N. Kaden, "*Moulin Rouge!*," October 27, 2009, http://www.rottentomatoes.com/user/762150/reviews/?movie=12846/ (accessed October 15, 2009).

39 jasmineeeee, "Okay, Who Else Cried?," August 5, 2008, http://
 www.imdb.com/title/tt0203009/board/ (accessed November 1,
 2009).

40 kaylaerickson, "Okay, Who Else Cried?," September 13, 2008,
 http://www.imdb.com/title/tt0203009/board/ (accessed Novem-
 ber 1, 2009).

41 navy_lady69, "Okay, Who Else Cried?," October 20, 2008, http://
 www.imdb.com/title/tt0203009/board/, (accessed November 1,
 2009).

42 luffielove, "Goose Bumps!!"

43 moviecritic315-1, "Ewan's Voice Is Sex," December 1, 2009,
 http://www.imdb.com/title/tt0203009/board/ (accessed Decem-
 ber 10, 2009).

44 madameduran, "Ewan's Voice Is Sex," May 5, 2008, http://www
 .imdb.com/title/tt0203009/board/ (accessed December 10, 2009).

45 kerlyfries, "Ewan's Voice Is Sex," June 5, 2008, http://www.imdb.
 com/title/tt0203009/board/ (accessed December 10, 2009).

46 Moviefreek2, "Who out There Actually Agrees This Film
 Sucks?," February 19, 2008, http://www.imdb.com/title/
 tt0203009/board/ (accessed October 15, 2009).

47 ArtieWheels, "Ewan's Voice Is Sex," March 4, 2008, http://www
 .imdb.com/title/tt0203009/board/ (accessed December 10, 2009).

48 Johnston, Reel Spirituality, 242.

49 Bethany_Cox25, "What Movies Made You Cry?," April 9, 2008,
 http://www.imdb.com/title/tt0203009/board/ (accessed October
 15, 2009).

50 Johnston, Reel Spirituality, 243. In following chapters we will
 explore more fully the seemingly paradoxical nature of human
 "S/spirituality" as an experience that is at once "transcendent"
 and "immanent."

51 I owe this insight to Virginia Postrel, who suggests that contem-
 porary persons primarily orient their patterns of consumption
 around their "moods," "emotions," and "feelings." See Postrel,
 The Substance of Style: How the Rise of Aesthetic Value Is
 Remaking Commerce, Culture, and Consciousness, 1st ed. (New
 York: HarperCollins, 2003).

52 Postrel offers a salient example of the significance of affective
 spaces in contemporary culture when she analyzes the exhibi-
 tion booths for interior design companies. She states, "Light-
 ing, sound, and textures convey not only information but the
 right mood. The goal, writes an exhibit designer, is to create 'a

complete environment—one that gets inside the minds of the attendees and triggers the right *feelings.*' Form follows, and leads, *emotion.*" Postrel, *Substance of Style*, 21 (emphasis added).

53 Friedrich Schleiermacher, *On Religion: Speeches to Its Cultured Despisers*, trans. John Oman (London: K. Paul, Trench, Trubner, 1893), 49–50.

54 Philip Edward Stoltzfus, *Theology as Performance: Music, Aesthetics, and God in Western Thought* (New York: T&T Clark, 2006), 69.

55 This initial formulation would eventually lead to Schleiermacher's well-known definition of religion in *The Christian Faith* as "the feeling of absolute dependence." See Friedrich Schleiermacher, *The Christian Faith*, vol. 1 (New York: Harper & Row, 1963), xvi and 12. This notion of religion has exerted tremendous influence throughout the development of liberal Protestant theology. Rudolf Otto, although slightly augmenting Schleiermacher's language, suggests that genuine religious experience is a "numinous feeling" (*das numinose Gefühl*) of the "*mysterium tremendum et fascinans.*" Otto, *The Idea of the Holy*, A Galaxy Book (New York: Oxford University Press, 1958), chs. 1–7. Schleiermacher's notion also emerges when Paul Tillich points to faith as "ultimate concern." See Tillich, *Systematic Theology*, vol. 1 (Chicago: University of Chicago Press, 1951), 12. While both of these authors adapt Schleiermacher for their particular purposes, it is difficult to overstate the influence of his thought and the influence of the reception of his thought on modern theology.

56 According to Thandeka, "Schleiermacher began a revolution in nineteenth-century Protestant thought by redefining human consciousness so as to include organic human 'affect.'" She goes on to say that, "[b]y so doing, he created a new vocabulary for Protestant thought, one that could describe the organic material and physical facts of one's own personal and communal spiritual life." Thandeka, "Schleiermacher, Feminism, and Liberation Theologies: A Key," in *The Cambridge Companion to Friedrich Schleiermacher*, ed. Jacqueline Mariña (New York: Cambridge University Press, 2005), 290.

57 According to Charles Taylor, we are living in what he terms a "post-romantic" age. See Taylor, *A Secular Age* (Cambridge, Mass.: Belknap Press, 2007), esp. ch. 15. For Taylor, modern persons have inherited a number of romantic sensibilities, three

of which are important for our discussion. First, the determining ground for both aesthetic judgment and human meaning is subjective; it resides in the "interior" of our minds. Second, it is through our hearts—our affectivity—that we not only form a basic awareness of the world but also develop a meaning-filled life. Finally, postromantics consider art to be a "creation which reveals." In an important sense, art is "epiphanic." Charles Taylor, *Sources of the Self: The Making of the Modern Identity* (Cambridge, Mass.: Harvard University Press, 1989), 368.

58 I owe the conceptual structure of the following section to Philip Stoltzfus, who has suggested that musical *Gefühl* in particular features prominently in Schleiermacher's theological reflection. Consequently, Stoltzfus will be our primary dialogue partner as we assess Schleiermacher's notion of religious and musical *Gefühl*.

59 Although we are taking his entire body of work into consideration, *On Religion: Speeches to Its Cultured Despisers* will be the main text we rely upon in this section.

60 It therefore involves "the immediate consciousness of the universal existence of all finite things, in and through the Infinite, and of all temporal things in and through the Eternal. . . . It is to have life and to know life in immediate feeling [*Gefühl*]." Schleiermacher, *On Religion*, 38.

61 I have borrowed this term from Damasio, *The Feeling of What Happens*.

62 However, it must be noted that, given the limitations of the particular ethnographic sources from which we have culled, the prevalence of this desire to reflect upon one's emotions is likely skewed. For, by drawing from a discussion forum, we are necessarily limiting our analysis to individuals who are already actively processing their emotions in a public arena. The general population might very well be different.

63 This phrasing is taken from another of Schleiermacher's musically oriented works, *Christmas Eve: A Dialogue on the Celebration of Christmas*. In this work, he states, "[M]usic produced at first a quiet satisfaction and retirement of soul. There followed a few silent moments, in which, however, they all knew that the heart of each of them was lovingly directed towards the others, and towards something still higher." Friedrich Schleiermacher, *Christmas Eve: A Dialogue on the Celebration of Christmas*, trans. W. Hastie (Edinburgh: T&T Clark, 1890), 10.

64 "For this cultivation [of religion] we believers know of only one means—the free expression and communication of religion. When religion moves in a man with all its native force, when it carries every faculty of his spirit imperiously along in the stream of its impulse, we expect it to penetrate into the hearts of all who live and breathe within its influence." Schleiermacher, *On Religion*, 119.

65 I have borrowed this concept from Stoltzfus, who suggests that the musical-aesthetic experience "is not so much an expression of defined states of feeling as it is the *communal womb* within which feeling is allowed to emerge." Stoltzfus, *Theology as Performance*, 72 (emphasis added).

66 Consider his statement in *Speeches*: "The piety of each individual, whereby he is rooted in the greater unity, is a whole by itself. It is a rounded whole, based on his peculiarity, on what you call his character, of which it forms one side. Religion thus fashions itself with endless variety, down even to the single personality." Schleiermacher, *On Religion*, 51.

67 Schleiermacher, *On Religion*, 50.

68 Schleiermacher himself rejected the idea that he was a pantheist. Although he was hesitant to make too much of the God/world distinction for fear of developing a "doctrine" that was wholly incapable of capturing the true nature of God, this distinction was the very thing that separated him from Spinoza. In the critical commentary he wrote in 1806 for the second edition of the *Speeches*, he states somewhat sarcastically, "A pious spirit, which is here unquestionably the subject of discourse, is elsewhere always defined as a soul surrendered to God. But here the universe is put for God and the pantheism of the author is undeniable! This is the interpolation, not the interpretation of superficial and suspicious readers." Schleiermacher, *On Religion*, 24.

69 Schleiermacher, *On Religion*, 49 and 89.

Chapter 5

1 George Steiner, *Real Presences* (Chicago: University of Chicago Press, 1989), 227.

2 Even those who subscribe to a strictly formalist or absolutist understanding of musical meaning recognize that the intuitive and affective power of music strains against the limits of an arid rationality, eluding the grasp of purely empirical analyses and discursive reasoning. Leonard Meyer, for example, employs an

absolutist conception of musical meaning. He suggests that "it is pointless to ask what the intrinsic meaning of a single tone or a series of tones is. Purely as physical existences they are meaningless. They become meaningful only in so far as they point to, indicate, or imply something beyond themselves." Interestingly, though, as an absolutist who considers all musical meaning to be intramusical, Meyer argues that each tone points "beyond itself" only insofar as it points to another tone within the musical composition. Given our theological interests, we will be challenging and in a certain sense expanding this wholly intramusical conception. Meyer, *Emotion and Meaning*, 34.

3 For further insight and discussion concerning both the benefits and the problems of auteur criticism in general, see Johnston, *Reel Spirituality*, esp. 194–201. For a book-length contribution to the theology and film dialogue that highlights the value of auteur criticism by considering the distinctly Catholic understanding of the world that shapes the work of six prominent filmmakers, see Richard Aloysius Blake, *Afterimage: The Indelible Catholic Imagination of Six American Filmmakers* (Chicago: Loyola Press, 2000).

4 As Robert Johnston rightly notes, "When the creative effort of a moviemaker is dominant, a recognition of the auteur allows new insight into the power and meaning of the movie itself." Johnston, *Reel Spirituality*, 195.

5 In order to address the whole of Anderson's oeuvre, we might also include *Boogie Nights* (1997) in our discussion. However, the music in *Boogie Nights* does not share the same discernible characteristics as the music in his later films, although it certainly hints at the direction his work would eventually take beginning with *Magnolia*. Almost the entirety of the film's soundtrack is diegetic popular music from the 1960s and 1970s. Consequently, the music functions principally as a means for situating the narrative in a particular time period, which it does quite effectively. After *Boogie Nights*, however, the popular music in his films moves into the nondiegetic realm and more freely floats away from the constraints of the narrative, speaking from a realm beyond or outside the diegetic world.

6 I owe this insight to Jeffrey Overstreet, *Through a Screen Darkly* (Ventura, Calif.: Regal Books, 2007), 256. His discussion of Paul Thomas Anderson's films is quite insightful and, as such, offers a nice foil for the musically oriented analysis I am offering here.

7 "Anderson employs musician Jon Brion to surround Barry with a soundtrack that behaves like another character—one who is armed with sharp objects, rattles and noisemakers. The music comes to manifest the sparking nervous system that keeps Barry jumping at the slightest provocation." Overstreet, *Through a Screen Darkly*, 250.

8 The titles of these two scenes on the DVD are "Harmonium Drop" and "Lena Drops," which significantly hints at the interconnected nature of these seemingly random events.

9 Buhler, "*Star Wars*, Music, and Myth", 43.

10 Theodor W. Adorno, *Mahler: A Musical Physiognomy* (Chicago: University of Chicago Press, 1992), 14 and 17.

11 Adorno, *Mahler: A Musical Physiognomy*, 129.

12 "Adorno sees breakthrough [i.e., the in-breaking of a transcendent "Other"] as a temporary suspension of the artistic logic of the work. Such a suspension attempts the paradoxical task of rendering apparent what a work's artistic logic has excluded in terms still consistent with that logic. In short, breakthrough is an attempt to represent transcendence through immanent means." James Buhler, "'Breakthrough' As Critique of Form: The Finale of Mahler's First Symphony," *19th-Century Music* 20, no. 2, Special Mahler Issue (1996): 129. It must be noted, however, that we are not attempting to appropriate the technical aspects of Adorno's work in a straightforward manner. Rather, we are employing his conception of a musical "breakthrough" in order to speak of film music's capacity to "represent" the unrepresentable.

13 Using Michel Chion's terminology, this type of musical presence would be more of an "acousmatic intrusion" than an emergence of a transcendent Other. Chion, *Audio-Vision*, 29.

14 Richard Peña, "Magnolia," in *The Hidden God: Film and Faith*, ed. Mary Lea Bandy and Antonio Monda (New York: The Museum of Modern Art, 2003), 237.

15 The title of this track is "Popcorn Superhet Receiver." Greenwood actually wrote it prior to and independently from the film, but it serves as a fitting opening "sound" for *There Will Be Blood*.

16 I owe this insight concerning the "monomaniacal note" and its relationship to the collapse of Plainview's "soul" to Alex Ross, who wrote a particularly penetrating analysis of the music in *There Will Be Blood* for *The New Yorker*. See Alex Ross, "Welling Up: A Film Score and an Orchestral Work by Jonny Greenwood, of Radiohead," *The New Yorker*, February 4, 2008.

17 Daniel literally translated means "God is my judge." Although space precludes a full exploration of either of the characters' names (chose by Anderson, not from his source), it is interesting that, just as Daniel could not escape the mysterious force signified by the film's music, neither could he escape the divine mark on his life imprinted in his very name. Yet, as Daniel kills and therefore passes judgment upon Eli ("my God"), he takes the final step toward supplanting God, assuming the role of both divine judge and executioner. In an important sense, this echoes Nietzsche's conception of the death of God in the modern person's experience of the world. Nietzsche's madman proclaims, "'Where is God? . . . I'll tell you! We have killed him—you and I! We are all his murderers. . . . God is dead! God remains dead! And we have killed him! How can we console ourselves, the murderers of all murderers! The holiest and the mightiest thing the world has ever possessed has bled to death under our knives: who will wipe this blood from us? With what water could we clean ourselves? . . . Do we not ourselves have to become gods merely to appear worthy of it?'" Friedrich Wilhelm Nietzsche, *The Gay Science*, trans. Josefine Nauckhoff (New York: Cambridge University Press, 2001), 119–20.

18 In a single discussion on the film's score, opinions abound. Two examples will suffice. "Eleventh_sun" suggested that he "loved the perfect combination of audio and visual." "Potzdorf" demurred: "People give Jonny Greenwood too much credit as a veritable orchestral composer for this score. . . . Jonny Greenwood is a rock musician and is not schooled in classical music. He is WAY in over his head here." See http://www.imdb.com/title/tt0469494/board/thread/154003800. Those writing online reviews of the film are equally divided. One reviewer suggests that the music in this scene is "tighter, more disciplined, and lonelier than anything he's [Greenwood] done before." Mark Pytlik, "Jonny Greenwood: There Will Be Blood," http://pitchfork.com/reviews/albums/11007-there-will-be-blood-ost (accessed March 10, 2010). A different reviewer suggested the very opposite: "Its music is . . . incomprehensible, disrespectful and what is worse, very annoying." Paul E. Robinson, "There Will Be Blood & Bad Music Too!" http://theartoftheconductor.com/news/2008/06/11/there-will-be-blood-bad-music-too/ (accessed March 10, 2010).

19 Peña, "Magnolia," 236.

20 Although we are attempting here simply to chart the responses of various filmgoers as they reflect on their experience of Anderson's films, we must remain aware of their somewhat ambiguous use of the word "transcendent." Typically, individuals do not employ this term in the classic, ontological sense. Rather, they most often speak of "transcendence" in the post-Kantian, phenomenological sense as the ground of our experience. However, this distinction often breaks down on a concrete level. Therefore, rather than discarding their responses due to this uneasy conflation, I want to suggest that it simply reflects the basic Romantic notion of art as something that reveals. What is revealed can be at times "something higher" but is more often "something from within." Thus, this very tension between notions of transcendence reflects a conception of "immanent transcendence" that lies at the heart of contemporary understandings of art and spirituality.

21 John Updike, "Packed Dirt, Churchgoing, a Dying Cat, a Traded Car," in *Pigeon Feathers and Other Stories* (New York: Random House, 1996), 253.

22 Ross, "Welling Up."

23 kottke, "Early Rave Review for There Will Be Blood," November 30, 2007, http://www.avclub.com/articles/omg-there-will-be -blood,10221/ (accessed March 10, 2010).

24 Bryant, "Magnolia," http://www.deep-focus.com/flicker/magno lia.htmlk, (accessed March 10, 2010).

25 Sleeperz, "Magnolia," December 28, 2009, http://iwatchedthis movie.wordpress.com/2009/12/28/magnolia-1999/ (accessed March 10, 2010). In addition to "revelatory" and "spiritual," reviewers often speak of Anderson's films as "transcendent." Of all his films, though, *Magnolia* seems to most often garner this type of description.

26 Carla Meyer, "Mad Love: Sandler, Watson Make an Odd but Believable 'Punch-Drunk' Pair," *San Francisco Chronicle*, October 18, 2002.

27 Lisa Schwarzbaum, "There Will Be Blood," January 9, 2008, http://www.ew.com/ew/article/0,,20168259,00.html (accessed March 10, 2010).

28 Peter Travers, "There Will Be Blood," *Rolling Stone*, January 7, 2008.

29 Stephen Erlewine, "There Will Be Blood," December 18, 2007, http://www.allmusic.com/album/there-will-be-blood-original -soundtrack-mw0000499799 (March 10, 2010).

30 This of course is not to say that these "revelatory" experiences contain no content whatsoever. For instance, although it is likely inaccessible to most filmgoers, the orchestral underscoring of Anderson's films certainly contains musical content that is related to the music's formal structures. In addition, when Anderson employs popular music, most audiences are able to discern the lyrical content of the music. As we will further discuss below, these musical-aesthetic experiences contain theological content as well. However, as we are intentionally allowing Anderson's artwork to set the parameters of our discussion, we are concerned here with orchestral music's ability to function theologically even when it contains no *explicitly religious* content. Consequently, by highlighting the way in which music addresses the ineffable, we are focusing on one dimension of film music and, thus, on a singular aspect of "revelatory" experiences. However, it is this aspect of contemporary aesthetic experiences that is in most need of development from a theological perspective.

31 Ross, "Welling Up."

Chapter 6

1 Robert Johnston suggests that film's revelatory capacity is rooted in the Spirit's general activity in the artistic endeavors of humanity. He also helpfully points out that "Christian theology, though it might give lip service to the presence of the Spirit in all of life, continues largely to ignore such works of the Spirit in the mundane, the ordinary experiences of human life." Johnston, *Reel Spirituality*, 97. Echoing Johnston, Craig Detweiler states, "*General Revelation* is a term created by theologians to describe the experience of God available to all people. . . . [W]e are considering the term *revelation* much more broadly. . . . I expect contemporary cinema to serve as a vexing but rewarding source of divine inspiration." Detweiler, *Into the Dark*, 33 (emphasis in original).

2 Aquinas, *Summa contra Gentiles*, IV, ch. i., as quoted in John Baillie, *The Idea of Revelation in Recent Thought* (New York: Columbia University Press, 1956), 4.

3 Bruce A. Demarest, *General Revelation: Historical Views and Contemporary Issues* (Grand Rapids: Zondervan, 1982), 35–37.

4 Moltmann, *Experiences in Theology*, 65 (emphasis in original).

5 This terminology is John Calvin's.

6 Demarest, *General Revelation*, 30.

7 It is important to note that, within the Reformed Protestant tradition, individual theologians emphasize the "preparatory" and "condemnatory" aspects of general revelation in varying degrees. Compared to Bruce Demarest, for example, G. C. Berkouwer is far more pessimistic concerning the possibilities of general revelation. He clearly states that general revelation's basic insufficiency, although not related to any deficiency in God's revelation, is related to humanity's sinful blindness. Thus, "when we speak of the insufficiency of general revelation, we may never diminish and relativize the greatness and majesty of this revelation. The fact that man does not behold and recognize the superior power of the working of God in the creation, maintenance and governance of the world, can be explained only in terms of his guilt." Berkouwer, *General Revelation*, Studies in Dogmatics (Grand Rapids: Eerdmans, 1955), 312.

8 Demarest, *General Revelation*, 79.

9 Graham Ward notes that "fundamental to Barth's theological thinking [was] his need for dialogue partners, even, as with Brunner, if these partners are to be critically assailed." Later he states, "From the start his [Barth's] writing set out to shock and be polemical." Ward, *Cultural Transformation and Religious Practice* (New York: Cambridge University Press, 2005), 20 and 33.

10 Barth was concerned not necessarily with the anthropological starting point of Roman Catholic or liberal Protestant theology, but rather with the way in which these theological traditions made human subjectivity their "primary and decisive concern." To suggest otherwise is simply to paint Barth as a caricature, which often occurs in summaries of his work. In this regard it is also important to note that he reduced the combative tone of his work over time and as he engaged in theological reflection in a different context. In fact, after World War II, Barth was markedly more open, yet still hesitant, concerning the anthropological dimension of theology. Writing in 1957 he states, "An abstract doctrine of God has no place in the Christian realm, only a 'doctrine of God and of man,' a doctrine of the commerce and communion between God and man. . . . There is no reason why the attempt of Christian anthropocentrism should not be made, indeed ought not to be made. There is certainly a place for legitimate Christian thinking starting from below and moving

up, from man who is taken hold of by God to God who takes hold of man." Karl Barth, *The Humanity of God* (Louisville, Ky.: John Knox Press, 1967), 11 and 24.

11 See especially Emil Brunner and Karl Barth, *Natural Theology* (Eugene, Ore.: Wipf & Stock, 1946).

12 Significantly, neoorthodox theologians like Barth and Brunner were concerned not only with protecting revelation from the abuses of the modern critical historian, but also with "an attempt to rehabilitate Reformed theology as a constructive response to modern thought." Laurence W. Wood, *Theology as History and Hermeneutics: A Post-Critical Conversation with Contemporary Theology* (Lexington: Emeth Press, 2005), 5. Consequently, the heated exchange between these two theologians often centered upon who was interpreting the Reformers (namely Calvin) correctly. This is especially the case when they broached the concept of general revelation and Calvin's *sensus divinitatis*.

13 Barth states, "God can be known only through God, namely in the event of the divine encroachment of His self-revelation. There can be no question of any other *posse* [ability or capacity], i.e., a *posse* which is not included in and with this divine encroachment." Karl Barth, *The Church Dogmatics*, trans. T. H. L. Parker, W. B. Johnston, Harold Knight, and J. L. M. Haire, vol. II.1, ed. Geoffrey William Bromiley and Thomas Forsyth Torrance (Edinburgh: T&T Clark, 1957), 79.

14 Barth, "Revelation," in J. Baillie and H. Martin, eds., *Revelation* (London: Faber & Faber, 1937), 53. As quoted in Demarest, *General Revelation*, 124.

15 Interestingly, while he bemoaned the many problems that beset "modern" theology, by appropriating Kant's assertion that God is beyond the reach of human knowledge, Barth's theology is, in fact, significantly informed by modern philosophical categories.

16 "In defining revelation as *self*-revelation, one can understand why Barth said that there is only one revelation—the person of Jesus Christ. If revelation means '*self*-revelation,' i.e., what God reveals is God's *self*, then Barth properly drew the logical deduction that only in one event can God be revealed, namely, in the Christ event. If God should be revealed elsewhere, then it would be obvious that God's very selfhood in Jesus had not been really revealed. The idea of several revelations would be a logical inconsistency." Wood, *Theology as History and Hermeneutics*, 6 (emphasis in original).

17 Although space precludes a discussion of this sort, I would also argue that these two concerns are by-products of the modern, foundationalist epistemology that pervades much of contemporary theological reflection, and necessarily involve an approach rooted in epistemological certainty and unidirectional reasoning. Consequently, contemporary theology often follows a predictably foundationalist trajectory: revelation is defined as the communication of "knowledge" about God; therefore, because general revelation fails to provide "adequate" or "certain" knowledge of God, salvation, which is "based" upon and "follows from" the indubitable foundation of "certain" knowledge, cannot be obtained through general revelation. I owe this insight in part to Ronald Thiemann, who suggests that "the fatal flaw which haunts the modern doctrine of revelation (in both its explicit and implicit forms) is the epistemological foundationalism which theologians employ in order to provide the theoretical justification for Christian beliefs in God's prevenience." Ronald F. Thiemann, *Revelation and Theology: The Gospel as Narrated Promise* (Notre Dame: University of Notre Dame Press, 1985), 7.

18 Barth, *The Church Dogmatics*, 179.

19 This basic suspicion regarding experience is not isolated to Barth. Rather, as Robert Johnston suggests, "Christian theologians have too often looked at general revelation as a 'cup half-empty,' even while their own experience of God's Spirit, like that of others in the culture around them, has been of a 'cup half-full.' The difference has proven more than semantic. It has described the 'spectacles' we have worn as we have engaged both biblical text and cultural context. It has defined either a posture of suspicion or one of appreciation through which we have filtered the witness of others (and ourselves) to the Spirit's illumining presence in our lives." Johnston, "Discerning the Spirit in Culture: Observations Arising from Reflections on General Revelation," *Ex Auditu* 23 (2007): 52.

20 Interestingly, although Barth resolutely opposed natural theology and general revelation, his experience of Mozart's music was decidedly theological, even mystical. Not only did Barth listen to Mozart each day prior to writing his *Dogmatics*, and claim that he once had a "vision" of Mozart at a piano concerto, but he even went so far as to say that Mozart has a "place in theology, especially in the doctrine of creation and also eschatology. . . . It is possible to give him this position because he knew something

about creation in its total goodness." Barth, *The Church Dogmatics* III.3, 9. Thus, it would seem that, even within Barth's otherwise uncompromising worldview, there existed a space where his "sacred" encounters with Mozart's music rested uneasily alongside his theological formulations.

21 Writing in 1968, Barth states, "In *Church Dogmatics* IV, 1–3, I at least had the good instinct to place the church, and then faith, love, and hope, under the sign of the Holy Spirit. But might it not even be possible and necessary to place justification, sanctification, and calling under this sign—to say nothing of creation as the *opus proprium* of God the Father? Might not even the Christology which dominates everything be illuminated on this basis (*conceptus of Spiritu Sancto!*)?" Karl Barth, *The Theology of Schleiermacher*, trans. Geoffrey W. Bromiley, ed. Dietrich Ritschl (Grand Rapids: Eerdmans, 1982), 278.

22 Barth, *The Theology of Schleiermacher*, 278–79.

23 Indeed, "[a]n interpretation of Moltmann's work which stressed his continuities with Barth could see his work, in its development from a strongly Christological focus in his early work to a complementary pneumatological focus in his later work and from being a theology of the word of God to a complementary stress on experience of God, as appropriating this dream of Barth's and realizing it in a certain sense." Richard Bauckham, *The Theology of Jürgen Moltmann* (Edinburgh: T&T Clark, 1995), 215.

24 Although we will focus our energies on *The Spirit of Life*, the whole of Moltmann's theology is at least implicitly concerned with pneumatology and is decidedly Trinitarian. Thus, where appropriate, we will draw on his larger corpus of work in order to enhance our understanding of his basic concerns in *The Spirit of Life*. For an insightful analysis of the pneumatological shape of Moltmann's earlier work and how his concerns with a doctrine of the Spirit emerged as the vital element in Moltmann's later thought, see D. Lyle Dabney, "The Advent of the Spirit: The Turn to Pneumatology in the Theology of Jürgen Moltmann," *The Asbury Theological Journal* 48, no. 1 (1993): 81–107.

25 It is important to note that Moltmann is employing an intentionally panentheistic formulation here and not, as some suggest, a pantheistic conception of the Spirit. As he suggests, "If experience of God is related to the experience of the whole world and the whole of life, this by no means implies that all possible experiences have to be turned into the same thing and pantheistically

made a matter of indifference. . . . Given the premise that God is experienced in experience of the world and life, it once again becomes possible to talk about special experiences of God in the contingent and exceptional phenomena which are called 'holy,' without having to declare everything else profane." Moltmann, *The Spirit of Life*, 35.

26 Moltmann, *The Spirit of Life*, 35.

27 Moltmann, *The Spirit of Life*, 35.

28 This passage is often translated "Or do you not know that your body is the temple of the Holy Spirit who is in you, whom you have from God, and you are not your own?" Interestingly, though, the Greek reads *tou en humin hagio pneumatos*, which, given the position of the prepositional phrase, might be literally translated as "The in-you-Holy-Spirit." In this reading, the human condition is a constitutive part not only of the Spirit's presence in the world but of the Spirit's very self. However, the larger point Paul is making in chapter 6 of 1 Corinthians relates to the Spirit's presence in the whole of our physical lives. From the food we eat to the lawsuits we file to the sexual acts we engage in, God's presence is infused into the entire scope of our physical life. The Corinthians sought legislation for "Christian behavior" so as to continue in their compartmentalized living. Paul refused them this luxury and demanded a holistic, embodied conception of God's pervasive presence in their lives.

29 Moltmann, *The Spirit of Life*, 212.

30 "To experience God in all things presupposes that there is a transcendence which is immanent in things and which can be inductively discovered. . . . To experience all things in God means moving in the opposite direction. . . . We sense that in everything God is waiting for us. . . . For this, the term *immanent transcendence* offers itself." Moltmann, *The Spirit of Life*, 34–36 (emphasis in original).

31 Moltmann, *The Spirit of Life*, 41.

32 Moltmann, *The Spirit of Life*, 82.

33 We might note that Paul employs the term *pneuma* throughout his writings, and conceives of it in relationship to the concept "flesh"or *sarx*. Indeed, it is for this very reason that many have approached human physicality cautiously in the Christian tradition. However, as Moltmann rightly notes, Paul was rooted in the Jewish tradition and thus conceived of *pneuma*, not as a "higher principle" but as the center of the whole person. Thus, "spirit"

and "flesh" do not represent a dichotomy or dualism within the human person, but an orientation toward God and our life in the world. "Flesh" is a concept used to speak of the sphere of the created world and the transitory world-time of sin and injustice, not an ontologically lower part of the human person that is less "real" or "good" than the "spirit." Thus, Paul can encourage the Corinthians to "glorify God with your body" (1 Cor 6:20), for sin is not located in the physicality of the body; it is found in the disorientation of the human as a whole.

34 Moltmann states, "The *ruach* as Yahweh's *ruach* is of course transcendent in origin; but it is equally true to say that as the power of life in all the living it is immanently efficacious. The creative power of God is the transcendent side of *ruach*. The power to live enjoyed by everything that is alive is its immanent side." Moltmann, *The Spirit of Life*, 42.

35 Moltmann, *The Spirit of Life*, 155.

36 "That is why we seek ourselves in everything without ever finding ourselves. We are deeper than things. It is because of the presence of the divine Spirit in us that we are so far beyond ourselves. It is only in us ourselves that we find this self-transcendence. Only God's Spirit can be more intimately near to me than I am to myself." Jürgen Moltmann, *The Source of Life: The Holy Spirit and the Theology of Life*, trans. Margaret Kohl (Minneapolis: Fortress, 1997), 77.

37 "When we say that the creation's Creator Spirit indwells both every individual creature and the community of creation, we mean that the presence of the infinite in the finite imbues every finite thing, and the community of all finite beings, with self-transcendence. There is no other way of conceiving the presence of the infinite in the finite, if the infinite is not to destroy the finite, or the finite the infinite." Jürgen Moltmann, *God in Creation: A New Theology of Creation and the Spirit of God*, trans. Margaret Kohl (Minneapolis: Fortress, 1993), 101.

38 For the sake of clarity, I want to stress here that, while we are developing Moltmann's notion of immanent transcendence because of the ease with which it speaks to film music's "revelatory" capacity, Moltmann is quite forthright in talking about the personal and Trinitarian nature of his pneumatology. He states, "The Trinitarian concept of creation binds together God's transcendence and his immanence. The one-sided stress on God's transcendence in relation to the world led to deism, as with

Newton. The one-sided stress on God's immanence in the world led to pantheism, as with Spinoza. The Trinitarian concept of creation integrates the elements of truth in monotheism and pantheism. In the panentheistic view, God, having created the world, also dwells in it, and conversely the world which he has created exists in him. This is a concept which can only really be thought and described in Trinitarian terms." Moltmann, *God in Creation*, 98. These dual emphases therefore do not allow us to speak of the Spirit in completely impersonal terms. The Spirit is both the energy of life and the space in which we live, but the Spirit is also the third person of the Trinity. The two are inter-related and inseparable.

39 Moltmann, *The Spirit of Life*, 42.
40 Moltmann, *The Spirit of Life*, 157 (emphasis in original).
41 Moltmann, *The Spirit of Life*, 179.
42 Moltmann, *The Spirit of Life*, 46.
43 Moltmann, *The Spirit of Life*, 46.
44 See Moltmann, *Experiences in Theology*, 315.
45 This notion of the Shekinah develops and expands upon the work of the Jewish existentialist philosopher Franz Rosenzweig, who suggests that "The Shekhina, God's coming down to men and his dwelling among them, is explained as a separation that occurs in God himself. God himself separates from himself, he gives himself away to his people, he suffers with its suffering, he migrates with it into the misery of foreign lands, he wanders with its wanderings." Rosenzweig, *The Star of Redemption*, trans. Barbara E. Galli (Madison: University of Wisconsin Press, 2005), 432.
46 Moltmann, *The Spirit of Life*, 12.
47 Moltmann, *The Spirit of Life*, 93.
48 Bauckham, *The Theology of Jürgen Moltmann*, 22.
49 Andrew Greeley, *The Catholic Imagination* (Berkeley: University of California Press, 2000), 1.
50 In his discussion of the "symbols" in Andrei Tarkovsky's films, Gerard Loughlin suggests that his images function as icons. "They are just themselves; but disclosive of more than just themselves. And because they are disclosive—disclosive when venerated—they are venerable." Gerard Loughlin, "Video Divina: Viewing Tarkovsky," in *Reconfigurations: Interdisciplinary Perspectives on Religion in a Post-Secular Society*, ed. Stefanie Knauss and Alexander D. Ornella (New Brunswick, N.J.: Transaction Publishers, 2007), 190.

51 "Echon" and "echonic" are neologisms that I have created to speak of this particular function of music. As the word "icon" emanates from the Greek *eikon* or image, "echon" is taken from the Greek *echos* or "sound."

52 Jeremy Begbie makes a similar claim regarding music and time. He states, "Music requires my time, my flesh and blood, my thought and action for its performance and reception. Music asks for my patience, my trust that there is something worth waiting for. . . . Music can teach us a kind of patience which stretches and enlarges, deepens us in the very waiting." Begbie, *Theology, Music, and Time* (Cambridge: Cambridge University Press, 2000), 87.

53 Again, it is helpful to note that I am not suggesting here that an individual's experience with film music or any other medium of God's general revelation is without theological content, nor am I suggesting that music's "theological" appeal should be strictly equated with its "ineffable" characteristics. Certainly we can speak of the content of revelation even when this content is perhaps vague or intimated, such as the knowledge of a Creator that might emerge in and through our experience of the created order. However, the point I am making here is that, given the particularities of the music in Paul Thomas Anderson's films, a fully orbed notion of God's general revelatory presence provides us the means for speaking of contemporary experiences that may in fact contain no *explicitly* Christian or religious content. That is, general revelation allows us to value and affirm those experiences of life that contain not only explicit theological content, but implicit content as well. Thus, we are speaking here of only one dimension of revelatory experiences and, thereby, one dimension of pneumatology.

Conclusion

1 I owe this insight regarding Job to Robert Johnston. See Robert K. Johnston, "The Tree of Life: The Gift of Life," Reel Spirituality/Film, Brehm Center website, July 27, 2011, http://www.brehm center.com/initiatives/reelspirituality/film/reviews/the_tree_of _life_the_gift_of_life (accessed November 12, 2011).

2 This segment begins at 20:05 on the DVD.

3 Listen closely for the appearance of this melody at 1:49:12.

4 I have borrowed the term "cinematic event" from Rick Altman, who argues convincingly for approaching film analysis from the

perspective of film as an "event" rather than as a "text." See Rick Altman, ed., *Sound Theory, Sound Practice* (New York: Routledge, 1992), 3–4.

5 Interestingly, during his speech before the Areopagus in Acts 17:22-34, Paul never mentions the name of Jesus. In this way, rather than condemning and "correcting" the Athenians' lack of knowledge about Christ, Paul affirmed the general revelation they had discovered in and through their poetry and religious devotion.

BIBLIOGRAPHY

Abel, Richard, and Rick Altman. *The Sounds of Early Cinema.* Bloomington: Indiana University Press, 2001.

Adorno, Theodor W. *The Culture Industry: Selected Essays on Mass Culture.* Routledge Classics. London: Psychology Press, 2001.

———. *Mahler: A Musical Physiognomy.* Chicago: University of Chicago Press, 1992.

Adorno, Theodor W., and Hanns Eisler. *Composing for the Films.* London: Continuum, 2007.

Altman, Rick. *The American Film Musical.* Bloomington: Indiana University Press, 1987.

———. "Inventing the Cinema Soundtrack: Hollywood's Multiplane Sound System." In *Music and Cinema,* edited by James Buhler, Caryl Flinn, and David Neumeyer. Hanover, N.H.: University Press of New England, 2000.

———. *Silent Film Sound.* New York: Columbia University Press, 2004.

———, ed. *Sound Theory, Sound Practice.* New York: Routledge, 1992.

Anderson, Lauren. "Case Study 1: Sliding Doors and Topless Women Talk About Their Lives." In *Popular Music and Film,* edited by Ian Inglis, 102–16. London: Wallflower, 2003.

Augustine. *The Confessions of St. Augustine.* Translated by John K. Ryan. Garden City, N.Y.: Image Books, 1984.

Baillie, John. *The Idea of Revelation in Recent Thought.* New York: Columbia University Press, 1956.

Barth, Karl. *The Church Dogmatics.* Translated by T. H. L. Parker, W. B. Johnston, Harold Knight, and J. L. M. Haire. Vol. II.1, edited by Geoffrey William Bromiley and Thomas Forsyth Torrance. Edinburgh: T&T Clark, 1957.

———. *The Church Dogmatics.* Translated by T. H. L. Parker, W. B. Johnston, Harold Knight, and J. L. M. Haire. Vol. III.3, edited by Geoffrey William Bromiley and Thomas Forsyth Torrance. Edinburgh: T&T Clark, 1960.

———. *The Humanity of God.* Louisville, Ky.: John Knox, 1967.

———. *The Theology of Schleiermacher.* Translated by Geoffrey W. Bromiley. Edited by Dietrich Ritschl. Grand Rapids: Eerdmans, 1982.

Bauckham, Richard. *The Theology of Jürgen Moltmann.* Edinburgh: T&T Clark, 1995.

Bazin, André. *Qu'est-Ce Que Le Cinéma?* Paris: Editions du Cerf, 1975.

Begbie, Jeremy. *Resounding Truth: Christian Wisdom in the World of Music.* Grand Rapids: Baker Academic, 2007.

———. *Theology, Music, and Time.* Cambridge: Cambridge University Press, 2000.

Berkouwer, G. C. *General Revelation.* Studies in Dogmatics. Grand Rapids: Eerdmans, 1955.

Blackwell, Albert L. *The Sacred in Music.* Louisville, Ky.: Westminster John Knox, 1999.

Blake, Richard Aloysius. *Afterimage: The Indelible Catholic Imagination of Six American Filmmakers.* Chicago: Loyola Press, 2000.

Brecher, Daniel. "Finding Nemo: Review." http://www.soundtrack.net/albums/database/?id=3270&page=review, August 25, 2003 (accessed May 15, 2010).

Brown, Royal S. *Overtones and Undertones: Reading Film Music.* Berkeley: University of California Press, 1994.

Brunner, Emil, and Karl Barth. *Natural Theology.* Eugene, Ore.: Wipf & Stock, 1946.

Buhler, James. "Analytical and Interpretive Approaches to Film Music (II): Analysing Interactions of Music and Film." In *Film Music: An Anthology of Critical Essays*, edited by K. J. Donnelly, 39–61. Edinburgh: Edinburgh University Press, 2001.

———. "'Breakthrough' As Critique of Form: The Finale of Mahler's First Symphony." *19th-Century Music* 20, no. 2, Special Mahler Issue (1996): 125–43.

———. "*Star Wars*, Music, and Myth." In *Music and Cinema*, edited by James Buhler, Caryl Flinn, and David Neumeyer, 33–57. Hanover, N.H.: Wesleyan University Press, 2000.

Buhler, James, David Neumeyer, and Rob Deemer. *Hearing the Movies: Music and Sound in Film History*. New York: Oxford University Press, 2010.

Carey, Melissa, and Michael Hannan. "Case Study 2: The Big Chill." In *Popular Music and Film*, edited by Ian Inglis, 162–77. London: Wallflower, 2003.

Chion, Michel. *Audio-Vision: Sound on Screen*. Translated by Claudia Gorbman. New York: Columbia University Press, 1994.

———. *Film, a Sound Art*. New York: Columbia University Press, 2009.

Cook, Nicholas. *Music, Imagination, and Culture*. Oxford: Clarendon, 1990.

———. *Music: A Very Short Introduction*. Oxford: Oxford University Press, 2000.

Cooke, Mervyn. *A History of Film Music*. New York: Cambridge University Press, 2008.

Crainshaw, Jill Y. *Wise and Discerning Hearts: An Introduction to Wisdom Liturgical Theology*. Collegeville, Minn.: Liturgical Press, 2000.

Dabney, D. Lyle. "The Advent of the Spirit: The Turn to Pneumatology in the Theology of Jürgen Moltmann." *The Asbury Theological Journal* 48, no. 1 (1993): 81–107.

Damasio, Antonio R. *The Feeling of What Happens: Body and Emotion in the Making of Consciousness*. New York: Harcourt Brace, 1999.

Dargis, Manohla. "The House That Soared." *The New York Times*, May 28, 2009. http://movies.nytimes.com/ 2009/05/29/movies/29up.html (accessed June 15, 2010).

Davis, Ellen F. *Getting Involved with God: Rediscovering the Old Testament*. Lanham, Md.: Cowley Publications, 2001.

Deacy, Christopher. *Faith in Film: Religious Themes in Contemporary Cinema*. Burlington, Vt.: Ashgate, 2005.

Demarest, Bruce A. *General Revelation: Historical Views and Contemporary Issues*. Grand Rapids: Zondervan, 1982.

Detweiler, Craig. *Into the Dark: Seeing the Sacred in the Top Films of the 21st Century*. Cultural Exegesis. Grand Rapids: Baker Academic, 2008.

Detweiler, Craig, and Barry Taylor. *A Matrix of Meanings: Finding God in Pop Culture*. Grand Rapids: Baker Academic, 2003.

Dickinson, Kay. *Off Key: When Film and Music Won't Work Together*. New York: Oxford University Press, 2008.

Doane, Mary Ann. "Ideology and the Practice of Sound Editing and Mixing." In *Film Sound: Theory and Practice*, edited by Elisabeth Weis and John Belton, 54–62. New York: Columbia University Press, 1985.

Docter, Pete. "*Monsters, Inc.* Director's Commentary." *Monsters, Inc.* Emeryville, Calif.: Disney, 2001, DVD.

Dyrness, William A. *Poetic Theology: God and the Poetics of Everyday Life*. Grand Rapids: Eerdmans, 2011.

Flinn, Caryl. *Strains of Utopia: Gender, Nostalgia, and Hollywood Film Music*. Princeton, N.J.: Princeton University Press, 1992.

Geertz, Clifford. *The Interpretation of Cultures*. New York: Basic Books, 1973.

Goizueta, Roberto S. *Caminemos Con Jesus: Toward a Hispanic/Latino Theology of Accompaniment*. New York: Orbis Books, 1995.

Gorbman, Claudia. "Ears Wide Open: Kubrick's Music." In *Changing Tunes: The Use of Pre-Existing Music in Film*, edited by Phil Powrie and Robynn Jeananne Stilwell, 3–18. Aldershot, U.K.: Ashgate, 2006.

—————. *Unheard Melodies: Narrative Film Music.* Bloomington: Indiana University Press, 1987.

Greeley, Andrew. *The Catholic Imagination.* Berkeley: University of California Press, 2000.

Johnston, Robert K. "Discerning the Spirit in Culture: Observations Arising from Reflections on General Revelation." *Ex Auditu* 23 (2007): 52–69.

—————. *Reel Spirituality: Theology and Film in Dialogue.* 2nd ed. Grand Rapids: Baker Academic, 2006.

—————, ed. *Reframing Theology and Film: New Focus for an Emerging Discipline.* Grand Rapids: Baker Academic, 2007.

—————. *Useless Beauty: Ecclesiastes through the Lens of Contemporary Film.* Grand Rapids: Baker Academic, 2004.

Jost, François. "Les Voies du silence" ("The Voices of Silence"). In *The Sounds of Early Cinema,* edited by Richard Abel and Rick Altman. Bloomington: Indiana University Press, 2001.

Kalinak, Kathryn. *Settling the Score: Music and the Classical Hollywood Film.* Madison: University of Wisconsin Press, 1992.

Lewis, Brad. "Fine Food and Film: A Conversation with Brad Bird and Thomas Keller." *Ratatouille* (Emeryville, Calif.: Disney, 2007), DVD.

Loughlin, Gerard. "Video Divina: Viewing Tarkovsky." In *Reconfigurations: Interdisciplinary Perspectives on Religion in a Post-Secular Society,* edited by Stefanie Knauss and Alexander D. Ornella, 179–95. New Brunswick, N.J.: Transaction Publishers, 2007.

Lynch, Gordon. "Critical Theory and Cultural Studies." In *The Routledge Companion to Religion and Film,* edited by John Lyden. London: Routledge, 2009.

Lyon, Charlotte Haines, and Clive Marsh. "Film's Role in Contemporary Meaning-Making: A Theological Challenge to Cultural Studies." In *Reconfigurations: Interdisciplinary Perspectives on Religion in a Post-Secular Society,* edited by Stefanie Knauss and Alexander D. Ornella, 113–26. New Brunswick, N.J.: Transaction Publishers, 2007.

Marsh, Clive. "The Arts, Learning and the Cultivation of Piety: Contemporary Theological Reflections on Schleiermacher's Approach to Pedagogy and Person-Formation." Paper presented at the AAR National Meeting, Montreal, November 2009.

Meyer, Carla. "Mad Love: Sandler, Watson Make an Odd but Believable 'Punch-Drunk' Pair." *San Francisco Chronicle*, October 18, 2002.

Meyer, Leonard B. *Emotion and Meaning in Music.* Chicago: University of Chicago Press, 1956.

Milbank, John, Catherine Pickstock, and Graham Ward, eds. *Radical Orthodoxy: A New Theology.* New York: Routledge, 1999.

Moltmann, Jürgen. *Experiences in Theology: Ways and Forms of Christian Theology.* Translated by Margaret Kohl. Minneapolis: Fortress, 2000.

———. *God in Creation: A New Theology of Creation and the Spirit of God.* Translated by Margaret Kohl. Minneapolis: Fortress, 1993.

———. *The Source of Life: The Holy Spirit and the Theology of Life.* Translated by Margaret Kohl. Minneapolis: Fortress, 1997.

———. *The Spirit of Life: A Universal Affirmation.* Translated by Margaret Kohl. Minneapolis: Fortress, 1991.

Neumeyer, David, and James Buhler. "Analytical and Interpretive Approaches to Film Music (I): Analysing the Music." In *Film Music: An Anthology of Critical Essays*, edited by K. J. Donnelly, 16–38. Edinburgh: Edinburgh University Press, 2001.

Neumeyer, David, Caryl Flinn, and James Buhler. "Introduction." In *Music and Cinema*, edited by James Buhler, Caryl Flinn, and David Neumeyer, 1–29. Hanover, N.H.: University Press of New England, 2000.

Nietzsche, Friedrich Wilhelm. *The Gay Science.* Translated by Josefine Nauckhoff. New York: Cambridge University Press, 2001.

Otto, Rudolf. *The Idea of the Holy.* A Galaxy Book. New York: Oxford University Press, 1958.

Overstreet, Jeffrey. *Through a Screen Darkly.* Ventura, Calif.: Regal Books, 2007.

Peña, Richard. "Magnolia." In *The Hidden God: Film and Faith,* edited by Mary Lea Bandy and Antonio Monda, 234–38. New York: The Museum of Modern Art, 2003.

Plantinga, Carl R., and Greg M. Smith. *Passionate Views: Film, Cognition, and Emotion.* Baltimore: Johns Hopkins University Press, 1999.

Plotinus. *Enneads: English & Greek.* Translated by Paul Henry and Hans-Rudolf Schwyzer. Vol. 1. Cambridge, Mass.: Harvard University Press, 1966.

Postrel, Virginia I. *The Substance of Style: How the Rise of Aesthetic Value Is Remaking Commerce, Culture, and Consciousness.* 1st ed. New York: HarperCollins, 2003.

Powrie, Phil, and Robynn Jeananne Stilwell. "Introduction." In *Changing Tunes: The Use of Pre-Existing Music in Film,* edited by Phil Powrie and Robynn Jeananne Stilwell, xiii–xxviii. Aldershot, U.K.: Ashgate, 2006.

Prendergast, Roy M. *Film Music: A Neglected Art; A Critical Study of Music in Films.* 2nd ed. New York: W.W. Norton, 1992.

Reay, Pauline. *Music in Film: Soundtracks and Synergy.* Short Cuts. London: Wallflower, 2004.

Robinson, Tasha. "Interview: Andrew Stanton." *The Onion AV Club* video. June 25, 2008. http://www.avclub.com/articles/andrew-stanton,14263/ (accessed June 1, 2010).

Rodman, Ronald. "The Popular Song as Leitmotif in 1990s Film." In *Changing Tunes: The Use of Pre-Existing Music in Film,* edited by Phil Powrie and Robynn Jeananne Stilwell, 119–36. Aldershot, U.K.: Ashgate, 2006.

Rosenzweig, Franz. *The Star of Redemption.* Translated by Barbara E. Galli. Madison: University of Wisconsin Press, 2005.

Ross, Alex. "Welling Up: A Film Score and an Orchestral Work by Jonny Greenwood, of Radiohead." *The New Yorker,* February 4, 2008.

Saliers, Don E. *Music and Theology.* Nashville: Abingdon, 2007.

Schleiermacher, Friedrich. *The Christian Faith.* Vol. 1. New York: Harper & Row, 1963.

———. *Christmas Eve: A Dialogue on the Celebration of Christmas.* Translated by W. Hastie. Edinburgh: T&T Clark, 1890.

———. *On Religion: Speeches to Its Cultured Despisers.* Translated by John Oman. London: K. Paul, Trench, Trubner, 1893.

Smith, Christopher. "Up: Movie Review." *Bangor Daily News.* July 14, 2009. http://www.weekinrewind.com/ (accessed August 15, 2009).

Smith, Greg M. *Film Structure and the Emotion System.* New York: Cambridge University Press, 2003.

Staiger, Janet. *Media Reception Studies.* New York: New York University Press, 2005.

Stanton, Andrew. "Animation Sound Design: Building Worlds from the Ground Up." *Up.* Emeryville, Calif.: Disney, 2008. DVD.

———. "Documentary: Making Nemo." *Finding Nemo.* Emeryville, Calif.: Disney, 2003. DVD.

Steiner, George. *Real Presences.* Chicago: University of Chicago Press, 1989.

Stoltzfus, Philip Edward. *Theology as Performance: Music, Aesthetics, and God in Western Thought.* New York: T&T Clark International, 2006.

Taylor, Barry. "The Colors of Sound: Music and Meaning Making in Film." In *Reframing Theology and Film: New Focus for an Emerging Discipline,* edited by Robert K. Johnston. Grand Rapids: Baker Academic, 2007.

Taylor, Charles. *A Secular Age.* Cambridge, Mass.: Belknap Press, 2007.

———. *Sources of the Self: The Making of the Modern Identity.* Cambridge, Mass.: Harvard University Press, 1989.

Taylor, John Vernon. *The Go-Between God: The Holy Spirit and the Christian Mission.* London: SCM Press, 2004.

Thandeka. "Schleiermacher, Feminism, and Liberation Theologies: A Key." In *The Cambridge Companion to Friedrich Schleiermacher*, edited by Jacqueline Mariña, 287–306. New York: Cambridge University Press, 2005.

Thiemann, Ronald F. *Revelation and Theology: The Gospel as Narrated Promise*. Notre Dame: University of Notre Dame Press, 1985.

Tillich, Paul. *Systematic Theology*. Vol. 1. Chicago: University of Chicago Press, 1951.

Travers, Peter. "There Will Be Blood." *Rolling Stone*, January 7, 2008.

Updike, John. "Packed Dirt, Churchgoing, a Dying Cat, a Traded Car." In *Pigeon Feathers and Other Stories*, 246–79. New York: Random House, 1996.

van der Leeuw, Gerardus. *Sacred and Profane Beauty: The Holy in Art*. 1st ed. New York: Holt, Rinehart, & Winston, 1963.

Ward, Graham. "All You Need Is Love: Moulin Rouge or Christian's Tragedy." In *Reconfigurations: Interdisciplinary Perspectives on Religion in a Post-Secular Society*, edited by Stefanie Knauss and Alexander D. Ornella, 167–78. New Brunswick, N.J.: Transaction Publishers, 2007.

———. *Cultural Transformation and Religious Practice*. New York: Cambridge University Press, 2005.

———. *Theology and Contemporary Critical Theory*. 2nd ed. New York: St. Martin's Press, 2000.

Wierzbicki, James Eugene. *Film Music: A History*. New York: Routledge, 2009.

Wood, Laurence W. *Theology as History and Hermeneutics: A Post-Critical Conversation with Contemporary Theology*. Lexington: Emeth Press, 2005.

INDICES

SCRIPTURE INDEX

SUBJECT INDEX

FILM INDEX